Drawing with Children

Drawing with Children

A Creative Teaching and Learning Method That Works for Adults, Too

Mona Brookes

Foreword by Ann Lewin

JEREMY P. TARCHER, INC.
Los Angeles

The following works of art are reprinted with permission of the
Los Angeles County Museum of Art:

Woman, 1952. Willem de Kooning, United States (b. Holland).
1904– . Purchased with funds provided by the Estate of David E.
Bright, Paul Rosenberg & Co., and Lita A. Hazen. M.75.7.

Le Vestiaire, l'Opera, Paris. Kees Van Dongen, Holland, 1877–1968.
The Mr. and Mrs. William Preston Harrison Collection. 26.7.15.

Decorative Composition, 1914. Maurice Prendergast, United States,
1859–1924. Mr. and Mrs. William Preston Harrison Collection. 31.12.1.

The Accordian Player, 1940. Rico Lebrun, United States (b. Italy),
1900–1964. Gift of Miss Bella Mabury. M.45.1.11.

Library of Congress Cataloging-in-Publication Data

Brookes, Mona
 Drawing with children.
 Bibliography.
 Includes index.
 1. Drawing—Study and teaching (Elementary)
2. Drawing ability in children. 3. Drawing—
Psychological aspects. 4. Drawing—Study and
teaching. 5. Interaction analysis in education.
I. Title.
NC615.B7 1986 741.2 86-14342
ISBN 0-87477-395-4
ISBN 0-87477-396-2 (pbk.)

Jeremy P. Tarcher, Inc.
5858 Wilshire Boulevard
Los Angeles, CA 90036

Design by Mike Yazzolino
Illustration by the author and her students

Manufactured in the United States of America
10

With gratitude to my friend and thinkmate, Elliott Day, for the hours he talked with me about drawing and the process that would help four-year-olds to understand it.

Thanks also to Gertrude Dietz, for inspiring me to provide her Tocaloma Tots with her wonderful vision.

Contents

Acknowledgments

Thanks to so many:

To Mark Hall, for the endless ways he kept me and the Monart School going while I wrote the book.

To Noah Purifoy, for the original support and encouragement.

To the Monart staff, for their patience and understanding.

To Marilyn, Ray, Ruth, Paula G., Paula P., Ina, Alice, Diana, Donna, Anita, Michael B., Michael N., Lucia, Carla, Steve, and Opel for their input and energy toward completion.

To Janice Gallagher, Laurie Held, and the Tarcher staff, for their great support to a beginning writer.

To the Monart students, for their wonderful illustrations.

To my aunt, Beverly Bender, for spending time drawing with me when I was a little girl.

To my mother, Mary Boles, for always inspiring me toward a questioning mind.

Foreword

I loved to draw. My first box with twenty-four Crayola crayons was my most valued possession. The words *azure,* *mauve,* and *taupe* made me tremble with anticipation. The silver and gold crayons were especially precious; I used them more sparingly than any other colors. I drew all the time— colorful flowers, trees, houses, dancers curtsying on a stage, abstract designs. Drawing was a favorite pastime—until I was six. I have not drawn since.

In first grade, we painted at an easel in front of the classroom. I loved the paints: their texture was entirely different from my crayons, and they flowed so smoothly. But I hated painting in front of the class. One day when it was my turn, I painted a park full of trees as they had looked last time I had seen them in the rain, their tall trunks wet and black and shiny. As I painted, I became conscious of snickers in the classroom and fingers pointed at the easel. I paused and noticed some drips, big black drips, which had rolled down the page. "Drips," I thought to myself, "aren't so terrible. Lots of *their* paintings have drips." My teacher, noticing that I had stopped painting, came and whispered gently, "They're laughing because you made the trees black." I looked at the painting, but the leaves were green, there was nothing

wrong. My teacher continued, addressing me softly, "Trees have *brown* trunks." There was a muddy brown in one of the paint jars and there was black. I had chosen the color that looked the closest to the real trees. My teacher explained to the class, "Ann makes her tree trunks black." There was an outburst of laughter. I put the brush down and made myself walk slowly to my seat, fighting back tears.

From that day I always managed to find an excuse not to go to the easel when my turn came. My drawing at home became confined to coloring books. Whether this happened as a result of the painful incident in school or because of the decline in drawing that often occurs in children as they approach eight or nine, I do not know. Today, if asked whether I can draw, I shudder and reply, "Not even a straight line with a ruler." In fact, I thought of myself as a person who both cannot draw and could not learn if taught . . . until I met Mona Brookes.

Mona presented her method of teaching drawing at a conference for five hundred educators. She asked the audience, "Who can draw?" About twenty hands went up. She asked, "Who can draw well?" About five hands stayed up. She asked, "Who can't draw but thinks they could learn?" About ten percent of the hands went up. Finally: "Who can't draw and thinks they can't learn?" The rest of the hands went up; mine was the first. Apparently, I was not alone in my attitude toward drawing.

Mona proceeded with her presentation. She told us how capable a drawer she had been in elementary school, how confused she had felt when singled out time and again for her ability, how she had become an art teacher (almost by chance). She described how she teaches and guides her students. She told us as much about child psychology, pedagogy, and overcoming learning handicaps as she told us about drawing.

Then, she taught us to draw. First she showed us her warm-up exercises. Next, she projected a still life, a teapot in front of a small vase, and taught us how to copy it. "What shape is this?" she asked, pointing to the small round handle on top of the teapot. "Yes, it's a flattened circle. Draw it on your paper with enough space to put the pot under it." "Where does this line go?" she asked, pointing to the stubby

left side of the handle. Step by careful step she talked us through the shape of the teapot, guiding our eyes with her words, shaping the image in our mind, bit by bit, until the connection between the detail of the object, its registration in our eyes, its interpretation in our mind, and its recreation by our hand resulted in a drawing. She taught us how to gather information visually, elaborate it mentally, and express it manually. She taught us a thinking process, how to analyze anything we saw so that we could draw it.

I loved my teapot. It was the first time in my life I had drawn an object from the real world and made my drawing look like the object. It was the first time I had not crumpled my paper in embarrassment and quickly thrown it away. I stole glances at the teapots of the people to my right and left. I liked mine best. I was forty-six years old, and I had learned to draw.

In the decade from 1975 to 1985 we learned more about how our mind functions than in all previous years of our species' existence. From that decade some general theories of intelligence emerged—theories of mediated learning experience, theories of multiple intelligences, techniques to enhance both serial (left brain) and holistic (right brain) thinking. Mystic Eastern thought is now viewed by proponents of rational Western thought not as a strange form of religion but as a manifestation of a particular kind of intelligence. Nonetheless, there is still a long way to go in understanding how the brain develops, how the mind is fashioned, and how the kind of human potential manifest in a Michelangelo, Bach, or Einstein can be nurtured. Further understanding will most likely occur in small steps, in the meticulous work of a brain surgeon, in the prolonged treatment of a learning disorder by a clinical psychologist, in the detailed pedagogy of a new teaching method.

The 1980s is not a generous decade for our children. The pervasive use of television as a baby-sitter has stolen much of children's free time. Penurious local governments have cut "frill" subjects like art and science from school budgets. Toy manufacturers, pressured by market forces, successfully promote toys that have more sales potential than play potential. We have moved from extended family to nu-

clear family to single parent to latchkey child, stripping away the nurturing adults who knew how to provide children with activities that connect mind and body. Our lives are governed by the convenience of shortcuts rather than the convergence of experiences, like drawing, that encourage the growth of a child's mind.

Today, child psychologists tell us that drawing is as spontaneous and innately human an activity as learning to walk and talk, and that the stages children go through in learning to draw are predictable. For children under age three, drawing is an extension of their observation of how things move. Young children are satisfied with scribbles that appear meaningless to older persons because they have not yet learned to observe the differences between what they see and what they draw. Drawing is a complex process that requires you to isolate discrete bits from a complex entity, with three dimensions, to reproduce those bits accurately, in only two dimensions, to relate them logically to each other, and all the while to move your hand carefully. By age five or six many children can connect these simultaneous processes rather well, and if children of this age have been fortunate enough to have had time and materials, their drawings are often imaginative, inventive, and detailed. It must have been of this age that Picasso is quoted as saying, "I used to draw like Raphael, but it has taken me my whole life to learn to draw like a child." But toward age eight or nine children often drop out, their drawings become stiff, and they frequently stop drawing altogether. The more astutely they observe the real world, the less accepting they become of their attempts to reproduce it.

Mona Brookes's method turns off the critical voice that says, "This looks wrong." It turns off the rational voice that says, "This is a square, not a thick line." It turns off the mature voice that learned at a very young age to say, "I can't draw." Mona Brookes's way to teach drawing enables anyone to draw who is willing to try.

Ann White Lewin
Founder and Executive Director
The National Learning Center/
Capital Children's Museum
Washington, D.C.

A Note to Scientists, Educators, and Parents

Drawing, like speaking, is a natural human response. Throughout history, evidence of this response was left in caves, where humans visited at least 50,000 years ago, and in tombs where Egyptians and indigenous Americans buried their god kings. In every culture—whether with pen and paper or sticks in the sand—children draw. They draw what they see as important in their environment: people, shelter, trees, and animals.

In our culture, facility of speech wins enormous value and respect, and the precocious speaker receives reward and encouragement for every effort. Drawing has no such value. It is considered play, something children do until they go to school and learn to read. For fifteen hours each week, forty weeks a year, in an atmosphere of serious mental and emotional intensity, the child develops as a speaker and a reader. Five more hours are spent in gym class developing the physical skills, and for one hour, usually on a Friday afternoon when teacher and students are too tired physically and emotionally to do anything else, they get to draw.

The proportion of drawing time decreases as the child grows, until by high school it is eliminated entirely from the curriculum. Most adolescents and adults do not draw at all. There are of course a few exceptions, the lone and different survivors of our ancient heritage as drawers, and they pay the price society extracts for daring to value something in themselves others have not dared to value.

But drawing is a natural human response. Our brain is still programmed to draw.

What if this skill were nourished and nurtured for all children?

What if it had value as a way to communicate as speech does?

What if it were stimulated, rewarded, practiced, trained, and educated?

What would happen in the brains of human beings so nurtured and so educated?

As the new science and technology of the brain and mind advance, we are learning that stimulated brains are neurobiochemically different from unstimulated ones. In every field of human endeavor, from mathematics to music, to science, to athletics, the performance of those people whose brains are practiced, stimulated, stretched, and rewarded is incredibly superior. We may thus speculate that their brains are also different qualitatively and physically.

Mona Brookes has discovered a systematic way to stimulate the normal human response of drawing and has designed a method that is simple and universal. As soon as one sees the superior quality of the performance of her students, one comes away astounded on a profound mental and emotional level.

As brain scientists interested in the whole spectrum of human learning, we know that the trained, practiced, stimulated brain is also more efficient at new learning. If we develop the building blocks of visual perception, visual spatial organization, and visual discrimination by learning to draw, our brains cannot help but transfer these skills to such tasks as mathematics, which is at its base the organization of objects in space, or to reading and spelling, which require visual attention to detail as well as pattern and organization

in space, as the eye sweeps across the line of print and down to the next line.

Thus it is no wonder to a neuroscientist that teachers and parents alike report that Mona's drawing lessons have helped children in subjects other than art. Indeed, those teachers' and parents' reports are just the beginning of what we would see if Mona Brookes's method became part of our educational curriculum.

In *Drawing with Children*, Mona Brookes has made a contribution that educators and scientists in the dawn of the third millennium cannot ignore. In the decades ahead, knowledge is increasing and changing at such a rate that we cannot possibly learn enough content for it to be useful. The most important skill children will take into their future will be their ability to learn and to think.

Our educational system, designed for an industrial age now past, is in crisis in every place in the world it continues to preserve twentieth-century ideals. We must find other ways to enhance, change, and redefine the curriculum so that education becomes dynamic, vibrant, and useful to these young consumers. The drawing method Brookes has designed is one of these ways.

Geraldine Schwartz, Ph.D.
Founder and President
Vancouver Learning Center

Preface
The Monart Method

The drawing method in this book was originally designed as "preventive medicine" for children. The plan was to successfully teach children the basics of drawing prior to the critical stage they reach when they conclude, "I can't," and will no longer try. It began in 1979, when I found myself agreeing to develop an art curriculum for 100 toddlers in a preschool. The director wanted the students to experience drawing styles other than the typical ones depicting happy faces, stick figures, rainbows, hearts, and space monsters that they copied endlessly from each other. We knew it was important for children to draw with these symbols when they were quickly sketching stories about the people and events in their lives. But we felt they should have the option to also draw representationally and know the difference. Neither one of us knew there was a philosophy that stated you shouldn't teach children how to draw or it would stifle their creativity. All we knew was that the majority of the population stopped drawing at the age of eight or nine, because they felt they didn't know how and were bored with drawing the same symbols over and over. The world of four- and five-year-old children was as unknown to me as representational drawing was to them.

The method developed as the children and I experimented and learned what worked. I reminisced about my own art training, trying to remember how drawing was taught. I remembered demonstration and structured guidance in my design, color theory, anatomy, perspective, and painting classes, but no instruction regarding how to actually draw. There was an agreement among the students and teachers, including myself, that being able to draw was more of an innate talent and that it could not be acquired. As the years went by, I learned that people could transform their abilities in other areas, and I reconsidered my childhood opinions about artistic ability. I ended up believing that if I could demonstrate the general shape of objects, allow for individual interpretation, and establish a noncompetitive atmosphere, children's creative and technical skills would unfold with jet speed. The results were so successful that within one year the toddlers were inviting friends and relatives to the Los Angeles Children's Museum, community centers, and local businesses to see their drawings exhibited. We discovered that the children's creative works (which can be seen in the color insert) far surpassed the results expected for their ages; if the exposure continued, we were certain these youngsters would go on functioning independently and successfully as creators of artworks.

The method involves training children to perceive visual data with an alphabet of five elements of shape, demonstrating how the general shape of an object is composed of those elements, and giving them the freedom to create their own compositions and detail interpretations. The language is geared toward creating a noncompetitive and nonjudgmental environment in which the child learns that there is no wrong way to draw and that everybody can be successful. We never guessed the ramifications and impact that this would have in the field of education.

For the next three years projects were funded by the California Arts Council with the original toddlers, a school for learning-handicapped students from kindergarten to 12th grade, and another school for teenage gang members who were designated as learning handicapped. It worked far beyond our expectations for all the groups. The surprise came when adults and teachers began requesting to take the

classes along with the children. They wanted to use this simple method to treat their own "I can't draw" disease. The simplicity of a system that was designed for four-year-olds made it possible for people of all ages to achieve immediate and tangible results.

By 1981 I found myself giving in-service training workshops throughout California to help teachers draw with their students as a part of their regular curriculum. Teachers who never thought they could draw found out they could and felt comfortable to teach others after the training. They began reporting that the structured lessons did not stifle children and in fact improved their creativity. They found that the drawing sessions were helping the children in subjects other than art. Similar reports began to surface. Children who couldn't learn the alphabet suddenly remembered all their letters after the elements of shape exercises. Reading levels jumped after teachers introduced visual perception warm-ups and eye relaxation techniques. Math abilities rose after children visually dealt with numbers of elements in their exercises and drawings. Problem-solving skills developed after they explored solutions to drawing challenges. Willingness to try other feared subjects increased after they experienced tangible success in drawing, and social skills and self-esteem soared.

Prior to developing this method to teach drawing, I had never considered the importance of art in education. As a product of the public school system and an art student, I believed that art classes were extracurricular and unrelated to the basic skills. I now believe that "the arts" are necessary to the development of a fully rounded education. Now that I travel through the schools, I find myself on an incredible journey, meeting artists from every field who are participating in teaching basic skills through their art forms. We share the view that children from all economic levels are experiencing difficulty in concentrating on problems long enough to solve them. The arts provide a format in which students are motivated to work out the problems and learn to focus. They also grow in their ability to expend the energy necessary to carry a project through to completion.

In 1983, I participated in a comprehensive public school program with a team of artists. After completion of the

Mona Brookes–age eleven
(From a storybook illustration.)

Mona Brookes–adult
(From plants in the garden of a restaurant.)

program, test findings showed as much as a 20-percent increase in reading and math scores from a population of students with great language and cultural barriers.

With very little effort, you can use the methods in this book to teach yourself or your children how to draw. You will be given permission to use the structure that you need in order to free up your intuition. It is an integrated approach to learning, using both structured and intuitive processes to balance the split that has been created in our learning systems. Everyone can draw if exposed to the proper information about materials and given an orientation to visuality. A few suggestions on how to use the book will be presented before you begin.

I feel very fortunate for the opportunity to reverse my opinions about inherited talent and the role of the arts in our education systems. Thank you to all who showed me the way. I continue to find that we are capable of drawing, and much more, when we can relate to a simple learning method that eliminates judgment and competition. Since the drawing mode is one of the most relaxed, productive, and enjoyable ways to communicate and express ourselves, I invite you to explore its magic with me.

How to Use This Book

Y ou do not have to be working with children in order to use this book. It was also designed as a self-teaching method for teenagers and adults. Of course, any child who can understand the text and instructions could do the same. Simply turn to the child within yourself when you read instructions on how to teach, treat, or talk to a child, and you will be your own best teacher. If you are going to be working with other adults or the elderly, you can appeal to the child in them and use the instructions in the same manner. The instructions are phrased in such a manner that you can read them to yourself as your own teacher, or you can read them out loud and guide the child or other adult whom you are teaching.

Take a quiet hour by yourself and first scan the entire book without doing any drawing. Put the book aside to let it settle a bit, and then start back at the beginning, by yourself. Read the *Preliminaries* section through Lesson 1, in depth, following any instructions that are given. You may need several days to assimilate all this information, experience your prelesson drawing, and complete the instructions regarding purchasing of supplies and setting up the environment. It is very important to the success of this undertaking that you do this preplanning. If you are working alone,

complete the lessons in the same sequence as they are presented in the book. If you are going to be teaching children, don't introduce them to the lessons until you have dealt with the majority of your own drawing blocks and confusions. It is rare for this to take more than a couple of weeks if you open yourself up to change.

When you are completely ready to guide a child, return to Lesson 1 and repeat it together. Then scan each lesson by yourself, prior to teaching another person, taking as many sessions as you need to digest the material before moving on to the next one.

There are a couple of things you will need to understand in order to make the most efficient use of the lessons. If you take care of these now, you will be ready to start.

Duplication of Drawing Samples

With apologies for the possible inconvenience, I recommend that you make photocopies of several of the exercises and drawing samples presented in the following pages. Otherwise, it becomes very awkward to try and study a sample in the book and also turn pages and follow the instructions in the text. This can be especially disruptive to a child who is already dealing with motor coordination problems. If for any reason you can't get to a copy machine, trace as many of the exercises as you can for easier handling. It would be better for a child to work from a copy of an exercise that is a bit different from the one in the book than to prop the book up or work with a piece of paper folded into the book. Following is a list of the copies you will need.

1. Starting Level 1, exercise (page 41, Fig. P.5)

2. Starting Level 2, exercise (page 41, Fig. P.6)

3. Starting Level 3, exercise (page 42, Fig. P.7)

4. The Five Basic Elements Chart (page 54, Fig. 1.2)

5. Mirror Imaging, exercise (page 62, Fig. 1.6)

6. Wow! I Can Draw, exercise (page 70, Fig. 1.11)

7. Overlapping, exercise (page 79, Fig. 2.5)

8. Leo the Lion, lesson sample (page 87,
 Fig. 2.11)

9. Leo the Lion, simplified (page 87, Fig. 2.12)

10. Bird Montage, lesson sample (page 93,
 Fig. 2.15)

11. Individual Birds, simplified (page 94, Fig. 2.16)

12. Carousel Horse, lesson sample (page 100,
 Fig. 2.18)

13. Carousel Horse, simplified (page 100, Fig. 2.19)

14. Teapot Still Life, lesson sample (page 113,
 Fig. 3.4)

15. Teapot Still Life, simplified (page 113, Fig. 3.5)

16. Positive/Negative, exercises (page 139 and page 141,
 Figs. 4.3–4.5)

17. Shading, exercises (page 143, Figs. 4.7–4.9)

18. Tiger Lilies, lesson sample (page 149, Fig. 4.14)

19. The Body as Circles and Tubes (page 176,
 Fig. 5.26)

Drawing Instruction Format

The step-by-step instructions offered for drawing the lesson samples follow the same pattern in all the lessons. When drawing examples are shown in the side margin, notice how some of the drawing is in dotted-line form and some in solid. You will not be drawing in dotted lines. Such lines are present only to help you visually keep track of the instructions. The dotted lines represent the current instruction being followed in the text. As you go on to the next instruction, those dotted lines will become solid ones. You will draw in regular solid lines, with the exception of a few instances where you will be taught to use "guideline" dots.

As you experience each lesson, you may want to take time for it to digest before rushing on to the next one. If you do this, you'll get a nice surprise—you and your child will begin to think of projects to draw that are similar to the lesson you just finished. It will reinforce the learning if you

go ahead and do a few similar projects before taking on the additional information involved in the next lesson.

Any further instructions will be incorporated in the individual lessons themselves. Have a wonderful time exploring your world of perception and sharing it with others.

Free Use Permission Information

If you are employed as a school teacher or an institutional worker, you have permission from the publisher to photocopy materials for use in the classroom to accompany your verbal lessons.

If you are using the book to teach a college-level course, you have permission from the publisher to photocopy no more that ten to fifteen pages for handouts to your students. Beyond that amount you need to write the publisher for permission or consider assigning the book as a textbook for the class.

If you wish to teach private art classes, it would not be legally appropriate to present yourself as a Monart teacher, solicit private art students based on this book, or photocopy materials from the book for such classes.

The only certified Monart Drawing Schools in existence display a license signed by the author and are operated by owners who were personally trained by Mona Brookes. The only people qualified to conduct in-service training seminars, in the use of her methods, are members of her personal staff. For further information, contact Mona Brookes directly, at P. O. Box 1630, Ojai, California, 93024.

Preliminaries

Before You Draw

In order to develop yourself as an artist and be able to teach others, you need to consider your feelings about your own drawing and your opinions about drawing in general. The adults who take my training say that their drawing ability is strongly improved by this preliminary work on their opinions; they are surprised to find it as equally beneficial as the drawing experiences themselves. This section will help you explore your feelings, provide you with a preinstruction drawing experience, and assist in the unfolding of your full potential.

How You Feel about Your Own Drawing Ability

If you feel confident about your drawing but want a vehicle to teach others, approach this method with a fresh and open outlook. If you don't feel confident about your own drawing or your ability to work with children, let me assure you that this can change. The parent/child drawings that you see in the color section exemplify the kind of work that was achieved by such beginners. None of the parents knew whether they could draw and were surprised at their results. If you want to improve your own drawing and don't

intend to teach anyone else, simply become your own teacher.

How often have you heard someone conclusively state, "I can't draw"? It is accepted that only a few are blessed with the gift of drawing and that no excuse is necessary. You can even hear successful painters, designers, and artistically inclined people make this statement, but with additional embarrassment and frustration. This attitude can change, whether you want to teach yourself or others. One gentleman, shaking and sweating at the beginning of a one-day workshop, admitted to the group he was shocked to display such real fear over the idea of possibly being unable to draw. He said he was sorry he had come, he was sure he'd fail. By the end of the day, he was beaming with pride at his accomplishments, and he said that if he could draw, anyone could. He couldn't believe I had witnessed this same phenomenon many times.

Where You Stand Now

Read the list of five statements and pick the one that best fits the way you feel about your drawing. Make the choice by the way you feel now, rather than past opinions.

1. I am very confident and satisfied with my current drawing ability.

2. I can draw, but I would like to draw better.

3. It has been so long since I've drawn, I don't know if I can draw any more.

4. I can't draw, but I think I could learn.

5. I can't draw, and I don't think I could learn.

What You Think About Drawing

Let's see how you feel about drawing in general. Read these eight statements and notice how many you tend to agree with:

1. The ability to draw is inherited.

2. There is a right and a wrong way to draw.

3. Drawing is simply for pleasure and has no practical use.

4. Art lessons should be given only to those children who show talent and may become artists when they grow up.

5. Children should acquire drawing techniques only by trial and error.

6. People who can draw only abstractly aren't real artists.

7. Real artists draw from their imagination and don't need to copy things.

8. Real artists are pleased with most of what they produce.

Most of us feel that certain of these statements are true. I now believe that none of them are true. As we consider these questions, we begin to relate emotionally to our frustrating childhood drawing experiences. Reevaluating those memories with updated information helps make the shift toward success. As we proceed we'll be discussing these ideas in more detail.

Let's Draw

You can make the most progress in your drawing by establishing how the eight issues you just considered affect your current drawing ability. Take the next few minutes and see how you draw today. You want to evaluate how you feel about your drawing the way it is, so there is nothing to gain by trying to attain any particular effect. Just do as well as you can without worrying about it.

- Find a quiet space where no one will interrupt you for at least 30 minutes.

- Unplug the phone.

- Find a flat surface to draw on, and make yourself comfortable.

- Use plain paper and black felt-tip marker or ballpoint with a regular to fine point. If all you have is a pencil, don't use the eraser.

- Have paper for note-taking next to the drawing paper.

DRAW A SCENE WITH . . .

a house.

a person.

a tree.

some bushes and flowers.

at least five other things of your choice.

A FEW TIPS

- Relax and enjoy the process.

- Don't start over or erase if you don't like something. Make some kind of adjustment and continue until you finish drawing all the subjects.

- Don't allow yourself to be interrupted.

- As you have thoughts about your drawing ability, stop and write them down on the notepaper. You needn't take time for complete sentences.

- As you notice your emotional reactions, stop and write them down on the notepaper. For the sake of the exercise, try not to analyze them yet. Simply note your feelings and jot down a few words to remind yourself of them.

WHEN YOU HAVE FINISHED

- Get up and take a stretch, but don't allow yourself to talk to others or be distracted from the process.

- Come back, prop the drawing up, and take a long, hard look at it.

- Add any additional comments to your notes.

How You Felt

Now you can analyze your feelings and comments. Take a few minutes to let the memories that go with the feelings surface. Here are some things to consider as you learn what it all means for you.

How did you do, compared with how you thought you would do?

While you were drawing, did your thoughts reflect any of the opinions or experiences you had while drawing as a child? What can you remember about those times?

Were any of your thoughts related to the eight statements about drawing that you considered prior to the drawing experience? If so, how did you come to have those opinions?

If you found yourself being overly critical about your performance, don't worry; you're not alone. I find that even people who do quite well will malign themselves. The other day I heard a 10-year-old quietly tell another student, "I don't even believe the awful stuff I say about my drawings anymore; I must be fishing for compliments," and they both burst into knowing laughter. If you experienced any self-doubts while you were drawing, it would be normal for you to feel reluctant to let others see your drawings, to feel that you would not be able to improve easily, or to feel uncomfortable with the idea of teaching someone else. None of that is necessary. If you can hang in there for just a few days of discomfort and are willing to change your opinions and expectations, you can quickly see amazing growth.

Changing Your Attitudes and Abilities

Exposing yourself to new information about the drawing process will make a more dramatic change in your current ability to draw than will any other factor. Changing your expectations about what is acceptable and possible can be the key to unlocking the door. So let's take the eight statements you considered about the subject of drawing itself and see if we can shed some new light on them.

New Understandings

1. *The ability to draw is inherited.* This is one of the main reasons people believe they can't draw. If you don't have an artist in your immediate family, as many of us don't, you might have decided it was impossible for you to draw after a few minor attempts. Once you've bought the idea that drawing is an inherited talent, you are too quick to give up when things don't automatically please you.

Artistic talent can be developed. When I first faced packed schoolrooms of 35 restless and doubting 11- and 12-year-olds, I wasn't quite sure they would have the success that the four-year-olds had had. I think I was as shocked as anyone else when, time after time, all the children achieved a variety of imaginative and successful results. And as for "hereditary artists," some of the most resistant students come from immediate families with an artist in them and have no inclination toward drawing. My own son, for instance, never participated in art in school, convincing all the teachers he just wasn't interested in the subject. Since he was an excellent musician, no one felt it was necessary for him to draw. When he was a teenager he came into my studio a few times and announced his inabilities. We were all amazed when he took the training at 19, learned he could draw after all, applied the philosophy he had heard all around him for years, and became the preferred substitute teacher for the Monart staff. His drawings are very sensitive and imaginative and show great promise.

2. *There is a right and a wrong way to draw.* You will find very little agreement, even among art critics, on what is good or bad art. In art courses, one professor will grade a drawing with an "A," while another will reject it. Since it really boils down to personal opinion, you might as well listen to your own and make the drawing the way you want. Unless you want to sell your art, it is not important to consider what others may or may not like.

3. *Drawing is simply for pleasure and has no practical use.* Operating on this premise, elementary schools in the United States have cut art budgets enormously. The little art that is offered usually comes in the form of periodic crafts or free and unguided drawing time. Drawing is offered in high schools, but the students who elect to take such classes are primarily those who already feel they can draw.

Educators are just beginning to recognize the loss of the arts in the curriculum as a mistake. Administrators and teachers are beginning to see that the drawing process, as well as the arts in general, provide a type of problem solving that is essential to the development of a fully functioning individual. Teachers often report that children who were having tremendous difficulty in school simply improve after

their successful drawing experiences, without having remedial academic instruction.

Teachers have convinced me that drawing is more than a pleasant way to pass the time; it's a learning experience and a tool that can be used to aid the teaching of other subjects.

4. *Art lessons should be given only to children who show talent and may become artists when they grow up.* Now that I know that all children can draw if given the proper exposure, I find this statement misleading and controversial. I regret that it intimates that you need to "grow up" to be an artist; this only adds to the confusion. Who says you have to be a certain age to be an artist? Children's artwork is looked down on; Its intrinsic worth is not recognized, nor is it displayed or hung with due respect. Children could be enjoying their own artwork in the books they read, the items they use, and on the walls of their nurseries. This way they might not feel inadequate and set their work up against the slick commercial adult drawings of the childhood subjects they see all around them.

As the Monart students began to have their work hung in museums, educational conferences, and community centers, they received encouragement to become artists when they "grew up." They began telling relatives and friends, "I'm an artist now!"

5. *Children should acquire drawing techniques only by trial and error.* We don't expect children to play a piano without demonstrating familiarity with the basic components of music and the instrument. Why do we expect them to understand the components of drawing, with all its complexities, on an independent basis? It is a totally acceptable expectation that children will develop creative and independent expression after they learn the basics in every other artistic, athletic, and intellectual process that we teach. Imagine expecting children to write creative stories without demonstrating the basics of language. The same is true for drawing and painting.

Adults who forget how to draw can relearn through demonstrated visual exercise techniques such as mirror imaging, copying other line drawings upside down, and drawing the edges of negative space. Children need to learn the drawing process also, but with visual exercises that are

geared to their age level. The secret to demonstrating is to show the general concepts of shape and leave the detail interpretation up to the individual child. The original Mon-art students are now 9 or 10 years old. Many of the students who dropped out before the critical age of 8 or 9 could not continue on their own without the guided exposure. But this is true in music, math, dance, and most other subjects. If you renew the exposure, these same children will blossom again very quickly. The ones who stayed exposed to the process can draw what you set in front of them with far more confidence than the average child of comparable age. They have shown that their creativity was never stifled, that the skills are staying with them, and that they have become independent, as they produce extraordinarily individual and imaginative works. They are receiving recognition in their schools as artists and are beginning to consider art as a possible life work. The structure has provided them with the tools they need to manifest their natural creativity.

If you provide children with this guidance you will be encouraging artistic competence that will last a lifetime, and you will give students another option to include in their choice of fulfilling work.

6. *People who can draw only abstractly aren't real artists.* Just mentioning Picasso's name seems to remind everyone of the inaccuracy of this statement. Many people don't even know that he was an accomplished realist in his early years. They are not aware that an artist can be equally proficient in both modes but simply prefer one over the other. Certain children show a pattern of abstract learnings from the early age of four or five and continue to have that preference as they get older. Nonetheless, they can also draw representationally when it is requested of them, for the learning experience. It is my hope that we will drop our need for comparative judgment and learn that both approaches are valid. One is not better than the other; they are just different forms of expression. In a similar vein, it would be helpful if artists themselves stopped judging fine art against commercial art and recognized them as two different and equally creative forms of expression.

7. *Real artists draw from their imaginations and don't need to copy things.* Both my fellow art students and I had the nagging fear that we were "cheaters" if we had to look outside ourselves for inspiration. When we later learned that

professional artists had filing cabinets full of pictures and data to refer to, we wished we had known about that as kids. Child artists should have the same options as adults.

Artists often function like this: They decide they want to draw, say, a camel in the desert. So they research pictures of camels, go to the zoo and study the movements and energy of camels; they use their imagination for style and composition and make sketches of camels; they use tracing paper and piece together the parts that work and get the camel into their drawing; they study a lot of data about deserts and use their imagination again to fit those additional ideas into their composition.

Imagination *always* plays a part in the proceedings. It is not a separate function existing independently from visual data. Integration of observation and imagination is what is needed. Again, I see both as necessary to the process, rather than any controversy as to which is better.

8. *Real artists are pleased with most of what they produce.* Most artists aren't satisfied with the majority of their preliminary works. When I tell this to students, most of them are amazed. They really think that artists are immediately able to draw what they want; they think artists have constant success. They aren't used to the idea that it doesn't mean failure to dislike a particular drawing. Every drawing serves as a step toward the ones you end up being pleased with. Children are used to being talked into liking a drawing that they really don't like. It is *freeing* to discover that "real artists" don't even expect to like all of their attempts. It gives children permission to just "be an artist now" and have "fun," to change or discard something they don't like, to go on to another. It is as equally relieving to learn that artists don't finish a drawing in one sitting and may work on it many times before completion.

Knowing this saves people from most of their frustrating experiences, encourages them to continue drawing and learning, and liberates them to devise creative solutions to their drawing problems.

Giving the Artist in You Permission to Unfold

Now that you have some new information and realize you have more in common with artists than you thought, here are some suggestions on how to let the artist in you come out.

● Listen for your "silent critic" and retrain it. When you find yourself getting negative ideas about your abilities, don't judge yourself; just notice it and insert the new information you have just learned about your real potential.

● Know that you can be your own teacher.

● Remember, there is no wrong way to draw. If it is the way you want it, it is perfect. If it isn't, you can change it or start over, without feeling it's a failure.

● You don't need to feel guilty about using other visual data; professional artists don't draw entirely from their imaginations either.

● Don't prevent yourself from copying ideas from things you see; you'll interpret them differently anyway, the way other artists do.

● Be patient with yourself, and have fun while you learn. Remember that all artists experience a certain dissatisfaction with much of what they do. And don't throw away a drawing you don't like; someone else may love it.

This book will help you change your misconceptions. Except for that of one student, the adult drawings throughout the book were created by people who were afraid they could never draw. The realistic drawings you see by children are the type of drawings that only 1 to 2 percent of the children in the U.S. ever achieve.

The typical symbolic stick-figure drawings that you see on pages 13–17 are the type of drawings that children all over the world do naturally, and should be encouraged to do, until they are 8 or 9, when they will decide to stop. The realistic drawings that you also see on pages 13–17 can be achieved by all children, if given the guidance and basic information contained in these lessons. Instead of being limited to stick-figure drawing and giving up drawing at age nine or ten, all children can enjoy the added benefits of realistic drawing into their teen years, and easily make the transition into the sophisticated styles of drawing done by adults. If children can respond and draw this way, so can you. I encourage you to put your doubts aside and watch the transformation take place.

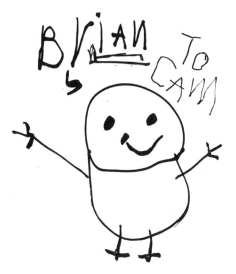

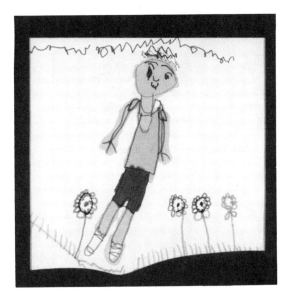

Brian Solari's stick-figure drawing at age four of himself.

On the same day, Brian also learned how to do a more realistic drawing of himself.

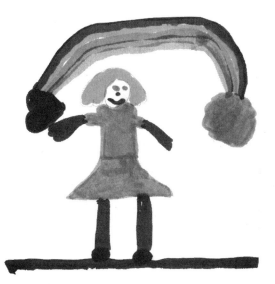

Molly Adams' symbolic drawing at age nine of a little girl.

After six months of instruction, Molly was able to expand her rendering ability and also draw with realistic interpretations and complex detail.

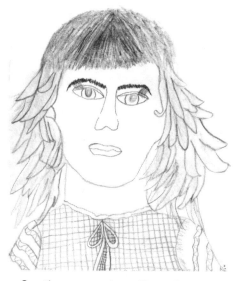

At age seven, Alexandra Salkeld looked into the mirror and created this self-portrait.

On the same day, Alexandra received the instruction in Lesson 5 on how to draw faces, and saw herself with retrained eyes, easily accomplishing this drawing.

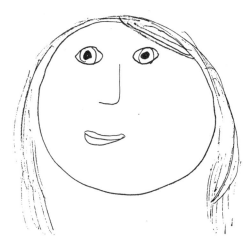

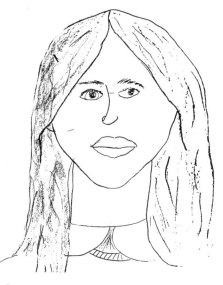

At age seven, Donna Albertson looked at herself in the mirror and drew herself.

She redrew herself with new-found realism after the instructions you will find in Lesson 5.

TYPICAL THREE-YEAR-OLD SYMBOLIC DRAWINGS AND SCRIBBLINGS

Ben Pfister—age three

Ba-nhi Balin—age three

TYPICAL THREE-YEAR-OLD REALISTIC DRAW-INGS AFTER INSTRUCTION Not all three-year-olds are ready to draw, but as soon as their motor coordination allows them to duplicate the five elements of contour shape, they can understand how to construct the objects they want to render.

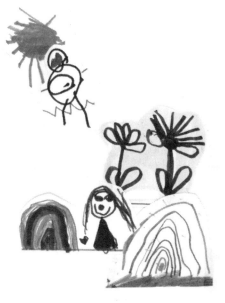

TYPICAL FOUR-YEAR-OLD STICK-FIGURE AND SYMBOLIC DRAWINGS

Margo Vega—age four

Etah Kaplan—age four

TYPICAL FOUR-YEAR-OLD REALISTIC DRAWINGS AFTER INSTRUCTION

Most four-year-olds are ready for instruction. They understand the process but may have to wait a little for their motor coordination to develop. By four and a half it is rare that they are not ready. Of course, it is not important to rush them. You may begin the visual perception games until they can duplicate the five basic elements of shape.

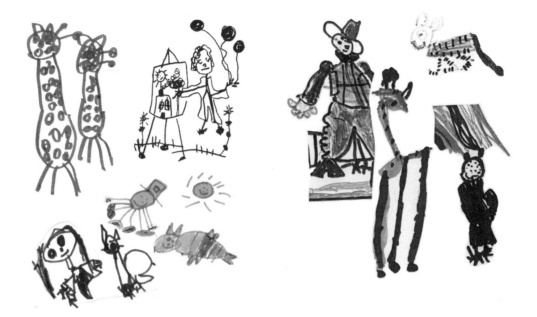

TYPICAL FIVE-YEAR-OLD STICK-FIGURE AND SYMBOLIC DRAWINGS

Kim Balin–age five

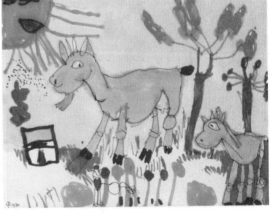

Jonathan Retsky–age five

TYPICAL FIVE-YEAR-OLD REALISTIC DRAWINGS AFTER INSTRUCTION

All five-year-olds are ready to add the joy of representational drawing to their lives. They will continue to draw stick figures and wonderful symbolic images by themselves until eight or nine years of age. Symbolic drawing is a natural process and is not replaced with more representational styles. The two are different subjects, and you can encourage them both.

Setting the Stage

Part of being able to create is having an enjoyable space in which to work with the kind of supplies that will facilitate success. In setting the stage we will create a comfortable space and a conducive mood, go shopping for supplies, and get inspired to begin a collection of drawing projects.

Preparing Your Work Space

It is highly recommended that all the people who are going to be drawing together take part in the planning. Encourage a process by which you openly communicate about the location of the space and the type of mood you will need for concentration and creativity.

Picking the Space Together

As you decide where you are going to draw, there are some factors to consider.

- *Accessibility.* The ideal space would be one in which you can leave art equipment set up. If that isn't possible, keep materials as accessible as you can.

- *Size.* Make sure there is freedom to move around each other without being cramped and that there is plenty of elbow room.

- *Movement flow.* Watch out for heavy traffic. You don't want others trekking through your "studio" en route to someplace else.

- *Drawing surface and seating.* You need a smooth desk or tabletop surface to draw on that can also hold the supplies. Use a piece of heavy paper or cardboard as a mat to protect the surface against ink and marker stains. Be sure the chair is a height that allows your elbows to rest comfortably on the table surface. Provide booster seats or pillows for little children, who shouldn't be on their knees.

- *Neatness.* You will be learning how to see the shapes of things, and a visually cluttered area can make it difficult to focus. It is very important to remove all items that do not relate to the drawing process. For instance, if you are using a kitchen table you would want to remove the toaster and jelly and dishes; or if you were using a child's desk you would want to remove the lunchbox and sweaters and books.

- *Demonstration area.* Have a separate table or tall stand nearby to set up still life or drawing projects. If possible, place this stand in front of a blank wall or wherever the background is least distracting. If this proves impossible, hang a cloth drape behind the stand, or prop up a plain board. If you have only one child to work with, it is best to sit next to him with a paper of your own on which to demonstrate ideas and shapes. If you have more than one child, it is best if you have a bulletin board or demonstration surface on a nearby wall, so that all the children have an upright view of your samples.

- *Lighting.* Try to avoid fluorescent light, which is hard on the eyes. A swivel light can be adjusted a bit more easily than can an overhead light, but whatever you choose, your hand or body should not cast a

shadow onto the drawing surface. Inexpensive swivel lights that attach to a table with a screw-on device can be purchased at art or stationery stores.

Creating the Mood Together

Take some time to sit in your drawing space and talk about the kind of mood you want to achieve during your times there. When my Aunt Beverly invited me to do art-work with her when I was a little girl, she would set up an area for me to work in, explain how the supplies were used, provide me with stimulating examples, and encourage me to draw. Those times together were as special as the drawings that unfolded. Beverly herself did intricate needlework and painted pottery, claiming she didn't draw well. But the atmosphere she provided me with and her guidance with the supplies were enough to open the way. Neither of us could have guessed to what extent I would someday explore it.

Take this time to set the mood before any drawing instruction, so that the child won't be restless and inattentive. Here is a refresher course on the things to discuss with her, so that you can have an environment in which you both will be free to have fun.

- *Concentration.* Explain the virtue of silence and how talking and noise can interrupt the mind, eyes, and heart from drawing the way you'd like.

- *Learning to see.* Build an appreciation for the time you will be taking to learn to see first. Let her know that it is the eyes that need the training and that the hand will follow easily.

- *Planning.* Make her aware of how much time and frustration can be avoided by being patient, warming up, and planning first.

- *Speed.* Tell her how drawing is a subject that doesn't work well if she's too quick to draw before looking, and that you are both going to learn to study things and take your time.

- *Perfection.* Explain how there is no wrong way to draw. Let her know that you will be learning ways to

fix and change things and that she isn't expected to like everything during the learning process.

- *Feelings.* Encourage her to let you know how she's feeling. Assure her that as you learn together you will help each other with your problems and frustrations, and that she always has the option to take a rest and finish later.

Let's Go Shopping for Supplies

Imagine if you had never bowled before and were dropped off at a deserted bowling alley to play. The essence of bowling may completely escape you if you can't look at others use the equipment, find out what the rules of the game are, and practice using the ball. The same is true of the drawing process. No matter what age a student is, he needs to explore the materials and find out how they can be used first.

What to Buy

For the beginner, it is very important to use supplies that assist motor coordination. When you draw in a representational style and are trying to represent the shapes and sizes of things realistically, you need to control the configurations of your marks and lines. Felt-tip markers are excellent for this; they provide the flowing control of line in many different thicknesses, and they allow for color effects similar to the beauty of watercolor. The inability to erase forces the beginner to look at the subject carefully and plan first before drawing—which is appropriate, since looking more accurately is the main challenge. Crayons do not lend themselves to representational drawing because the line is not sharp and smooth and is difficult to control.

Watercolors and brushes are the most difficult drawing media to control, and so they are more appropriate for free and loose painting projects until some drawing confidence is attained. Drawing pencils, with all their wonderful shading abilities, can be used after the student learns to see and there is no more danger of becoming dependent on the eraser.

Before I recommend pen and paper supplies to start out with, I want to bring up one "point" about felt-tip markers.

Solvent-based inks give off a strong odor and can cause headaches or other reactions. You have the option of using odorless, water-base inks, but if you choose to use the indelible inks, which do provide more variety of color and shading, be sure the room is well ventilated.

Beginning Shopping List

Fine and broad-tipped colored markers. Fine-tipped markers are for drawing with, so buy an assortment of the darker colors. Broad-tipped markers are mainly for coloring in with, so lean toward lighter shades that blend well together. Buy an assortment of all the colors in the rainbow, with extra shades of blues, greens, and browns for making foliage and skies and water more varied.

This is one time when buying the expensive brands will save you money. The price of art materials increases very rapidly; now better-quality markers range from $1.90 to $2.40 each. The problems with the cheaper markers, however, are points that break easily or become mushy, poorly designed caps that cause pens to dry out sooner, and colors diluted with water so that the ink streaks and clumps up on the paper. Cheap markers are also very unsophisticated in color range and can severely limit the beauty of a drawing. If you must buy the cheaper pens, then supplement your supply with a few of the expensive ones, especially in lighter blues and greens for sky and foliage.

Test the pens in the store to make sure they are not old stock and close to drying up. Make a good square of color, since a dried-up pen will work for a few strokes after it is dead. What you are looking for is a smooth wetness. If the pen streaks or makes a squeaky noise, it is probably close to drying out.

With just two of you using the pens once or twice a week, they should last about six months. (By the way, don't throw the broad-tipped ones away when they dry up. They will work for months, in small areas, after you recap them and let them sit for a few minutes. Keep a separate box of them to use in designs and small spaces in drawings.

Black drawing marker. Since most brands of black ink fade, smear, and turn greenish when touched by nearby colored inks, it is important to find a particular brand that will retain its quality. The pen that I count on not to smear

is the Flair brand. If it is unavailable to you, be sure to test your choices first by running yellow or light-colored inks next to the black.

Scratch paper. A ream of photocopying paper is about the cheapest available and lets you feel free to do a lot of testing and planning.

Drawing paper. Most art stores carry a medium-priced paper in sketch-pad format. Get the thickest brand available that has a matte finish. Slick or shiny paper will cause a lot of smearing problems.

Where to Shop

Shopping for supplies can be a part of the whole creative process. Inadequate supplies can limit your ability to produce the effects you want. Try to develop a relationship with a particular salesclerk to help you with your needs. Check out some of the types of stores that carry drawing or graphics supplies. Prices may vary considerably, so it is worth the extra time to find a reasonably priced store.

Art store. Traditional art stores carry the better-designed solvent-based and water-base ink markers and a wide variety of drawing papers and graphics supplies in large quantities. But prices range dramatically, so shop around.

Larger-chain paint store. In most cases, prices here are much lower than in even the chain-type art stores. But take the time to compare the brands, since some stores carry only the cheaper pens.

Large drugstores, stationery stores, and markets. Watch out for narrow selection and limitation to cheaper brands. This is, however, one of the best places to find black regular-tip Flair pens.

Department stores. Art departments in department stores tend to carry the better-quality pens you are looking for, but the prices can be higher than at art stores. Since turnover here can be slower, watch out for old stock.

Ideas for Inspiration

Most children in America have observed only the symbolic and stick-figure-type drawings that they and their friends engage in. They have never had the opportunity to see more fully developed drawings and artwork. Organizations from other countries may sponsor the collection of

such artwork, but in the format of contests, prizes, and a competitive atmosphere, and the results are not displayed in this country (to my knowledge) where children may see them. Some countries' entries include fully developed representational drawings by children as young as six or seven. It is the same type of drawing that Monart students are experiencing at an even earlier age of four or five. The sponsors of such contests report that children from all of America are poorly represented, due to the lack of any structured guidance or focus in the field of drawing. If children aren't exposed to this kind of realistic drawing, they don't know it is possible, and as a result don't even try to achieve it. The drawings by the four- and six-year-old students (in Fig. P.1) exemplify this more fully developed representational work.

Knowing What Is Possible

A first "assignment" in preparing children or yourself for this experience is to spend time simply perusing the student exhibitions in this book for inspiration and exposure to what is possible. Even children who are actively drawing and confident about their ability need new ideas and encouragement.

Remember, the type of work in the student exhibit of 7- to 10-year-olds in Fig. P.2 does not come from "special" or "gifted" children, but from "regular kids" in all walks of life. You can assure your children as well as yourself that you all can attain this level of drawing skill.

If you still aren't feeling comfortable about your own drawing ability, try admitting this to your children and soliciting their support in a team effort. The fact that you let children know that you will have to learn together is never a hindrance. Teachers tell me that their students are even more productive and cooperative when they feel it is a matter of helping each other.

Collecting Things to Draw

Purchase several file folders in which to start collecting your potential future projects. Label them with the major topics that interest you: birds, animals, flowers, sea life, people, transportation vehicles, buildings, landscape scenes, designs and so on. Look through illustrated books, greeting cards, posters, magazines, or photographs and pick images

Scott Callaghan–age four

FIG. P.1. With guidance, very young children can achieve fully developed drawings.

Christina Silverman–age six

Terence Tsai–age seven

FIG. P.2. This type of fully developed work can be achieved by all children, not just the gifted.

Renaie Nelson–age ten

that you like. Don't worry right now about whether a project might be "too hard," since you are going to be much more capable than you think. Save anything that has something in it that you would like to be able to draw, even if it is only part of the entire image. Ask friends to save illustrative materials for you.

Begin examining three-dimensional objects around your living space and be aware of the ones you might want to draw in later projects. Include everything from kitchen articles, knickknacks, flower arrangements, toys, sports equipment, and stuffed animals to such larger items as potted palms, bicycles, furniture, cars, and sculpture.

As you get more into the drawing lessons, you will be given specific advice on how to collect and plan projects. But there is no need to wait. Start gathering these materials now, and you will be more than inspired for your future drawing adventures.

Creating a
Supportive Climate

Now that you have set up your work area, considered what is possible to achieve, and begun collecting inspirational projects, give some thought to how you might make your drawing climate conducive to concentration and free from emotional stress. Confidence and drawing ability are very much affected by the way an artist emotionally reacts to ongoing experiences. The feelings involved may not even be related to drawing itself, but they can dramatically affect the ability to perform. Drawing and concentration are inseparable. When concentration is broken by talking and distractions, there is a very obvious rise in children's dissatisfaction with their work.

Unless you are aware of these issues, children can get confused, thinking that they don't have the ability to draw, and they may give up. Setting up a climate that will support children through their experience is as important as the particular method you choose to draw with.

Communication Can Aid the Process

While getting your drawing started, limit verbal communication to basic and simple instructions. Having to process words, even if they are in background music, distracts the part of our mental concentration needed for drawing.

Talk Adult

Children notice when you use a different tone of voice with them than you do with your adult friends, and they act accordingly. Talk to them normally and use mature language, and they'll act responsibly and perform with confidence. Use a sing-songy voice pattern with baby talk, and they'll be sure to act immature and become insecure about their performance.

Perhaps they interpret baby talk as a sign that you don't believe they are capable of much and that you don't expect them to understand much of what is going on. As you talk to them in a normal tone of voice and ask them to respond in kind, you will see tension release from their body and their ability rise to a more mature level.

Tape yourself talking with your children and listen to yourself later. Your awareness of baby talk is usually all it takes to begin to break the habit. A teacher friend of mine who was unaware of this tendency in herself and who couldn't make adjustments when she was told about it ceased baby-talking instantly once she actually saw and heard herself on videotape with the children. You'll be rewarded by children who begin to talk to you about what is important to them and trust that you will respect their thoughts and opinions. The two-way communication will result in more creativity and learning for both you and them.

Talk Nonjudgmental

Your use of language is as important to the process as any technical information you impart. If we truly want children to believe there is no right or wrong way to draw, then we have to back up our assertions with nonjudgmental language.

If you don't give some thought to the words that you choose, they can end up blocking you from the creativity you wish to experience. Certain phrases lock in judgmental ideas about the artistic process. These phrases address themselves to performance, competition, comparisons, and risk of failure. Take note of the following words and begin to listen to how you use them when you communicate:

WORDS THAT INSPIRE COMPETITION

Good

Bad

Better

Best

WORDS THAT INSTILL FRUSTRATION OR FEAR OF FAILURE

Right

Wrong

Cheat

Mistake

Easy

Hard

I suggest that you quickly replace these words with ones that are more neutral. As long as you use these words, the children really won't trust your insistence that they can do no wrong, and they will continue to be competitive and insecure about their artwork. When you use the word *mistake*, for instance, you immediately imply that mistakes exist and that your students are subject to making one at any minute.

Even though it takes attention to break these habits, it is well worth the effort. Tend to this language change before drawing begins, and decide on the words you are going to use instead. Following are some suggestions that will make the transition a little easier.

- Talk about how two drawings are *different* from each other, rather than describing either one in terms of good, bad, or better. Point out how you can personally *like* one drawing better than another, without that actually making it a better drawing. Talk about learning to appreciate differences.

• When you hear children talking about making a *mistake,* take the time to address that comment. Remind them that if there is no right and wrong, there can be *no mistake.* Help them remember that it is a question of deciding whether or not they *choose to change* something that they don't like.

• When you encounter resistance because something is *too hard,* find a way to insert new information about that idea. As you begin to see everything through the five elements of shape that you will learn, you will discover that *nothing is harder* than something else. It will just *take more or less time,* depending on the amount of complexity and detail of the subject.
When you realize you can take all the time you want to finish a project, you no longer have to steer away from things you want to draw but fear are too hard.

Talk Specifics

An adult student came into one of my classes from a college drawing course in perspective with the assertion that she was totally "inadequate." She had come to the conclusion she was so inadequate, she just "couldn't get it." It turned out her college teacher would discuss how to draw a box from various angles in an intellectually abstract and verbal mode, with a completed drawing as an example; there was neither demonstration nor actual box to serve as a model. As the instructor's hand flowed back and forth across the example, he would explain how to "come down here *like this,* then go back in there *like that,*" and so on.

I call it the "this and that" syndrome. Most of us can't relate at all to this mode of teaching. We need a combination of specific words that relate to the parts being discussed, an object to look at, and a step-by-step demonstration to understand the process. For example:

Notice the front of this box, just the part facing you. Notice that the rectangle it makes is made up of four straight lines coming to angle points at the corner. Draw that rectangular shape first. Now notice how the side of the box has straight lines that recede away from you and make the box appear smaller at the back than the front.

Notice how the top of this vase has a hole in it that is like a squashed circle. Now look at the curves on the side. First it curves in, then it curves out. Do one side of the vase first, then the other side.

We are blocked from understanding many subjects simply because of our desire to use impressive technical language to talk about them. Drawing is definitely one such subject. Here is a sentence I found in a drawing book designed for elementary-school children: "We call vertical lines perpendicular when they make right angles with horizontals." I question the average adult's ability to understand that sentence, let alone a young schoolchild. Replace abstract words with what they describe as much as possible. This is important for all ages, not just children.

The average adult has to think a minute to remember what vertical is as opposed to horizontal. If instead of a vertical line you mention a straight line that is standing upright, everyone knows what you are talking about and it represents what you are looking at. Using words that describe what you see will also hook up with and build inner vision. Here is an example of how to convert and use visual words.

- Horizontal line: a line lying down
- Vertical line: a line standing up
- Diminishing perspective: things getting smaller
- Profile: side view
- Contour line: line following the edge

In other words, just say what you are experiencing in the simplest words possible. Since children eventually need to recognize the terminology, you can always include it, but put the emphasis on the visually descriptive words.

Troubleshooting

No amount of persuasion can make a person draw who does not want to. Sometimes, however, you can get so worried about keeping your child involved in the drawing experience that you are not sensitive enough to a problem and let it go too far. Following are some potential problems you want to be alert to.

Visual difficulties or eye strain. Watch for tension around the eyes, frowning of the forehead, squinting, putting the face very near the paper, becoming unusually sleepy or nervous, drawing upside down or backwards, or drawing pieces of the object and not being able to connect the pieces. When these clues appear, take a break and do the palming exercise that you will learn in Lesson 1. Any of these situations can occur on an "off day," so don't be alarmed. If a child consistently displays this kind of difficulty it may be wise to consult an eye-care specialist.

It is not uncommon for four- or five-year-olds to draw backwards for a short time. In a nonstressful way, point it out, show them the difference on a separate paper, and then let it go for the time being. Each time you observe it, point it out again. It seems to correct itself within a few weeks if you just continue to remind them without demanding change. If it consistently continues for more than three months, it is recommended you check it out with a visual perception specialist.

Tension. Tension often occurs in the shoulders or jaw, manifested by shoulders raised in a rigid position or jaws clenched tightly. A gentle hand on the back of the neck or shoulder will help ease the tension and open the way for a few questions or support from you. Just a "How are you doing?" can begin to release inner tension. Tension is often unrelated to the drawing process. It may be there from something that happened earlier or from something else anticipated, so ask a few questions to allow space for the child to release his feelings.

Frustration. Frustrations are usually directly related to the process of drawing. Children will manifest their frustration in body squirming, nervous talking, playing with the equipment in a dazed state, banging their feet against the table or a neighbor, scribbling across the drawing, fidgeting with the paper as if they were going to crumple or tear it, and general loudness and disruptive behavior. The situation calls for a halt to the drawing process, a discussion about the child's drawing in relationship to the behavior, and friendly support. Suggestions and help in solving the drawing problem usually eliminates any further need to address behavior problems.

Distraction. It is very common for children of all ages to become distracted. Demanding constant or total attention will only make you irritable and result in exhaustion for you both. Just try to reclaim the child's attention and go on. Distraction as the norm needs your intervention, however. I find it best to pick a time when you are not drawing to talk to children and find out if there is something else they might rather be doing at that particular time. Sometimes it is simply a matter of picking a better time of the day. Right after school can be a time when a child needs to have a break by playing outdoors. Of course your drawing environment may be the culprit; check to see that television, radio, and family activity don't contribute to the distraction.

Fatigue. If a person is genuinely tired, it really doesn't matter what the reason is. Simply stop and put the drawing away to finish later. If, however, a pattern develops in which the child is no longer tired once the drawing has been put away, there may be another reason. Fatigue is often present when we are frustrated, when we just need some help to confront the frustration and go on.

The following general strategies will help set a good, positive tone to the proceedings. Copy them down on a separate piece of paper and just review them each time you begin a drawing session. Don't forget that if you are drawing alone, you need to treat *yourself* this way.

- Emphasize the fun of the process.
- Let go of any need for performance of a certain kind.
- Acknowledge tense feelings; don't make them wrong, but be willing to let go of them and relax.
- Allow others their way and don't try to manipulate them.
- Be supportive and understanding.

Be ready for the totally unexpected. It is not uncommon for a child who is drawing just fine from your point of view to suddenly burst into uncontrollable sobbing. In older students the reaction is more subtle, but the experience is

essentially the same. A child can also be very upset and not show any outward sign of it. Never assume that inner experience matches outer behavior. We have been so conditioned in this society that even four- or five-year-olds act docile instead of letting us know they are having a problem. Just this week, the mother of a child who appeared to be quite satisfied with her drawings and had never asked a question told me the child was distraught, didn't want to return to class, and was afraid to let me know in case my feelings would be hurt. When I related more closely to the child, I experienced the subtle level of her worry and fear that her drawing was not "right." It took little effort to keep checking with her in order to help resolve her hesitancies. When I assured her that my feelings would not be hurt at all and that I wanted to know what she needed so I could help her, she responded by asking questions and said she would like to return.

I strongly recommend that if things get to a crying stage, don't make a big deal about it or try to talk a child out of it. In fact, it helps if you make it clear it's OK to cry for a minute and get out the feelings. Encourage the child to stop as soon as possible and let you know what happened so you can help. Keep the same tone of voice, give some loving support, and go on with other things at the same time. As the crying winds down, ask the child to take a few big breaths first and try to express what's wrong. Statements about not having to like every drawing and seeing how we can change it are invaluable. But don't assume the crying is even related to the drawing, unless the child says it is.

What is really needed in any situation that begins to be tense or uncomfortable is concern about what is going on and a joint effort toward a solution. Thinking of solutions together is one of the joys of the process. Sooner than you would imagine, drawing problems become interesting challenges instead of uncontrollable calamities.

Choosing Your
Starting Level

Before you or your child use the lessons in this book, you will need to establish at which level you will begin the lessons. Due to motor coordination and attention-span differences, it becomes necessary to teach the lessons at different levels, established by simply ascertaining how complex a visual pattern the student is able to see and duplicate in an exercise provided for you. If the choice doesn't turn out to work well, you can always lower or raise the level as needed.

The exercises are based on the ability to recognize and draw the five elements of shape presented in Lesson 1: the dot, the circle, the straight line, the curved line, and the angle line. If your child has trouble duplicating the images in these exercises, go to Lesson 1 and work with him on the recognition of the five elements and the random warm-ups. Then return to the exercises and try them again.

After you do the exercises and pick your starting level, we will discuss developmental guidelines for children from the newborn through age 12. These guidelines represent only general age levels and how children's interest, attention span, and motor coordination tend to respond to these lessons. Teenagers have the same motor coordination and performance potential as adults, but they need extra encouragement due to emotional and social pressures.

Starting-Level Exercises

Start students of all ages at the beginning of the Level 1 exercise. Copy the image you see directly under the example with a regular-tipped black Flair. Offer a little guidance in the form of verbal support and suggestions to get your students going, but once the procedure is sufficiently understood, let them go on their own.

It is not necessary to produce the image exactly, since you have no desire to do that in the drawing process itself. You merely want to duplicate the same general structure with the same basic components. For example, it is not important to have the same exact size or confidence of line, but to duplicate the type and number of lines represented and be able to get the same relationships of how they are attached to each other (see Fig. P.3). Similarly, in the more complex examples as shown in Fig. P.4, it would not be important to have the same exact number of lines in an area, but to accomplish filling the area with lines in the same manner as represented in the example.

Approach each level progressively. As the child takes one image at a time, she will suddenly hit a place where she begins to have more difficulty. If a particular image causes much of a holdup, tell the child to skip it and go on; she can come back to it later. Even when an image starts having inaccuracies or missing parts, continue to go on to the next image, until more than half of a particular image is inaccurate or missing. Note that there has been a lack of completeness, but keep going on to the next one, doing one at a time, until the child is unable to complete two or three of them consecutively. Then stop and determine what starting level she completed the majority of the images in. This will be the tentative level to use in starting the lessons.

Above all, approach the exercise without tension or fear of failure. Explain to those children under eight that they probably won't be able to finish all the images and are not expected to, so they will not feel unsuccessful when they need to stop. Make it clear that this is not some kind of test or contest, that it is just an indicator of which lesson to pick in the book. Also make it clear that they won't miss any lesson. The higher-level lessons can be done later, when their confidence and skill has grown, and the lower-level

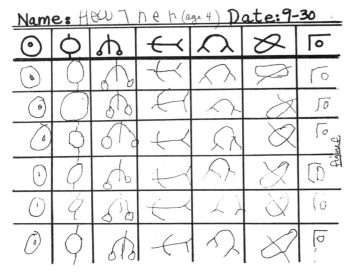

Heather Alef—age four

FIG. P.3. It isn't important to be exact; you are just looking for the same combination of elements. You don't need to say anything about the confidence of line, either; it gradually improves with maturing.

Melanie Schoenberg—age eight

FIG. P.4. It isn't important to fill an area with the exact same number of elements but to create the same type of texture in an area. The sample is to the left, and Melanie's duplication is to the right.

lessons can be done whenever they want. Have fun and treat these exercises as visual games.

Level 1. The images in Fig. P.5 can be redrawn by children as young as three and a half or four. If youngsters can duplicate the majority of the images, they are ready to begin drawing. The few three-year-olds who are ready may be able to duplicate shapes, but they have a much shorter attention span and will need lots of breaks during the lessons.

If a young child can not duplicate enough of the images to start the lessons, give him a lot of support, read Lesson 1 as suggested, begin doing some of the visual warm-ups to help him get ready, and try the exercise again in a couple of weeks. It usually takes only a few weeks of waiting until he'll be ready. Don't rush things. It's like walking. It will happen at the right time, and there is no reason to hurry it.

Level 2. These images in Fig. P.6 can be duplicated by children anywhere from just before age six up to seven or eight. Don't be concerned if a child as old as seven or eight has difficulty reproducing the images in this group. Start her out with Level 1 lessons, and she will probably jump very rapidly to Level 2 as she gets acclimated. As the child passes into the Level 2 exercise, offer some renewed encouragement and guidance to help her orient herself to the more complex ideas. Emphasize that these images are not really harder but just have a lot more lines and need more time and attention to complete. Encourage her to take one line at a time and build off it, choosing the simple ones to start with.

Level 3. The images in Fig. P.7 can be rendered by children from eight or nine years old up through adults. Some children are not really ready until they're around 10 or 12, but that doesn't mean they are slow. It is usually a case of no prior exposure throwing them off for a few weeks; once they've worked at Level 2 projects, there's invariably a sudden ability to handle the Level 3 type of complexities. As an adult, you may want to do the Level 3 lessons on your own, as well as the appropriate lessons for the children that you are working with.

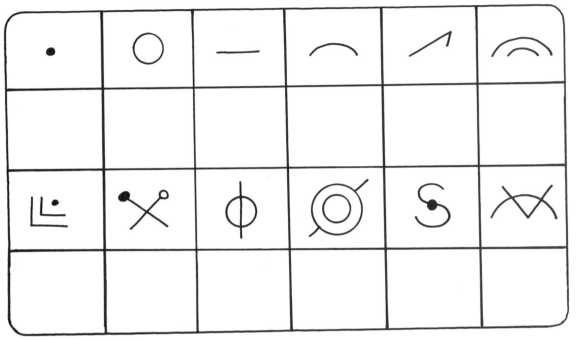

FIG. P.5. Level 1 exercise.

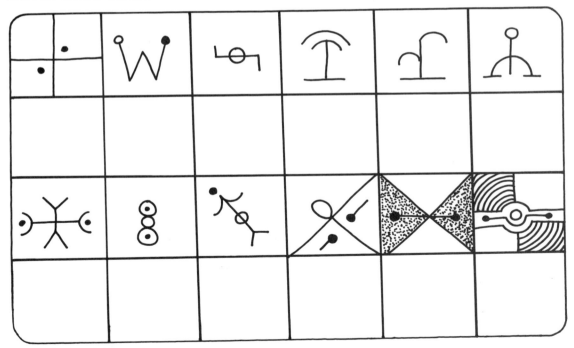

FIG. P.6. Level 2 exercise.

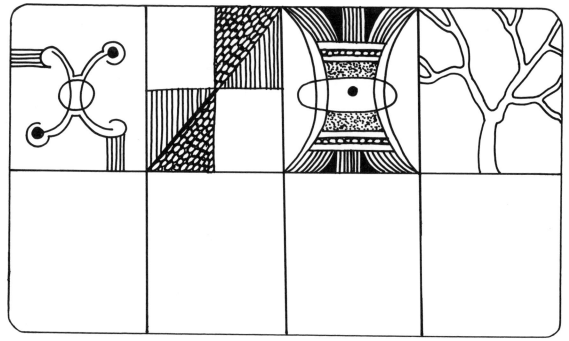

FIG. P.7. Level 3 exercise.

When you begin the lessons, don't be surprised if the performance level quickly changes and you can incorporate the more advanced suggestions. It is also possible for a person to regress and have difficulty for a brief period before regaining confidence and continued growth. Don't be concerned; it's a normal phenomenon. Keep flexible and open to changes in either direction. Of course you should add to the suggestions in the book whenever you have an inspiration of your own. You and the children are the best judges of how to interpret and embellish the ideas and lessons presented in a comfortable format for yourselves.

General Guidelines for Different Age Groups

Although age doesn't determine your starting level, certain general developmental guidelines for each age group will help you keep the lessons challenging without tedium or frustration.

The newborn to three-year-old. Motor coordination is rarely sophisticated enough for representational drawing, so encourage scribbling and playing with drawing equipment.

However, don't forget that babies are *fully capable of visually understanding and recognizing shapes.* It is not too early to go ahead and complete the lessons in the book yourself and to share all your information with the child in your daily routines. You can demonstrate the five elements of shape by showing a toddler the objects that represent those shapes and having him recognize them in his environment. You can let him help you choose things to draw and show him the way you draw them. Your baby will grow up appreciating the visual as a natural phenomenon.

The three-year-old. Begin discussing visual concepts with a three-year-old. You can make a game out of recognizing, touching, and naming the five elements of shape in objects. You can usually have the child duplicate the five elements in a crude way on paper, along with encouraging and supporting exploration and scribbling. Some three-year-olds may have the motor coordination to combine the shapes into basic recognizable objects, but they should not be pushed to do so when their attention span or interest is not up to it. A few three-year-olds may be ready to begin the lessons with Level 1 instructions, but they should be watched for tiredness and allowed to occasionally stretch and rest.

The four-year-old. Most four-year-olds are ready to begin the lessons with Level 1 instructions. Be on the lookout for tiredness and allow those necessary breaks. Four-year-olds need constant repetition of new information, so don't be alarmed if they completely forget everything from one week to the next. If the four-year-old is just not quite ready yet, give her a couple of months and try again, continuing to do the visual recognition work that is suggested for the younger child.

The five-year-old. Five-year-olds may fall either with the four-year-olds or six- to eight-year-olds in terms of performance level. Remember, this has nothing to do with intelligence or eventual performance, but may be directly related to interest and focus at the moment. It is very important that they participate according to interest and performance level rather than particular chronological age. They are apt to leap in ability overnight once they understand the basic concepts.

The six- to eight-year-old. The child in this age range can hold information longer but still needs constant reminding to stay visually alert. He may shift between two levels on any particular day, depending on energy level and ability to focus. A few seven- and eight-year-olds may be ready to take on the challenges of the Level 3 instructions, so give it a try every once in a while to keep the way open and flexible.

The eight- to thirteen-year-old. At this age the self-conscious child begins to compare her artwork with that of the adult illustrations gracing her toys, books, and clothing. Even children who have been having success with their drawings can suddenly become dissatisfied, regress to less-capable levels, and want to quit. Don't be concerned about starting level in this case. Encourage the child to start at any appropriate level and explain how it is very common for children to experience an overconcern for perfection around this age. Remind her that if she wants exact perfection it would be better to use a camera and explore the field of photography. Assure her that children's artwork has a different look to it than adults' and that she wouldn't want to rush the process. In most cases, progress is very rapid after you simply bring the fears and dissatisfactions out in the open.

These starting levels are devised only to give you a general guideline to the lesson plans. There is nothing that says you can't try an idea from any level that you wish, change it to suit a particular effect you want to create, or make up similar ones that work for you. Be patient with what unfolds, don't put any emphasis on comparison of levels, and keep encouraging yourself and your children to simply enjoy the learning process you are experiencing together. Don't let a few discouraging results stop you from shifting your starting level, regrouping, and trying again. I have watched many students continue in the face of doubts and can assure you that they were more than grateful for the encouragement to continue.

Dotti Stitz-Russell and her daughter, Michelle, are a dramatic case in point. In the color section following page 52 are two different still lifes by them. The first example in the parent-and-child section came from a time when Michelle was four and happily producing wonderful drawings

week after week. Around age eight she began to compare herself with a friend who had been in the same classes. She thought her friend drew much better, said that she couldn't draw anymore, and felt very insecure. We all encouraged her to continue and explained how this was very common at her age. We assured her that her fears were unfounded, but she faltered and had difficulty. For two or three months she continued in spite of the insecurity and discomfort. Then it began to turn around. She became more secure and independent than she had ever been, producing marvelously sophisticated drawings that she loved. A year later, at age nine, she was disappointed but proud when the publishers of this book felt a still life drawing of hers was too adult looking to be accepted for the cover of this book on children's drawing. Michelle has proudly begun teaching other children at her school how to see by the alphabet of shapes, and she now helps them to draw.

Dotti has just as remarkable a success story. In the beginning she sat on the couch of the studio and watched her daughter's lessons. She was one of the first adults who decided to try it herself. She was not sure if she could draw at all and spent several weeks denigrating her work and worrying about her results. Then she began to see encouraging changes. Two years of involvement later, she sheepishly asked me if I thought she could ever be a Monart teacher, quickly adding that I could laugh it off if I thought it was too ridiculous to consider. It is one of my greatest satisfactions now to look up and see Dotti, a successful teacher, with many young students of her own.

When you begin to have doubts, remember that there are many stories like Dotti's and Michelle's. Stick with it, and you will be more than pleased. When your child gets doubtful or feels insecure, be there with the needed encouragement. It is that easy to stop our competitive and stifling behavior patterns and encourage the dormant talents that are innate in us all.

Lessons

Learning the Basics

The steps in this lesson will help develop your drawing ability and enrich your visual perception of the world. Former workshop participants write most often about how radically they felt a shift in the perception of their environment, how much more aware they became of their detailed surroundings and the vastness and beauty of nature. In this lesson you will also learn some relaxation techniques to heighten your awareness, you will do some preliminary scribbling to get used to the equipment, familiarize yourself with the five basic elements of shape and see them in your environment, and learn how to invent warm-up exercises. As you see how everything you want to draw is continually made up of the same five elements, it will change your ability to observe visual data and demystify the drawing process. Then, poof! Before you know it, you and the children will be drawing recognizable objects as you put those elements together in specific combinations.

Conducive Relaxation

Before you even put pen to paper, it is important to release the tensions of the day and relax mind, body, and eyes. This will aid you and the children in reaching a state

conducive to concentration and visual focus. In order to gain the cooperation of your children, explain that it is common for physical and emotional tensions to be held in the neck and jaw, the eyes, the shoulders, and the lower back, and that the suggested exercises are designed to relax these areas. The five to ten minutes it takes is more than worth the effort and directly shows in children's ability to focus and achieve satisfaction with their drawing session. One day, after about twenty minutes of failing to get across a particular point, I decided I must have planned a confusing or disorganized lesson. Then I decided to stop and do some of the following relaxation exercises, just in case. When I continued with the same instructions, it was as if there had never been a problem. Try these exercises by yourself first, before discussing them and doing them with your children.

Mind and Body Relaxation

1. Sit at the drawing table, flat in the seat, with uncrossed legs. If a child is small, be sure you have a booster seat or something to prop him up to a height where his elbows rest comfortably on the tabletop. Pull up from the crown of your head to straighten the *spine,* and relax your whole *back* and *shoulders.*

2. Relax the tension in your *face,* especially the *jaw.* Let your jaw drop open and hang slackly. Then check out your *neck* and wiggle the tension out of it by rotating your head from side to side and up and down.

3. Take a big breath and let your *shoulders* drop as you exhale. Keep pulling up from the head with a straight spine as you drop your shoulders, and don't let yourself slouch. Do this at least two or three times.

4. Relax the *throat* and *chest* area by taking a big breath and sighing on the exhale. Repeat this two or three times.

5. Make sure your *legs* are uncrossed. Plant your feet firmly on the floor, reshuffling your bottom in the chair to help your *lower back* area hold your weight in a balanced and relaxed position.

6. Check out your *whole body* and see if you are holding tension anywhere else. Release it. Check one more time. Release it all.

Eye Relaxation

FIG. 1.1. Palming is a way to relax the eyes, and help them see better for longer periods of time.

The following exercise, which is called palming, was devised by William Bates, author of *Better Eyesight without Glasses,* and can be used before any physical or mental activity in which you want to perform more adequately. It seems to relax all the sensory nerves, including sight, and rids you of mental and physical strain. The eyes can see better for longer periods of time and can maintain a more relaxed state. Look at the photograph of a child palming in Fig. 1.1 and then follow these steps:

1. Take off any glasses or obstructions around the eyes.

2. Check out your body posture and relax as described above, with a straight spine and neck. If you need to bend forward, do so with the whole upper torso, rather than the neck. Dropping your head forward at the neck tends to rigidify your body.

3. Rest your elbows on the desk or tabletop surface in front of you. If this is not possible, rest your elbows near the waist area.

4. Rub your hands together until they are warm.

5. Cup the palms of your hands and place one over each eye, heel of palm on checkbone, fingers crossed over the forehead. Make sure that you are not pressing on the eyeballs directly.

6. Close your eyes lightly. Think of the area behind your eyeballs and feel it relax. Breathe deeply, let your jaw drop a bit, let your shoulders drop and relax again. Then go back to the spot behind the eyeball and relax it again . . . and more . . . and more.

7. Open your eyes slowly and try to maintain this relaxed state the entire time you draw. You can repeat this exercise for a minute or two at any time during the drawing session, if you become frustrated or tired but want to continue a project.

Experimenting with Your Supplies

Becoming familiar with your tools and equipment is essential. An enjoyable way to do this is to randomly play with the basics of drawn lines and marks. In other words, make the first drawing experiences scribbling and doodling. But remember: A child who works diligently on a scribble can be shocked and hurt if it is treated with disrespect by older children or thrown out before its time. In fact, when I pretend I'm going to throw the scribbles away in the adult workshops, I consistently see adult faces dissolve into child-like replicas of pouting or angry expressions. As you do the following exercise with children, try to appreciate the beauty of scribbling and the deep involvement the child feels as she experiences the flow of the lines and the color patterns. The following suggestions will also help.

1. Remember to use a heavy cardboard mat under the drawing to protect the tabletop from the bleeding of the marker ink. Have at least 20 sheets of 8½" × 11" scratch paper at hand.

2. Place all your markers near the drawing, so that you can test them for their different characteristics and abilities to blend with each other.

3. Choose any marker. Put the cap on its end or lay it down on the table, so that your other hand is free to hold the paper. This may seem picky, but insecure drawers often don't take charge of their paper; they tend to slump in their seat and hold their head in their hand, not noticing how the paper is slipping around and causing inaccuracies and more insecurity. It becomes a self-fulfilling prophesy for them to look at the shaky drawing and see proof that, just as they've known all along, they "can't draw."

3. Make an agreement with yourself not to create any specific shapes on the paper but to randomly make scribbling lines flow around the surface.

4. Use each one of the different types of markers you purchased and notice the way each performs. Notice the thickness and quality of lines that result from the different ways you use the points. Let the marker sit still and see how much it soaks into the paper.

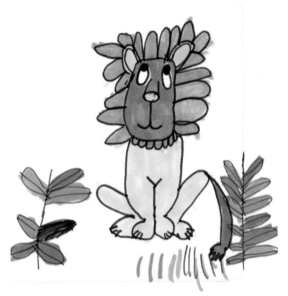

Blaise Trigg-Smith–age four
Stick-figure drawing prior to instruction

Blaise Trigg-Smith–age four
Realistic drawing accomplished at first lesson

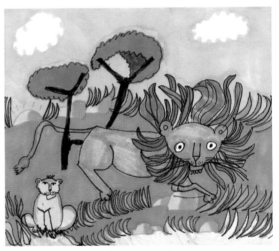

Samantha Robbins–age six
Symbolic drawing prior to instruction

Samantha Robbins–age six
Realistic drawing accomplished at first lesson

Blaise and Samantha did the wonderful stick-figure drawings on the left at their leisure at home prior to any instruction. At their first lesson, they learned how to draw a lion in a more realistic style. Note the vastly different interpretations of the same lesson by girls of different ages. Structured information need not inhibit individual creativity.

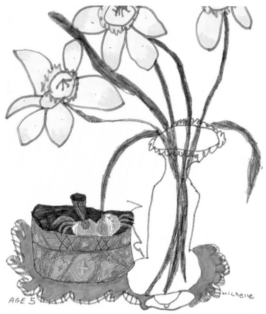

Michelle Stitz—age five

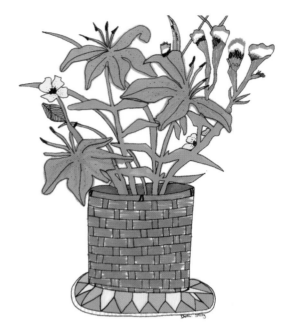

Dotti Stitz—adult

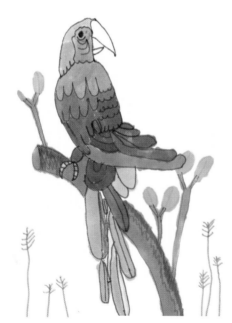

Maia Le May—age five

Reggie Le May—adult

These parents, who were not confident about drawing at all, learned along with their children and were pleasantly surprised with the results.

Whitney Rugg—age nine

Leslie Rugg—adult

Kindred Gottlieb—age twelve

Ray Gottlieb—adult

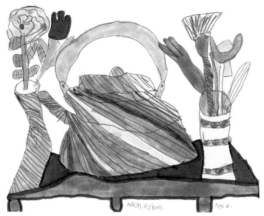

Arin Arbus—age six

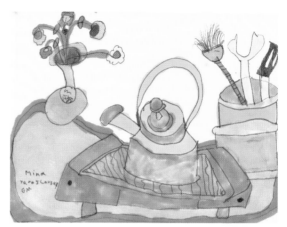

Mina Yaroslavsky—age six

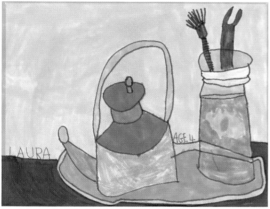

Laura Kreitler—age four

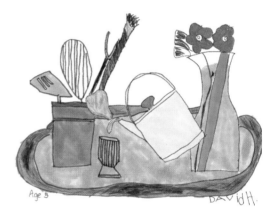

David Hajnal—age five

All of these drawings were done from the same still life. The children had the freedom to interpret the details in their own way, which accounts for the individuality of expression in each drawing.

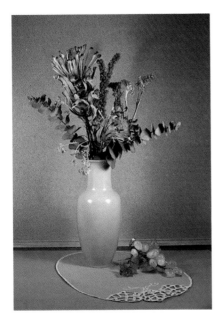

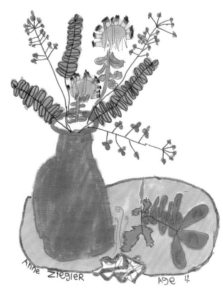

Anne Ziegler—age four

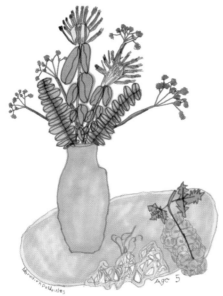

Meredith De Meules—age five

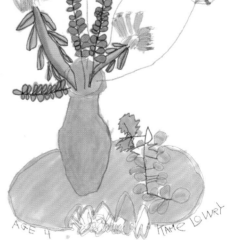

Katie Lowry—age four

The instructions for the varied renditions of this still life were
to represent as accurately as possible the colors and objects
observed. Once again, notice the range of interpretation.

Eric Guerin—age six

Rachel Broth—age eight

Ba-Nhi Balin—age six

Noel Chen—age five

The drawings on the next three pages show how children can develop their own styles with confidence. You'll find as you do the lessons in this book that the drawings won't be carbon copies of the model but will emphasize your own artistic flair.

Amir Marcus—age eleven

Melanie Schoenberg—age eight

Sarah Schneider—age seven

Julia Pilloni—age eight

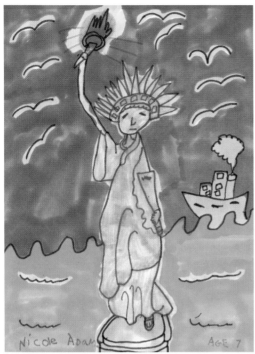

Nicole Adams—age seven

Laura Kreitler—age six

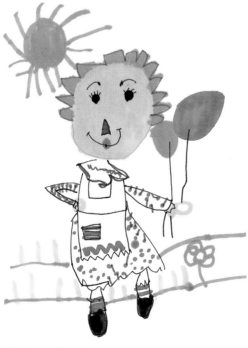

Whitney Gosden—age four

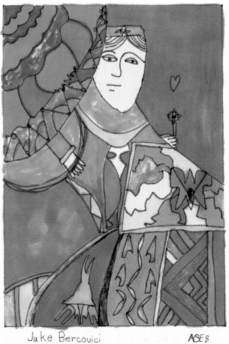

Jake Bercovici—age eight

5. Try overlaying colors onto each other and investigate which types you can blend and mix and which types smear and streak.

6. Notice that it is easier to make a mark down than up, since the pen point tends to stick into the paper when you push it upward.

7. Take charge of your paper and explore how you can turn it at different angles to control the direction and quality of the lines.

8. Use as much paper as you need to fully explore all these suggestions.

When you are done, take a look at all the patterns and colors, and make a note of which effects you like. Place these drawings under your mat and check to see that you have recapped all the markers adequately. You're now ready for the basics.

Recognizing the Five Elements of Contour Shape

We will now examine how to isolate and observe the five basic elements of shape. The contour edges of the objects you wish to draw and the spaces between them are represented by continual patterns of these same five elements. The elements give you the information you need to re-create any shape, whether simple or complex, on a piece of paper. After you become confident with drawing contour shape—the edges—you will learn how to fill in with volume and shading. Students report that seeing the edges of everything in terms of these five elements of shape is the main thing that got them to relax and feel confident.

Now that you have your body relaxed, your senses activated, and you are familiar with the tools of the trade, you are ready to tell your mind what to look for with your eyes. If you were unable to obtain a photocopy of the five basic elements chart in Fig. 1.2, I recommend that you fashion a handmade version to put up in your drawing space.

As you familiarize yourself with these elements, use all your senses to explore and recognize them in your environment. Research in movement therapy reveals that information and memories are stored in the body cells, and educators are claiming that learning is accelerated if you can tap into the body experience as well as the intellect. After you

THE 5 BASIC ELEMENTS OF SHAPE

THE DOT AND CIRCLE FAMILY

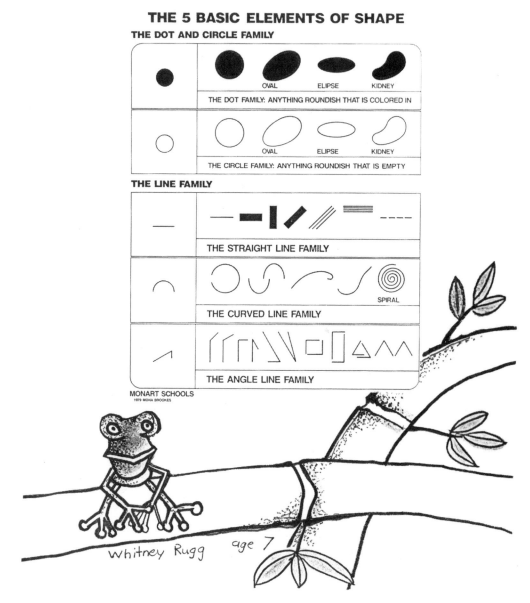

THE DOT FAMILY: ANYTHING ROUNDISH THAT IS COLORED IN

OVAL ELIPSE KIDNEY

THE CIRCLE FAMILY: ANYTHING ROUNDISH THAT IS EMPTY

OVAL ELIPSE KIDNEY

THE LINE FAMILY

THE STRAIGHT LINE FAMILY

THE CURVED LINE FAMILY

SPIRAL

THE ANGLE LINE FAMILY

MONART SCHOOLS
1979 MONA BROOKES

Whitney Rugg age 7

Whitney Rugg–age seven

FIG. 1.2. The contour edges of the objects you wish to draw and the spaces between them are represented by continual patterns of these same five elements.

talk about a visual element, get up, move around your environment, and begin to explore finding and touching that element in your visual field.

Keep in mind that there is actually more than one "right" answer in the world of vision. The same object looked at from different positions or distances has a different appearance. For example, the hole in a pencil sharpener is a circle to the student who is a foot away and a dot to the student who is 12 feet away. With small children, make sure you are discussing the same object by actually handling or pointing to it. For example, after discussing and looking at the dots on the chart, you might go to a doorknob and feel it in the palm of your hand, pluck a grape from a bowl of fruit and feel it in your mouth, or throw a ball back and forth. Later on, when you are drawing an object that is giving you difficulty, remember to get close to it and pick it up and feel it in order to better understand its shape.

You can also make up games of moving through space in shape patterns or making your body take on the shape of the elements. Get the children to do such things as pretend they are straight lines while walking in curved patterns on the floor, or make angles out of their arms and legs while hopping in dot patterns around the room.

The next section will give you the general description of what to look for in each one of the five elements and how to begin to recognize them in your environment.

The Dot Family

The difference between the dot and the circle is that the dot is colored or filled in and the circle is empty. Notice that the dot family includes anything that is round and has no straight or pointed edges. It can be perfectly round or very wobbly as long as it is filled in with texture or color.

Most of us think of a dot as small, and it limits our imagination. Open up your mind to dots of any size, and go point out at least three that you can see. Explore them.

Close your eyes and build your inner vision by seeing images of very small dots all the way up to huge ones, such as a speck of pepper, a tack, a hubcap on a tire, a weather balloon, the planet Earth from outer space.

The Circle Family

The circle has the same variety of shape and size as the dot but is empty of texture or color. Notice that the rim does not have to be thin, and the shape can wobble around as long as there are no pointed edges. Go around again and find at least three circles to explore. Be careful that you see the entire circle; don't talk about something that you intellectually know is a circle but is not wholly visible. For example, when there are flowers coming out of a vase, you can't really see the whole circle at the top of the vase, or when you slip a circular ringed bracelet over your wrist you are left with seeing only a curved portion of it. Your drawing ability is blocked when you try to draw from what you think instead of what you see.

Stimulate your inner vision again and try to imagine as many different circle shapes as you can in a variety of sizes, such as a necklace clasp, the rim of a glass, a hula hoop, the track around a football field, the white-light ring around the moon.

The Straight Line Family

Most people think a straight line can only be thin. As you look at the chart together, point out the straight lines that are fat and see them as straight lines rather than as small rectangles. You can observe a door or the ceiling of a long room as a fat straight line when considered in this way.

When you observe and explore straight lines in the environment, they are usually attached to things and have to be isolated in order to be recognized, such as a line going from the ceiling to the floor in the corner of the room, one side of a picture frame, or one particular branch in a tree. If you are inside a man-made structure, there should be about you an endless variety of straight lines.

When you make up straight-lined images in your inner vision, remember to vary the size and length: a cat's whisker, a ruler, a stairway handrail, a crosswalk line, the silhouette of an 80-story office building, a six-lane freeway out in the desert.

The Curved Line Family

The minute a straight line begins to bend, it becomes a member of the curved line family. Of course the ways in which a line can bend are infinite as long as it does not close together and make a circle. Since curves have a tendency to be strung together in many different directions, it becomes important to isolate them in order to see them individually. For example, the letter *S* is really two curves joined together.

One of the biggest challenges in drawing is when there is a series of curves all strung together that change direction. You might think it would be easy for beginners to draw subjects like Mickey Mouse or Donald Duck, for example, because of their childlike quality. But if you observe Donald Duck's bill closely, it's a perfect example of curves that weave in and out of each other, and it requires an extra amount of focus to duplicate. Children are really frustrated when they can't get recognizable characters to "look right," so beware of subjects that entail many multiple curves in the beginning lessons. As you look for curves in your environment, remember the shapes on human beings. It will help you get ready to draw people.

Close your eyes again and conjure up as many images as you can of the different sizes and widths of curves, keeping in mind the need to isolate one at a time, such as an eyebrow, the handle of a cup, a tree limb, the side of a blimp, a rainbow.

The Angle Line Family

The angle line is really made from two straight lines joining at some point, but it needs to be included in the basic five because of its common occurrence. Observe on the chart how an angle can be very thin and narrow or very wide and open. Notice how you can create triangles and rectangles and squares when you join more than one angle line together. You will need to isolate angles from what they are attached to in the environment, the same way you did with straight lines.

As you imagine them in your inner vision, you might refer back and forth to the chart to stimulate the variety of

degrees and sizes possible, such as in the corner of a staple, the bend in a spider's leg, a forked twig, the corner of a room, the top corner of a skyscraper, or a laser beam reflecting off something.

Playing Visual Games with the Family

An infinite variety of games and exercises can be devised to locate the five basic elements in the environment. You don't have to wait for a drawing time to engage in visual games; you can do them whenever you have a few free moments. Following are some suggested games and eye warm-ups to consider along with the ones you invent.

Find One. Call out one of the five elements of shape and have the child find an example of it.

Which One Is It? Point to one of the five elements of shape and have the child define it.

What's It Made Of? Pick an object and together try to define every element that is represented in its makeup.

What Is It? Describe an object verbally, telling how the five elements construct its shape. Have the child guess what the object is. Take turns coming up with the object. Here are some examples:

- A round dot of wood about two feet across, with four straight pieces of wood placed equally around the dot and extended downward about three feet to the floor. Two slats of straight wood extend upward from the round dot, which has a curved slat of wood across the back. (a chair)

- An open circular tube of plastic about four inches tall, which is sealed closed at one end by a thick dot of plastic. (a glass)

- A 12-inch round black dot of plastic with a circular small hole in the middle; circular lined grooves radiate out around the surface of the dot. (a record)

Warm-ups

Before you get into drawing representational objects, play with drawing the five elements in both random and structured warm-ups. You can create a balance between structured and free styles of drawing, since there are endless ways to do warm-ups and exercises. The following suggestions will help you create warm-ups and use visual awareness games for the young child. Remember that you want to be able to spontaneously use some kind of similar warm-up before each drawing session.

The Random Warm-up

Freehand shape-drawing is one of the best ways to become familiar with the elements of shape, since there is no way one can make a so-called mistake. Simply draw the five elements all over the paper with this random-type format.

Look at the chart; on a piece of scratch paper, make at least one of each of the five elements. Here are a couple of things you might watch for as you begin to draw them:

Coloring in the dot. As you draw your first dots, it is a perfect time to teach some basics about coloring in. Use the broad-tipped markers for any shape that is bigger than the head of a tack, since the fine-tips are too streaky and time-consuming. The main point to get across is to *go around the edges first, slowly; then go faster in the middle.* You will save time and prevent streaking if you follow this practice, especially when coloring in large backgrounds.

The angle line. If a child is trying to draw an angle and keeps ending up with a rounded bend instead of a point, it's probably because he doesn't understand the angle as two straight lines coming to a point. The way you can correct this is to tell him to *make a straight line, pick up the marker, put it down on the point, and go in the other direction.*

After you draw one of each of the five elements, place variations of them all over your paper in a similar way to the example in Fig. 1.3, done by a four-year-old child. Try not to make any recognizable objects this time.

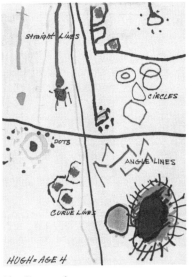

Hugh–age four

FIG. 1.3. Random placement of the five elements gives freedom while learning takes place.

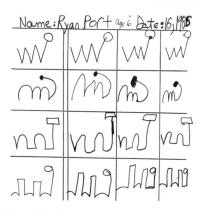

Ryan Port–age six
DUPLICATION WARM-UP

FIG. 1.4. Devise warm-ups for children to duplicate images. It will help them develop motor coordination and become more visually aware.

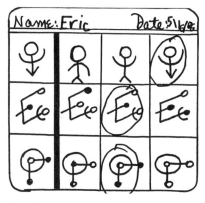

Eric Otani–age five
MATCHING WARM-UP

FIG. 1.5. Make warm-ups to help children differentiate between visual images.

The Duplication Warm-up

These warm-ups take the same format you used in choosing a starting level. Make yourself a master copy of blank squares, so that you can photocopy a good supply of blanks for the future. Then use your imagination and devise challenging warm-up exercises to fit your children's abilities, using combinations of the five elements in the same manner as shown in Fig. 1.4, done by a four-year-old. Although the child will be copying the image in the blank square next to your sample, remind her that exact duplication is not necessary. As long as the same kind of elements are in the same general pattern, the child will be learning enough structure to duplicate recognizable images. This is the first opportunity you have to make everyone feel OK about the copying that is necessary for learning to draw. It is important to explain that in other areas of study it may not be acceptable to copy, but that in the subject of drawing one must learn how to copy in order to learn how to duplicate shape.

Matching Warm-up

Look at Fig. 1.5 in which the child circled the image in each row that matched that of the sample. Again, make a master of blank squares, with a heavy black line separating the sample from the four choices, and photocopy a good supply. Then make up similar warm-ups to challenge your children's level of performance.

This exercise emphasizes a completely different learning process, in which there is differentiating between visual images in order to pick the ones that are the same. This is another way to help children be more visually alert to combinations of elements. Elementary-school teachers report that this warm-up also helps children with their math, since it deals with the counting of elements. Even if children don't know language or word concepts for numbers, they are visually comparing and analyzing numbers of digits and components. They seem to grasp a visual way of relating to numbers and sequence.

Mirror Imaging Warm-up

One of the things that confuses people in the drawing process is drawing the opposite side of an object. This happens in still life with vases or bottles and in figure drawing

when you attempt to draw both sides of the body. Being able to duplicate the symmetry in objects accurately is one of the skills that those who draw are particular about. Drawing two sides of an object that look the same but are in the reverse order is a challenge that takes some practice. The following warm-up in Fig. 1.6 was designed to provide such practice. This type of exercise is found in Betty Edwards's *Drawing on the Right Side of the Brain,* along with other very helpful suggestions on how to retrain your seeing.

I find that some people need guided suggestions in order to be able to relate to this exercise. It really helps when you can break the sample down and recognize the five elements as they are represented one after another, from the top down to the bottom. As you do so, note if you should draw the element toward or away from the central dotted line in order to create the reversed direction.

Look at the first sample in Fig 1.6 (duplicated at right), which is already completed, and imagine a thinking process that goes something like this: *First, I'll make a straight line down and stop across from the straight line on the other side; next, I'll make an angle corner and then a straight line laying down and going toward the dotted midline; then I'll stop halfway toward the midline and make another angle corner; then I'll make a straight line going down to about the center of the whole image. Next, I'll make a backwards C-shaped curve going away from the midline and out as far as the angle corner above it; then I'll make another backwards C-shaped curve going away from the midline that is half the size as the one above it; and then I'll make a curve line that gradually slopes out and down, away from the midline, and ends up on the tip of the baseline.*

With some such thinking process to understand what he's doing, the person who is struggling will suddenly get the idea and be able to solve the puzzle. Whenever you need extra focus, remember to take it slow and to concentrate.

Now complete the remainder of the samples. Note that some will make faces looking toward each other. Make up your own face in the last sample that is blank, and then reverse it.

When you want to construct mirror image warm-ups for children under eight or nine years old, make them very simple, with only one or two combinations of elements.

FIG. 1.6. Mirror imaging exercise.

The Abstract Design Warm-up

This warm-up game is one of the most fun to play. Everyone loves to doodle and make up abstract designs, but now that you have a repertoire of all the elements of shape, you can create with a different kind of confidence. Here are some suggestions on different ways to make up design warm-ups by your chosen starting level. This time, certain suggested techniques will enable you to make a cohesive design that can be colored in, as opposed to the elements floating around on the paper in random fashion. Notice how this is done by giving instructions that require the elements to connect with each other and extend to the borders of the paper. As usual, use your imagination to create some new experiences.

Level 1

Make the instructions very simple at first. Remember, there is nothing wrong with copying, and you might have a child simply copy your demonstrated design at first. It is also a good idea to keep the paper small—8″ × 8″ or even 6″ × 6″—to match the length of attention span for very young beginners. After they get used to the idea, you can make up verbal instructions and let them place the elements that are required into their own individual compositions, while you follow the same instructions. At this stage, wait to draw your version until they have committed themselves, in order to encourage individuality.

If the child does not follow instructions and does something different than you ask, there is no reason to start over or feel anything is wrong. Have the child notice the differences between what she drew and what your instructions were without requiring any change. You can comment on how her design is fine the way it is, but in the future when she is drawing recognizable objects it will make a difference if she continues to choose not to follow instructions. She may, for example, end up with a bunny rabbit that has three eyes instead of two.

Look at the two different Level 1 compositions in Fig. 1.7, created from the following instructions. Then follow the instructions yourself and see what you come up with.

- Turn your paper in any direction you want.

- Choose a fine-tipped colored marker and make three straight lines anywhere you want on the paper, but start the line on the edge of the paper and run it off another edge of the paper when you are done. It doesn't matter if the lines cross over each other; just be sure they start on an edge and stop on an edge.

- Choose a broad-tipped marker and make three dots anywhere you want on the paper. Remember when you color your dot in to go around the edges first, and then you can go fast in the middle.

- Choose another broad-tipped marker and put it on one of your dots; then make a curved line or a sequence of curves go in any direction you want, so long as it goes off the edge of the paper when you are done.

- Choose a fine-tipped marker and make one circle anywhere you want in your drawing so that it touches another mark somewhere.

- Now color in your design however you want. Use flat color, which is one color filling in the space evenly, or use textured color, which is using more than one color or making patterns with colors.

Level 2

Instructions for this can follow the same format as in Level 1, but with more complex ideas and a bigger piece of paper. The two student examples in Fig. 1.8 resulted from the following instructions; use the same instructions to come up with your own version.

- Turn your paper in any direction.

- Take two fine-tipped colored markers and use them any way you want to draw four straight lines on your paper, starting on the edge of the paper and running them off the edge when they are finished. It doesn't matter if they cross over each other.

- Take a broad-tipped marker and create three dots on your paper, all different varieties and sizes.

Sabrina Weisman–age four
FIG. 1.7. LEVEL 1. Two interpretations of Level 1 design warm-up, the beginnings of providing the general structure that will allow for creative interpretation.

Benjamin Marcus–age four

Christina Chang–age six
FIG. 1.8. LEVEL 2. Two interpretations of Level 2 design warm-up. Using more complex forms.

Brian Kang–age nine

- Take a fine-tipped marker and make a circle that touches one of your dots in some way.

- Take another fine-tipped marker and make two angles on your paper anywhere you want, starting on an edge and finishing on an edge the way you did your straight lines.

- Take a broad-tipped marker and make a curved line that starts at one of your dots and goes off the paper. Then start in the same place as you did before and make another curved line that goes off the paper somewhere else.

- Now color in your design any way you wish, but leave at least three of the blank spaces the color of the paper.

As you make up these types of warm-ups, do not feel you must always use every element. For example, make some of the instructions out of curved lines and angles only, or just dots and curves, or just circles and dots. Solicit the child's ideas and have her make up the instructions sometimes. This project can be a short warm-up for 10 or 15 minutes on a small piece of paper, or a comprehensive undertaking of an hour or two on a larger piece of good drawing paper.

LEVEL 3

Use all the same ideas as given in the examples for Levels 1 and 2, but strive for far more complexity. Attempt a more finished look, and use a larger piece of drawing paper with a border. One of the ways you can make it more challenging is to give each other verbal cues only and incorporate multiple concepts in an instruction.

Look at the two examples of the same Level 3 instructions in Fig. 1.9, and then follow the sample instructions yourself to see what happens.

- Using any variety of markers, draw a straight line that travels from one edge of the border to another with three circles of various sizes superimposed along it.

Lilia Fulton–age eleven

Junko Nakamura–age ten

- Incorporate a group of five dots within one of the circles, and then repeat another group of five dots somewhere else in your design.

- Take five colors of fine-tipped markers and use them all to draw two angles anywhere in the design, so long as they start and stop on the edges of the border.

- Use any broad-tipped colors you want to make straight-lined striped patterns in the negative spaces that are left in the design, but leave at least two of the spaces blank.

- Pick one of the striped areas and make straight lines going in a different direction with the same five markers you used to create the angles.

- Pick a light-colored broad-tipped marker and fill three of the areas in your design in with flat, plain color. Since it is a light color, you can go right over any stripes.

FIG. 1.9. LEVEL 3. Two interpretations of Level 3 design warm-up, using instructions with multiple concepts and incorporating blending of colors and textures.

Celene Temkin–age five

FIG. 1.10. Doing line designs on top of torn paper collage.

The variations on this kind of warm-up are endless, including making any kind of random design you want out of combining the five elements. Use your imagination to invent something different. For example, you could, as in Fig. 1.10, even take a separate piece of paper that is smaller than your drawing paper and cut it all up with scissors or tear it into shapes. Then you could color the pieces independently, paste them into the design space, and then add lines and element shapes on top of a collage.

These warm-up exercises show you that two people can use the same instructions and end up with a variety of results. Learn to encourage and appreciate the differences between one piece of art and another. In the color section of drawings, notice the different still lifes that resulted from the same lesson. The assumption that one must draw something exactly as it appears can be a major block to students feeling they are able to draw at all. The same is true of the exercises and lessons in this book; they are merely a guide to get you started. Once you get the idea of how to structure

an exercise or a project, change it around any way that suits you. Then you can sit back and learn to appreciate the different results. Give yourself enough freedom to appreciate the fact that in drawing you may set out for one result and actually end up with an entirely different one. If you are too fixed on one idea, you can completely squelch the playfulness and the spontaneity of your intuitive mind.

Wow! I Can Draw!

It is only one minor step further to drawing recognizable objects. If you take the elements and arrange the instructions into certain patterns, you will find yourself drawing an object with the same ease that you duplicated abstract design shapes in the duplication warm-up shown in Fig. 1.4. In other words, it is no harder to draw a bird than an abstract group of the same elements. It simply takes a different kind of focus to assure that you put all the parts in an order that will represent the bird in a recognizable way. Let's experience how easy it is.

Complete the exercise shown in Fig. 1.11 the same way you did the Level 1, 2, 3 exercises—by simply copying the images under the sample. As you draw the images, pay attention to which of the five elements you are using. Notice that the process is no different than that used in the level exercises; the images just make recognizable objects instead of abstract configurations.

Now look at the two examples of the bird drawings in Fig. 1.12, which were made from the same set of instructions; then follow the coming instructions yourself and watch your own bird unfold on the paper. When you draw this bird with young children, you will need to demonstrate the shapes on a piece of paper as you talk about them. The dotted line in the following example is only to indicate the current part you are to draw. You will draw in regular solid lines. As you go to the next instruction, the prior dotted line will convert to a solid one.

Use your black small-tipped Flair marker to draw the entire bird; then you can color it in any way you want when you are finished.

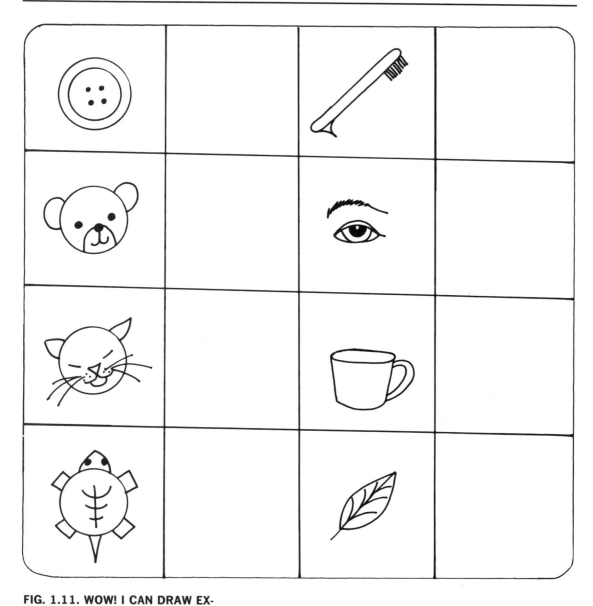

**FIG. 1.11. WOW! I CAN DRAW EX-
ERCISE.** If you take the five ele-
ments and arrange them in a
particular order you will find your-
self drawing a recognizable object
instead of an abstract design.

Henry Lee–age three

FIG. 1.12. Two different versions of the same instructions. Follow them and watch your own version unfold.

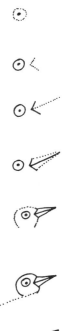

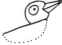

Tia Pulitzer–age seven

1. *The eye.* Make a *dot* for the center of the eye, anywhere you want on your paper, leaving room for the body, tail, and legs. Draw a *circle* around the eye to make the outside rim.

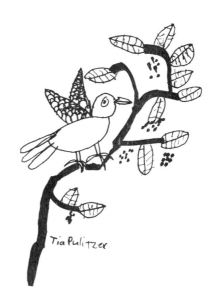

2. *The beak.* Make a small *angle line* in front of the eye, leaving a space between the eye and the beak, with the point of the angle going toward the eye. Draw a *straight line* for the middle of the beak, going away from the eye, as long as you want your beak to be. (It will look like an arrow.) To make a sharp point on your beak, start at the tip of the beak and draw a *straight line* from the tip across the top. Do the same for the bottom of the beak.

3. *The head.* Draw a *curved line* over the top of the head, until it comes down the back of the head and stops somewhere below the beak. Draw a *curved line* from the bottom of the beak downward to the same length as the back of the head. Draw a *straight line* across the bottom of the head and across the paper until it is as long as you want your bird's body to be.

4. *The body.* Draw a *curved line* from the bottom of the head to make a chest; curve it under to go across for the stomach, and then curve it up to the straight line you made to the end of the body.

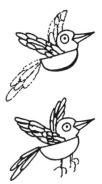

5. *The wing.* Make an *angle line* from the back of the bird to the length you want your wing to be. Make feathers on it in any design you want.

6. *The back, other wing, and tail.* Since everybody's bird is a different size and shape, add any lines you need to close the spaces between the wing and the body to show the back of the bird. Add the other wing if you wish, coming out from behind the bird. Add long *U-shaped curved lines* out of the back of the body for the tail, and decorate the feathers any way you want.

7. *The legs and feet.* Make *single or double straight lines* to create your legs where you want, and add three *single or double curved lines* for the toes.

8. *The branches and berries.* Take a brown broad-tipped marker and make a *straight or curved* branch that comes from the edge of the paper and through the feet of the bird. Yours may have to take a totally different shape than the one in this sample, due to differences in the placement of your bird and its size and shape. Add more branches, wherever you want them to be. Take a fine-tipped dark-colored marker and make leaves by drawing a *straight line* for the middle of the leaf and a *curved line* on either side that goes from tip to tip. Add any design or veins on your leaves that you wish. Then take a broad-tipped colored marker and make *dots* for berries wherever you want them.

9. *Finishing up.* Color your bird as you wish, but use at least three colors for variety. Look outside at a tree and notice how the leaves are never all the same exact color. Pick several colors for your leaves. Add anything else you want to your drawing. If you want to color in the background, be sure to go all around the edges of the objects in the picture and the border with the broad-tipped marker first. Then you can go faster as you color in the spaces, which prevents the ink from drying too fast and causing streaks.

Voilà! A drawing. A drawing that is recognizable. One in a series of many to come. Remember, you will be satisfied with some, and you won't be satisfied with others. All are steps toward the confidence and pleasure that are bound to come along with your explorations.

Drawing from Graphics

Now that you are able to look at a visual image, recognize each component as one of the five elements, and interpret those elements into your own drawing, you can use all types of graphic materials to inspire yourself and your young students.

Representational artists look at existing images in order to draw, use their imaginations to delete, add on, change things, and end up with a completely original work of art. Fig. 2.1 features a group of magical cats that were inspired by a greeting card, and Fig. 2.2 presents a beautiful abstract that was inspired by a photograph of a pelican. Continue collecting graphic materials for such inspiration. Get into the habit of carrying a pad, and sketch what you can't take home with you. I'll always remember the afternoon I was frantically looking for a new project at the last minute. I walked into the last store I had time to browse in. There before my eyes was a $300, five-foot batik of African animals. The price and size both made it impossible for me to buy, but it was perfect for a class project. Thanks to the sketch pad, I made two versions of pieces of the batik, with notes on color and designs. The next day I walked into class with my own 18″ modified marker-pen version of the batik.

It inspired, along with some other graphic materials, the elephant drawing by Leslie Rugg that you can see in the color plates at the front of the book.

Train your eye to spot possible subjects on any item that could be decorated with graphics, such as greeting cards, wrapping papers, billboard signs, paintings, fabrics, toys, household goods, pottery, jewelry, and printed materials such as books, coloring books, magazines, and brochures. You will find that you will draw more as you have more models to draw from.

This lesson will furnish you with some drawing tips and then go right into a project geared for your starting level. The drawing tips will give you some suggestions on how to instill a connection with your subject, how to plan compositions with overlapping objects, some ideas on how to change areas of the drawing that you are not satisfied with, and some suggestions on various effects you can achieve with coloring and shading. The lesson guides you through a project with a sequence of steps that can be used in all future drawing sessions. You will pick the project that fits your starting level, but you can always return to the others and do them later.

The progressive lessons were designed to fit the degree of motor coordination, mental readiness for complexity, and attention spans present in different children. For example, the lines in Level 1, Leo the Lion, represent very simple circular or boxed abstracted shapes, while the lines in the carousel horse, Level 3, represent complex relationships of subtle curves and delicate muscle patterns. The Level 2 project of the tropical birds has been designed to present a range from a simple rendition of one bird to a more complex version of many birds in a montage.

If working with children, be sure to read and share the drawing tips with them. Very young children may not be able to use all of the drawing tips, but they are ready to hear about them and be aware of them for the future.

Drawing Tips

Before you get engrossed in a project, there are several hints I want to share with you to increase your satisfaction with your drawings. If you help your children incorporate these ideas, they will get more feeling into their drawings,

Jennifer Whitney–age eight

FIG. 2.1. A magical group of cats that was inspired by a greeting card. Artists look at other images, change things, and end up with a completely original work of art.

Greeting card

Joel Axelrod–adult

FIG. 2.2. A beautiful abstract, inspired by a photograph. Artists copy a part of some image they see, play off it, change it, and build it into a statement of their own.

will risk more complex compositions, will have more options to correct unwanted results, and will incorporate more variety in their detail embellishments of color and shading. The section on adjustments and changes is very important. It is designed to help you let go of your fears about making a mistake and gain knowledge of changing things as you go along.

Keep the Flow and Follow Your Feelings

When you are first learning to draw, you usually give more attention to the technicalities. But your intuition and feelings will help your drawing as much as the specific techniques and processes that you master. Personal involvement and projection of the artist's feelings into the drawing is what we all respond to in our favorite works of art. If you look closely at the famous artworks in Fig. 2.3, you'll notice that each drawing is not necessarily technically accurate or even well rendered, but conveys a particular mood. If the artist were to get too analytical, the results might be technically correct but unevocative because of an overall rigid, hackneyed, or sterile presentation.

It is the artist's connection with energy, life, light, feeling, and mood that captures our attention. Here are some suggestions to help you develop these qualities:

- Pick a subject or some part of a subject that you have a connection to or feelings about.

- If you feel insecure about drawing an object, take a piece of scratch paper and force yourself to draw it without even looking at the paper. Just let your hand flow with your feelings, and experience the quality of lines that develop. When you decide to begin your finished drawing, try to retain some of that same fluid feeling.

- As you draw the subject be aware of your feelings about it and what you want to convey. Some artists describe how they project their feelings from their emotional center onto the subject and then read those feelings coming back through their eyes as they visually observe the subject. They say this helps them portray feeling and inject mood into their drawings.

The Accordian Player-Rico Lebrun

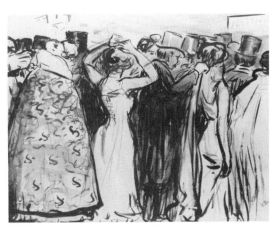

Le Vestiare, l'Opera, Paris-Kees Van Dongen

Decorative Composition-Maurice Prendergast

Woman-Willem de Kooning

FIG. 2.3. It is not necessary for your drawings to be technically perfect. Notice the inaccuracies and so-called mistakes in these famous artists' renderings. Personal involvement and projection of the artists' feelings is what we respond to in our favorite works of art.

● Try to familiarize yourself with the action or function of what you are drawing. It is more important to give the object energy and movement that is natural to it than to correctly duplicate its visual appearance. For instance, if you were going to draw a cat, it would help for you to study cats, watch what they did with their time, try to imagine how they felt as they engaged in different activities, and actually pretend you were able to move and feel like one. After a movement session in which a mime had us all understand the movement of a cat, I found I was able to draw one with much more feeling.

Overlapping

Once you learn how to draw objects that are in front of each other, you have far more variety in your choices of composition. Overlapping objects portray dimensionality of foreground and background and lend far more sophistication and interest. The key to overlapping objects is to remember this advice:

1. Draw the object in front first!

2. Begin drawing the object that is behind next, and *when you run into something, stop, jump over, and keep going.* Your hand should actually jump over the object in front and then keep going with the same line on the other side. You will be able to use overlapping in any of the projects in this lesson. Study the examples of placing objects in front of each other shown in Fig. 2.4, and then try the overlapping exercises displayed in Fig. 2.5.

3. A note to parents: Don't worry about the inaccuracies at first, especially with a very young child. The "jump over" can be awkward, and the "keep going" can end up in a place that isn't visually accurate. This is one of those things that just takes a little practice, so if a child isn't satisfied, just encourage him to be patient and to keep on trying; techniques will improve with practice.

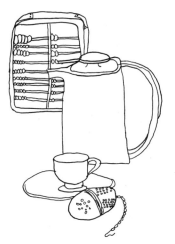

Molly Adams–age nine

Karen Kim–age seven

FIG. 2.4. Examples of drawings with objects overlapping each other.

FIG. 2.5. OVERLAPPING EXERCISE.
Try copying the combinations of overlapped components, and then make more up of your own.

Making Adjustments and Changes

When dissatisfied with the way you drew something, you don't have to experience the frustration of starting over or quitting. Instead, stop and quietly think of ways to alter things to your liking. Learning how to change things as you go along will enable you to draw with a lot more freedom and enjoyment. When six-year-old Alexandra Berger expressed great sorrow at "getting silly and ruining" a stunning drawing of a horse by giving it toes with red fingernail polish, she decided to try for an adjustment. I'll have to admit, this one had me stumped. I learned that I could count on the six-year-old imagination if I just kept encouraging her to think. An added apple tree, with falling apples and apples over the formerly red toes, worked perfectly. As one of Alexandra's favorites, it was framed and hung in many art shows. We both laughed as spectators commended her on such an original idea as the beautiful falling apples, never suspecting the red toes beneath.

As suggested earlier, it is best to completely stop using the word *mistake* so that you can remember there is no mistake possible. If the child is satisfied there is no need for change, whether someone else thinks there is or not. If the child is really dissatisfied, here are a few suggestions that will help her alter things. Use your own imagination to think of others.

Adding on. One of the best ways to accommodate an unwanted line is to repeat it somewhere else and make a symmetrical design out of it, as shown in Fig. 2.6.

Transforming. One of the most challenging ways to make changes is to completely transform the object you don't like into something else, as in Fig. 2.7. The texture and pattern of the area that you want to transform can give you ideas of what will work well. Children are very good at this and can come up with lots of creative suggestions when you solicit them.

Covering up. There is no end to the kinds of shading, design, or textures that will cover up an unwanted line or portion of a drawing. Use some thought first, and create a pattern that blends in with the subject and mood of the drawing, as is evidenced in Fig. 2.8.

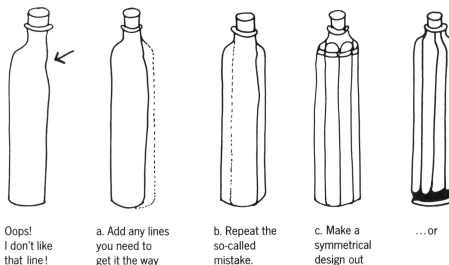

Oops!
I don't like
that line!

a. Add any lines
you need to
get it the way
you want.

b. Repeat the
so-called
mistake.

c. Make a
symmetrical
design out
of it.

...or

FIG. 2.6. Making adjustments by
adding on.

Oops!
I don't like
this elephant!

Baby elephant transformed
into a bush.

**FIG. 2.7. MAKING ADJUSTMENTS
BY TRANSFORMING.** Children can
come up with unbelievable ways to
transform an object they don't like
into something else.

Tracing and rearranging. Tracing as an artistic trick of the trade can be one of the most liberating things that can happen for you. It just doesn't make sense that it wouldn't be acceptable to retrace your own artwork in order to rearrange or change things. Taking the parts you like out of a drawing and tracing them into a new drawing, as in Fig. 2.9, helps you accomplish your ends. It is important to let children know this is an artist's option and not "cheating."

I am convinced this was one of the main things my Aunt Beverly showed me that allowed me to develop as an artist. I understood that it caused dependency to trace other people's drawings, but I never could understand how other children didn't know they could trace and rearrange parts of their own drawings.

Where to start. As there is no right way to draw an object, there is really no right place to start. But because I have found that one of the biggest blocks to drawing comes from not knowing where to start I have developed some general suggestions. These come from the observation that most objects have a central focus or basic function that leads you to a good starting place.

Examples of starting places:

- Most flowers have a center.

- Most plants have a central stem.

- Most still life containers have a hole.

- Most living creatures have eyes.

- Most buildings have a central door or archway.

You can't go wrong if you decide what the central idea of an object is and use these hints. So for the sake of learning, follow these suggestions. When you are confident about your drawing you can start wherever you want.

Projecting the image on the paper. Children tend to have little conception of how to incorporate a piece of paper into their drawing and use it as a whole. They usually make a small drawing right in the middle of the paper, which does not tend toward a finished or integrated look. They might put a blue line across the top of the empty paper for a sky, or a brown line across the bottom for the ground, or a lot

Oops! I went the opposite direction than I wanted!

Cover it up with texture that complements the drawing.

FIG. 2.8. CREATING ADJUSTMENTS BY COVERING UP. Shadings and textures can go a long way to cover up unwanted lines or portions of a drawing.

a. X-out unwanted parts.

b. Trace in wanted parts on a new paper through the window light.

FIG. 2.9. MAKING ADJUSTMENTS BY TRACING. It's not cheating to delete and add on parts of one of your old drawings into a new one.

of scribbly lines around to cover up the white spaces. Actually, left to their own, these are the children who quit drawing and are the same adults who later in life tell me they can't get beyond the starkness of so much white paper. I think the missing ingredient is the inability to look at the paper and project ideas of images onto it without actually drawing yet. As an artist, I found I did this naturally, and had no idea that everyone didn't do the same.

Projecting images onto the blank piece of paper allows you to know where to start, how to make the beginning shapes the sizes that will allow for everything to fit, and how to keep track of where you want everything to go. If you already know how to do it, you know exactly what I mean and no further explanation is necessary. Telling someone who hasn't experienced it how to do it is the trick.

The secret to helping someone see images on a blank piece of paper is to start with the simple and gradually build up to the complex. You might get a child to imagine a straight line running right through the middle of the paper, or a red dot in each corner of the paper. Slowly add more detail until he sees his entire general composition on the paper. You are helping him mentally project intangible but very visible marks on the paper. These imaginary marks are used as guidelines or reference points during the drawing process. It is the rare person who can not do this when informed of the process. Anyone having difficulty will come around quite rapidly after a little exposure. Of course, this is one of the most valuable tools you can develop, so play around with imagining images on blank surfaces as often as you can.

Making preliminary sketches. Take a piece of scratch paper and sketch a few small boxes on it that are the same general shape as your drawing paper. Use these boxes to organize the figures in your drawing and plan various compositions. These sketches involve only the general structure and need no detail, as seen in the preliminary sketches by a child in Fig. 2.14's Leo the Lion project.

Using a Test Paper. Put a piece of the same kind of paper next to your drawing to use for exploring difficult shapes, shades of colors, and blending of colors.

Using thick and thin line. If all the contour lines in a picture are the same thickness, it can make for a rather stilted look. One way to create interesting detail is to vary the width of those contour lines, as seen in the child's drawing in Fig. 2.10. You can achieve this by using different thicknesses of marker points or by simply taking the same marker and choosing some of the lines to retrace and broaden.

Creating flat, textured, or shaded areas. When you put the finishing touches on a drawing, you want to explore as many ways of creating color and texture as you can. Here are just a few of the main effects you can use.

- *Flat color* simply means using one color to fill in an entire space. Take your time and be complete, because little white specks of paper showing through can be a tremendous distraction in a beautiful drawing. When filling in large areas, avoid using zigzaggy lines of color for the same reason. Unless an area is very small, avoid coloring in with fine-tipped, streaky markers.

- When *shading,* pick several broad-tipped markers that you think go together and try them on your test swatch first. You will find that some combinations just won't work. I recommend that you purchase a simple drawing book on shading as you get into sophisticated renderings, but for these beginning projects it is enough to give the child the basics. Simply pick one direction for the dark sides of objects and stay consistent throughout the composition, as described in the section Warming Up to the Light and Dark in Lesson 4. You can add to the beauty by using gradations of three or four shades of dark to light, instead of the starkness of just a dark and a light side.

- In developing *texture* there is literally no end to the variety. This is one time when you can use any and all kinds of markers in endless combinations. For example, you could use a flat, light background in an area and then overlay thin-lined textures on top of it;

Camillia Ben-Basset–age eight

FIG. 2.10. Using thick and thin line to create interesting detail.

you could use several broad-tipped markers and let them bleed into each other in blotchy effects; or you could devise dotted or striped areas intertwined with each other out of several varieties of markers. The trick is to use your test paper and play with your imagination.

Each time you are stuck for ideas or are dissatisfied and think you have to start over, stop, give it some thought, and you probably will think of several ways to get started again or change things to your satisfaction. Rather than hoping nothing will go wrong and dreading a mistake, begin to think of altering things as a part of the drawing process itself. It will free up your drawing and include changing and fixing things as a part of the experience.

Level 1: Leo the Lion

We will use a photographed image of Leo (Fig. 2.11) and a simplified drawing of the basic elements that compose its shape (Fig. 2.12) as our samples for this drawing project. Leo comes from an embroidery that was inspired by a design on my shower curtain, years ago. Leo serves to give you only the general shape of the lion and to stimulate your imagination. You will add detail designs, other animals, or background and foreground figures to create your own original drawing.

Warming Up

Before you begin the project be sure to do your body and eye relaxations, review the five elements of shapes from your chart, and do some kind of warm-up from Lesson 1.

Planning

ARRANGE YOUR SAMPLE

Place the photocopy of Leo in front of you at your drawing place. Since propping the book up causes an awkwardness in following the printed instructions, it is suggested that you take time out to make copies of all the samples suggested in the section "How to Use This Book." You will be adding background and foreground ideas to the

FIG. 2.11. Photo of "Leo the Lion" embroidery.

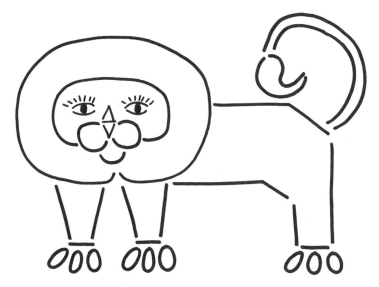

FIG. 2.12. Simplified drawing of Leo.

drawing, so gather any other graphic materials you may have collected for this purpose and place them in front of you as well.

CHOOSE THE PAPER AND SUPPLIES

Select the size and type of drawing paper you will use and your regular-tipped black Flair to draw with. Use smaller paper for very young children. Have the other narrow- and broad-tipped markers at the drawing table to use for detail and color.

IMAGINE YOUR MAIN SUBJECT IN THE DRAWING

Look at Leo and begin to imagine how you want to place him in your drawing. Consider what size you want him to be, where you want him in the composition, and in what direction you want him to face.

IMAGINE YOUR WHOLE COMPOSITION

Begin to project with your imagination different arrangements of the things you want in the drawing on the blank paper. Consider a variety of solutions by asking yourself the following kinds of questions: Do I want just one lion, or more? Do I want a stylized lion with designs, or a more realistic-looking one? Do I want to draw the lion on a field of solid color, on an abstract background, or in a scene? If I want a scene, where do I want my lion to be—in a jungle, in a zoo, in a circus, or in my room like a stuffed animal? What other figures or items do I want to put in the drawing with my lion? Fig. 2.13, the student exhibition of Leo, may give you some ideas.

MAKE PRELIMINARY SKETCHES OF YOUR IDEAS

Take a piece of scratch paper and draw some planning boxes for your preliminary sketches, as discussed in the drawing tips and shown in Fig. 2.14. When you feel you've exhausted your ideas for compositions, choose the one you want to begin your drawing with.

Beginning

As you take the blank piece of paper to begin, remind yourself and the children to project the image of the composition onto its surface with your imaginations. Make any

Alexis Collins–age five

John Boles–age seven

Robert Boles–age fifteen

FIG. 2.13. Student exhibition of Leo. Consider the variety of environments you can put Leo in.

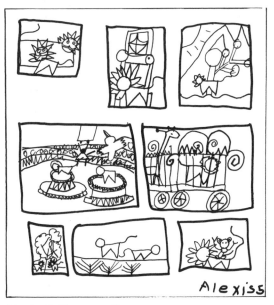

Alexis Collins–age five

FIG. 2.14. PRELIMINARY SKETCHES. This child drew some boxes to plan in and tried different ideas for compositions in a very general drawing style.

necessary guideline dots or marks to remind yourselves of where things will go. Get a sense of how large Leo will be and where he will sit on the paper. Since we are dealing with a living creature, we will follow the suggestion to start with the eyes. You can save a lot of paper and frustration with children if you ask them to show you with their finger where they are going to start the eyes. This allows time to refocus if the imaginary projections are too far off. Then follow the step-by-step suggestions and guide the child through the experience of choosing which part to draw next, what basic elements are involved in its construction, and how to render them on the paper. Remember, the dotted line is to represent the shape currently being discussed; you will, of course, draw in regular lines.

1. *Begin with the eyes.* Place the eyes so there will be room for the large mane, the body, and the legs. Draw an *oval dot* for each one of the pupils, a *curved line* over and under each one of the dots to define the outer edge of the lids, and tiny *straight or curved lines* for the eyelashes. When choosing the next thing to draw, try to build off the part you just drew by drawing what touches it or what is the next closest thing. So in this case, the next thing would be the nose.

2. *The nose.* Draw the *straight line* in the middle of the nose first. Then put a *tiny guideline dot* where you want the triangle points to end up. For the upper triangle, draw *straight lines* from the guideline dot to the ends of the midline of the nose. Do the same for the lower triangle.

3. *The cheeks and chin.* Start a *curved line* in the middle of the nose and bring it around to the tip of the bottom of the nose. Keep it small, or your lion will get too large. Notice it comes out about as far as the middle of Leo's eyes. Then draw a *curved line* on the other side, going the opposite way. Then draw another *curved line* to create the chin.

4. *The face and mane.* As you create the line for the face, remind a small child to stay close to the eyes, or the lion's head will be too large. Use a *guideline dot* over the nose and above the eyes a bit if you think you need to. Notice that as you draw you are always checking how close or far away things are in relation to each other. This is definitely one of the secrets to drawing things in proportion.

Start near the middle of one of your cheeks and create a *curved line* that goes all the way around to the other side and becomes the face line. Make a *guideline dot* above the face to mark how wide you want the mane to be. Leave a wide enough space to allow for the decorations you will insert later. Then start closely under the chin and create another *curved line* that goes all the way around the face and becomes the edge of the mane.

5. *The legs.* In order to get the legs the way you want them, it will help to do some real eyeballing and project the image of them onto the paper before you draw. You want to plan them to be wide enough to incorporate designs and to be slanted in such a way as to leave a triangular space between them that meets directly under the chin. It helps to make the triangular space in the middle first.

Draw an *angle line* with the point directly under the chin and as long as you want the legs to be. Notice that the angle comes out about as far as the eyeballs above it. Draw a *short straight line* for the end of each leg. Then draw a *straight line slanting out* and up to the edge of the mane to form the outside of the leg. Make it nice and wide so Leo won't be too skinny.

6. *The toes.* Draw three *circles* on the end of each leg. Don't make them too small, or your lion will look as if it may topple over.

7. *The body and the back leg.* Start somewhere on the side of the head and draw an *angle line* to create the back and the bottom. You can use another *guideline dot* where you want the point of the angle to drop down for the bottom, since you don't want the body to be too short or too long. Then draw a *straight line* for the back leg that ends at the same length as the front legs. Now you need to decide where to branch off next. Since the width of the stomach can turn out too small if you go up to it from the back leg, do it next. Use a *guideline dot* if you need it to designate where you want the stomach to bend into the back hip. Draw an *angle line* that starts near the bottom of the mane for the stomach and then dips down for the back hip. Draw an *angle line* to form the inner side of the back leg that bends to close off the end of the leg, and attach the three *circled* toes for the back foot.

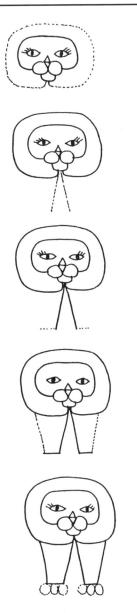

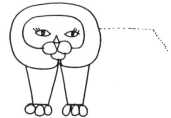

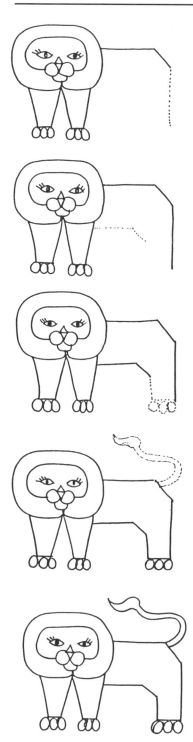

8. *The tail.* Make your tail go in any direction you want with *double curved lines* to form it. Make two *curved lines* that start out wide and taper down to a point to create the hairy end of the tail. The basic shape of Leo is completed, and you are ready to add the rest of your composition.

Finishing Touches

Make a general drawing of the rest of the objects in your composition before you begin to color in and decorate your lion, in case you want to retrace Leo onto a new piece of paper and start over for any reason. As you draw the remaining parts of the picture, begin to use other dark-colored fine-tipped markers for variety. Use a darker color to draw with than the broad-tipped markers you color in with, so that you don't lose your outline edge. For example, you can use a fine-tipped dark green to draw in leaves and then use lots of different lighter-green broad-tipped markers to color them; or you can use a fine-tipped dark brown to draw in contours of trunks and branches and then use several shades of lighter-toned browns to color and shade.

Finish the picture by coloring in and adding all the detail. Refer back to the drawing tips if you need to refresh your memory about using test papers, thick and thin line, and flat, textured, or shaded effects. Aim for using the whole paper to create a finished and organized look. If the child has a difficult time doing that, start with smaller paper.

Level 2: Tropical Birds

For this project we will use a montage drawing (Fig. 2.15) of different tropical bird illustrations that were collected from greeting cards, wrapping paper, and coloring books. The simplified renderings of the individual birds (Fig. 2.16) will help construct your drawing. Step-by-step instructions will be provided for the parrot, and then you can use the same general steps to draw any of the other birds in the montage. You can use this project in a variety of ways for different levels of readiness. Refer to the student exhibition in Fig. 2.17 and notice the wide range of interpretations that resulted from using the same images.

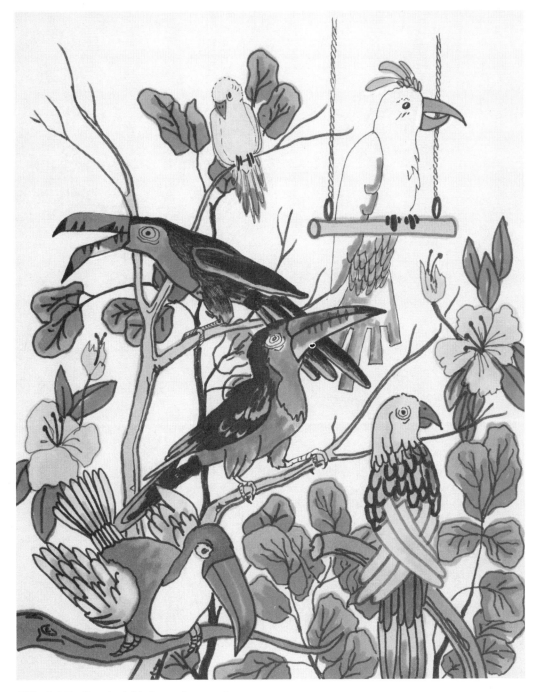

FIG. 2.15. Tropical bird montage, sample.

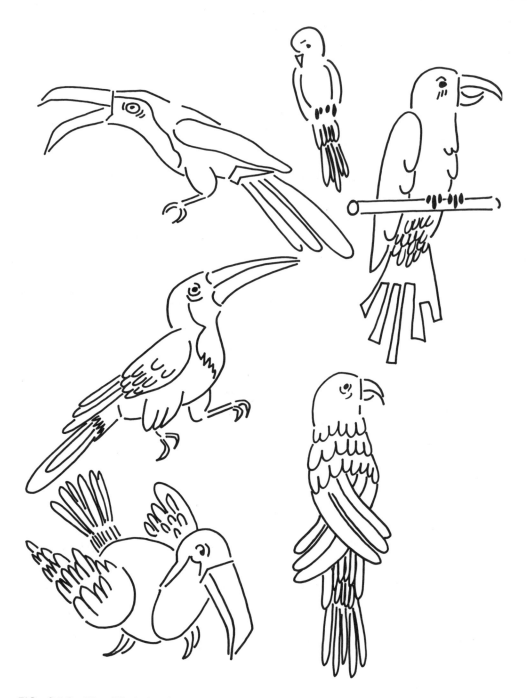

FIG. 2.16. Simplified drawings of individual birds.

Jonah Freedman–age eight

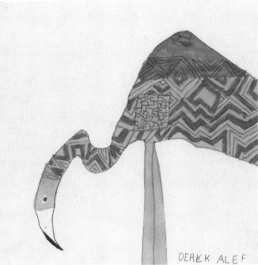

Derek Alef–age nine

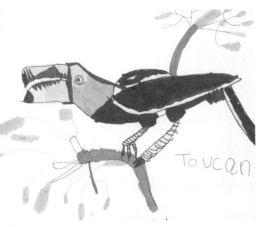

Hollan Van Zandt–age five

FIG. 2.17. A wide range of interpretations come from using the same images.

Alexis Armour–age nine

Warming Up

Remember to do your body and eye relaxation exercises, review the five elements of shape from your chart, and do some kind of warm-up exercise from Lesson 1.

Planning

ARRANGE YOUR SAMPLE

Place your photocopy of the bird montage (Fig. 2.15) and the simplified drawing of the individual birds (Fig. 2.16) in a comfortable spot near your drawing place.

CHOOSE THE PAPER AND SUPPLIES

Select the size and type of drawing paper as well as the fine- and broad-tipped markers. Use the black regular Flair (or its equivalent) to draw the bird or birds of your choice.

IMAGINE YOUR MAIN SUBJECT IN THE DRAWING

Since step-by-step instructions will be given for the parrot, you will use it as your main subject. If you want to make another drawing without the parrot in it, you can easily do so afterwards. Project the image of the parrot on the paper with your imagination and decide where you want it to be, how big it will be, and what general style you want to render it in.

IMAGINE YOUR WHOLE COMPOSITION

Ask yourself how you want the bird to be in your drawing, and what other things you want in the picture. For example: You might place the bird on a branch in the jungle, or with two of the other birds in an abstract design field, or in an elaborate cage sitting in the corner of a lovely room. Collect any samples of additional ideas you plan to add to your composition, and put them at your drawing space.

MAKE PRELIMINARY SKETCHES OF YOUR IDEAS

Take your scratch paper and draw boxes to plan alternative compositions within. Remember that these sketches are just general shape concepts roughly sketched out to get you started. Then choose the one that you like and begin.

Beginning

Birds are so similar in character that the general format for one can be used for most of them. The instructions will be for the parrot, but you will be able to use this sequence in the future to draw almost any bird. We will begin with the eye, since the parrot is a living creature and we know we can build out from it. The dotted line will be used for the current line being discussed, but remember that you will be drawing in regular lines.

1. *Begin with the eye.* Have the child point to the place on the paper where she plans to start, so you can make adjustments before drawing. This allows you to make sure you have enough room for the whole body and a long tail.

Place a *dot* where you want the eye, and then place a *small circle* around it. Watch that it doesn't get too large or your whole head will become too big to accommodate it. Then add some *little wiggly curves* around it for detail.

2. *The beak.* Really study the beak. The line that is attached to the head is the most grounding place to start on most birds.

Draw the *straight line* where the beak joins the head a bit away from the eye in whichever direction you want the bird to face. Draw the *curved line* in the middle of the beak to the length that you want. When doing the outer edges of the beak, it is best to start at the point and work back to the head, since this will help the beginner or small child get the point to be connected properly and appear sharp instead of rounded. Form the upper edge of the beak with a *curved line* that goes up to the top of the face, and the lower edge of the beak with a *curved line* that starts in the center of the midline and goes down to the bottom of the face.

3. *The head.* Draw a *curved line* from the top of the beak, over the eye, and down to where you want the body to start, for the top and back of the head. Form the throat area with a *small inward curved line* from the bottom of the beak. Finish it off by making *scalloped curved lines* across the bottom, to form the first row of feathers.

4. *The back.* Make a *curved line* on both sides of the bird to form the back.

5. *The wings.* Since, when drawing overlapping things, you want to draw what is in front first, start with the wing that is on top.

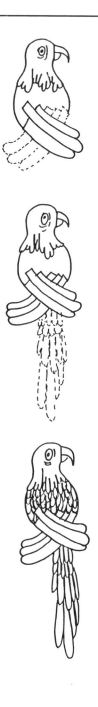

Draw a *short straight line* to designate the first feather, slanting it upward to create the slanting wing. Then draw a long *U-shaped curved line* that extends beyond the other side of the body. Make as many feathers as you want until you reach the center of the back. Repeat the exact same process for the wing that is underneath, only stop, jump over, and keep going with each one of the long *U-shaped curves* that form the individual feathers.

6. *The tail.* You never need to have the exact same shape and number of feathers that you see in the sample. Just look at the type of feathers that are involved and make them similar, in order to duplicate the type of bird you are drawing.

Use *long and narrow U-shaped curves* to form rows of feathers. Make your tail fit the size and style of bird that you have drawn, allowing for the other objects in your picture.

Finishing Touches

Draw any other birds that you want in your picture next. You can use the same progression of steps, but you will have to adjust for front-view or side-view birds. With front-view birds you may have two eyes showing, or you may need to draw feet and branches first that overlap the tail. With side-view birds, you may need to draw chests and legs. If so, do the chest after you have completed the back and wing, then the thigh and leg in front, then the leg in back, and finally the tail.

As you draw other subjects, along with background and foreground, into your picture, use different types of markers in order to get away from the stylized look of too many black-line outlines. This is where other graphic images will inspire you with ideas for scenery and environmental moods, foliage variety, textures, and color. Complete your drawing by coloring and shading your birds and any remaining objects. You may want to refer to the drawing tips to refresh your memory about flat, textured, and shaded areas.

Level 3: Carousel Horse

The photograph that we will use for our Level 3 project is of a carousel horse (Fig. 2.18). A simplified drawing (Fig. 2.19) of the elements that compose the outline shape of the

horse is included to assist you. Many people have blocks about drawing horses; they're intimidated by the subtle, curved lines and complex limbs and joints of the animals. But horses simply take more concentration than do other visual subjects. Along with using your concentration, let go of your need for perfection, and encourage the children to do the same. Look closely at the student exhibition of this project in Fig. 2.20 and notice how the charm of the horse is not diminished in any way by inaccuracies in the proportions. Let that encourage you to relax and learn from your first attempts.

Warming Up

Take a moment to do your body and eye relaxation exercises, and review the elements chart. Instead of doing a warm-up from Lesson 1, take a piece of scratch paper and try a quick sketch of the carousel horse by looking at the simplified drawing in Fig. 2.19. Make your sketch about the same size you intend your drawing to be. You may surprise yourself by how capable you are and find that you don't need to follow step-by-step instructions. If this is true, you may be able to copy it or trace it onto your drawing paper and be well on your way to the finishing touches. If you are not satisfied with your sketch, proceed with the instructions.

Planning

Arrange Your Sample

Place your photocopy of the horse (Fig. 2.18) and the simplified drawing of it (Fig. 2.19) at your drawing place.

Choose the Paper and Supplies

Be sure to select paper that is large enough to accommodate the legs. Draw the general shape of the horse with the regular-tipped black Flair, or its equivalent; then you can draw all the designs and fill in with a variety of colors later.

Imagine Your Main Subject in the Drawing

Study the general shape of the horse and begin to project the image of it onto your paper with the placement you desire.

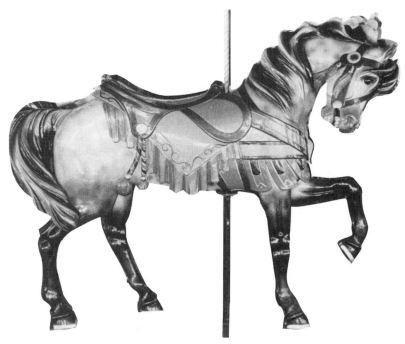

FIG. 2.18. Carousel horse, sample.

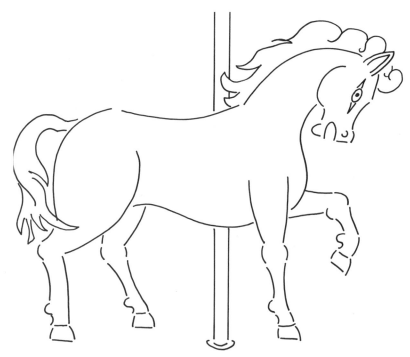

FIG. 2.19. Simplified drawing of carousel horse.

Stephanie Lloyd–age eight

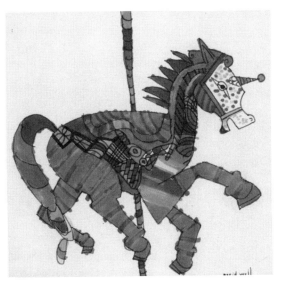

David Weil–age eight

IMAGINE YOUR WHOLE COMPOSITION

Think about how you want your carousel horse to appear in your drawing. You may want to draw it alone, you may want to put it against the backdrop of part of a merry-go-round, or you may want to draw it within an entire merry-go-round.

MAKE PRELIMINARY SKETCHES OF YOUR IDEAS

If you are going to draw the horse by itself, it is not necessary to make further sketches. If you are going to add background or parts of a merry-go-round, make your planning boxes and try out your ideas. Once you have arrived at the general format of your composition, you are ready to begin.

Beginning

Since you know you are drawing a subject that requires a lot of concentration, be sure to watch for distractions and tiredness, and take little breaks with the younger children. Keep reminding them to eyeball things and use guideline dots if they need to, especially when drawing the legs. The secret to drawing a series of curves is to recognize them as

FIG. 2.20. Notice how the charm of the horse is not diminished in any way by the inaccuracies of proportions.

separate curves; this reduces the complexity. The visual example will use a dotted line to identify the current instruction, but you will draw with regular lines. In order to explain a series of curves as separate units, it becomes necessary to make a break in the dotted line example. Of course you will not want this break in your drawing and will join each part to the next as you go along. We will follow the suggestion in drawing tips and start with the horse's eye.

1. *Begin with the eye.* Have the child project the image of the whole horse on the blank paper, paying attention to how much space will be needed for the legs and pole. Ask her to point to where she thinks she will start the eye. This allows for adjustments before false starts can be made.

Draw the central *dot,* but since it will actually determine the size of the head, watch that it is not too small or too big. Then add the *circle* around it and the *angle* shapes that complete the corners. It is not necessary to copy it exactly, but get the points of the angles to be up and down rather than sideways. A sideways eye tends to make the horse look bug-eyed.

2. *The nose.* Make the *straight line* for the forehead a bit in front of the eye. Again, go slowly and concentrate. If you get too far away from the eye or make it too long, the head can become enormous. Then draw the *sloped-in curved line* that forms the bridge of the nose. From here on isolate each curve and see it individually. Now draw the *curved line* that makes the nostril bump, and put the *little circle or curve* in for the nostril hole. Then draw the *straight line* that creates the flat end of the nose.

3. *The mouth, chin, and jawline.* Make a *U-shaped curve* to form the mouth. The curve can be as wide as you want the mouth to be open. Then draw the *C-shaped curve* that makes the bottom lip, and the *slightly curved-in* underside of the jaw, which stops approximately across from the bottom of the eye. Then draw a full *rounded outward curve* to form the jaw, noticing that it stops across from where the eye ends at the top.

4. *The ear, neck, chest, and mane.* Make an *angle line* to create the ear. You can *double* it to create the rim, and of course make it in any direction that you want it to tip.

Establish a guideline dot where you want the neck to end, and draw a *swooping curve* for the back of the neck. Make another guideline dot where you want the chest to end, and draw one *curve that goes slightly in* for the front of the neck and another *curve that goes out* to form the chest. Now use your imagination and create a flowing mane. It is not necessary to copy the same hair pattern as the one in the example.

5. *The back, bottom, and tail.* Draw a *gentle curve* for the back. Then establish a guideline dot for where you want to end the bottom, noticing that it ends at the same level as the chest does. Be sure to eyeball the amount of space that you will need for the legs and stomach, and don't let it curve in too much. Then draw the *curve line* for the bottom. Use your imagination for the tail and let it flow in any direction you want.

6. *The front-side legs and the stomach.* Remember that when overlapping you need to draw what is in front first. As you draw the legs on your horse they may have to take a completely different size and slant of angle due to the differences you have already created in your interpretation of the horse. So the remaining steps will be a little more general to accommodate this. Do the front leg first, and slowly work down section by section.

Use *slightly curved lines* to form the upper thigh, then bend the leg by making a kneecap out of two *little curved lines.* Bend the leg again, and form the fetlock (which is the bump on the back side of the leg above the hoof) out of two *very gradually curved in lines* that extend down to the hoof. Study the example carefully to note the *many little curved lines* that construct the hoof, and draw them one at a time, progressively toward the end of the hoof; use a *straight line* to close off the bottom.

Notice now how the back leg is formed differently, and follow the same procedure; isolate each section, from the hip down to the hoof, by slowly observing the elements that you see and duplicating them.

Now draw the stomach line. Notice that it is actually two curves joined together in a gradual backwards S-shape. Use one *curved line* in the front that is a continuation of where the chest ended on the other side of the front leg and another *curved line* that tapers up into the back hip.

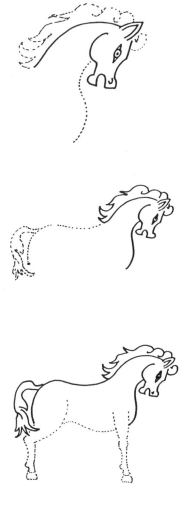

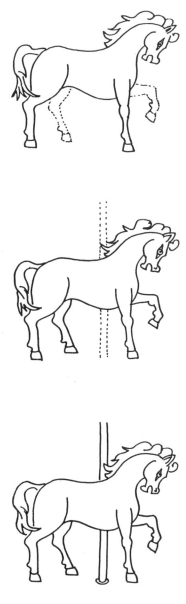

7. *The back-side legs.* Use the example as a guide only in how the legs are formed. It may be impossible to end up with the exact same configuration of legs as is shown in the example with the size and shape of your horse. In fact, every child's drawing will be different at this point, and their horses' legs will need special adjustments to fit properly. But don't worry; as long as you use the general elements to guide you and start at the top and work down, you will come out fine. Use the "stop, jump over, and keep going" principle to adjust to overlapping of legs and tail.

8. *The pole.* Simply draw in the *double straight lines* to form the pole, remembering to jump over when the body of the horse or legs overlap.

Warning to parents: Keep reminding beginners and small children not to be too particular. Encourage the learning process and tell them that each horse they draw will get more and more accurate. If they express total dissatisfaction, refer to the hints on how to trace the parts you like and redraw the parts you don't. These instructions will work with any horse and many of the four-legged animals, such as zebras, that have similar shapes.

Finishing Touches

If you are adding other things to your drawing, go ahead and draw in the outlines first, using different types of markers for variety. Use very intricate and detailed designs on your carousel horse and refer to the drawing tips on color, texture, and shading if you need some inspiration. Of course, the ultimate would be to visit a merry-go-round and make sketches of the whole thing, so that you could develop your drawing even further.

Choosing Other Projects

During this lesson you learned about most of the essential drawing tips that will free up your creativity. The more you choose projects and draw them, the more you will learn to incorporate these tips. The problem solving that you were exposed to will grow as you choose to challenge yourself and not worry about what might be "too hard." So relax and take on projects that you like, even if you are a little leery of them. Fig. 2.21 presents a student exhibition of some beautiful examples of results you can achieve.

Greeting Card

Andrea Hwang–age ten

Greeting card

Lauren De Meules–age six

FIG. 2.21. Student exhibition of projects inspired by other graphics.

In many cases, you will learn so much from the first experience that you will be ready to go to the next level right away. If you started out at Level 1, you probably can go right on to Level 2, and if a child is not too young you probably can subsequently go right on to Level 3. If you started at Level 2, you have probably already learned enough to go right on to Level 3, and you could of course enjoy doing Level 1 at any time. If you started at Level 3, I recommend that you go back and do Leo and the Tropical Birds and make them challenging for yourself and the children.

The drawing projects all follow the same sequential steps, which you can use with any project that you plan for the future. Here is the sequence of steps for you to see as a pattern. You might list them on the back of your sketch pad, so that you have them with you in your travels.

Warming Up

- Do body and eye relaxations.

- Review the five elements of contour shape.

- Do some kind of warm-up exercise.

Planning

- Arrange your sample materials.

- Choose the paper and supplies.

- Imagine your main subject in the drawing.

- Imagine whole compositions.

- Project them on the blank piece of paper.

- Make preliminary sketches of your ideas.

Beginning

- Choose the central point to start with.

- Project that starting point onto the blank paper.

- Observe the elements and duplicate them.

- Go to the adjacent part next.

- Observe those elements and duplicate them.

- Draw what is in front first.

- Draw the general shape of an object first.
- Draw the objects first and then add backgrounds.

Finishing Touches

- Add the details of the objects.
- Add color, shading, and textures.
- Add background ideas.

Don't worry about this much structure spoiling creativity. All artists use this much structure, or they would never produce the works they create. They do it automatically, without thinking about it, and therefore don't tend to talk about it, write it down, or know how to tell someone else to do it. As you get used to these guidelines, you can throw away the list and do them automatically yourself.

The next lesson will focus on still life and how to draw objects from the environment. But you will notice that the same basic sequence of steps will be used in dealing with the drawing process itself.

The more you draw, the more visually stimulated you become, and the more projects you will begin thinking of. So keep your sketch pad with you, take down ideas that can be combined in future drawings, and you will quickly integrate all the learning into a system that works for you. You will soon have the confidence to tackle any subject you want and feel comfortable guiding the children in your life to do the same.

Lesson 3

Drawing from a
Still Life

In Lesson 2 you learned how to draw the general structure of objects by looking at two-dimensional graphics. You learned to do this by deciding on a central place to start, observing the outer edges, recognizing the five elements and how they constructed those edges, and drawing those elements in a way to produce a recognizable picture of the object.

In this lesson, you will learn how to draw the general structure of three-dimensional still life subjects from your environment. Still life means an arrangement of inanimate objects that are used for the purpose of drawing. You will essentially use the same steps to accomplish drawing from still life as you did for observing and drawing from two-dimensional graphics. The main differences will be in training the eye to see the elements of shape on real objects and in planning lessons so that the child or the beginner is not confronted with perspective in the first few experiences.

You will be amazed at how quickly and proficiently you and the children make the transition to drawing from real objects. Children as young as four are very capable of working with still life if you demonstrate one article at a time and allow them to place the objects into their own groupings.

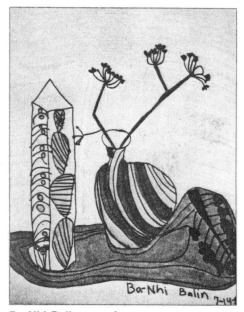

Ba Nhi Balin–age six

Meredith De Meules–age five

FIG. 3.1. Introducing young children to still life adds beauty and sophistication to their experience; they also learn to see the elements of shape on three-dimensional objects.

You will find that with the ability to recognize the five elements of shape, the freedom to move objects, and a general demonstration by you, children can draw from objects in the environment as easily as they did from graphics. Fig. 3.1 shows the beauty and sophistication that can be attained by introducing young children to this experience. After you both get used to the nature of three-dimensional objects and develop an awareness of the spaces in between them, you can leave arrangements as they are and add the challenge of drawing them from a particular perspective.

To draw from still life, you will need to collect real objects. For the sake of this approach, however, it's important for me to be able to refer to specific objects in a predetermined still life model. So in order to draw together by the book, we will have to first use a photograph for consistency of visual data. After we draw this lesson together, you and your child will be ready to build your own arrangements from things you choose and explore the transition to real objects.

Even though you will be using a photograph to study the still life, you will not be limited in individual interpretations.

The Fig. 3.2 photograph is followed, in Fig. 3.3, by two different renditions by each starting level that resulted from it. All six of the students were in the same drawing situation and used the same instructions that you will be using, yet all maintained their individuality and creativity throughout the process. The instructions will give you a format that is applicable for all future still life projects that you set up for yourself and your children.

The photographic model (Fig. 3.4) and the resulting simplified drawing (Fig. 3.5) that you will use for the project is a still life composite of all the objects to be drawn for the three different starting levels. Levels 1 through 3 will start with Level 1 instructions to draw the teapot and the vase: Level 2 and 3 will go on to add the cup and kitchen utensils; and Level 3 will go further to add an abacus. In this way, each level deals with more complexity of composition. In addition, the higher levels will be asked to use more imaginative detail in the rendering itself. As usual, use your discretion to alter the starting level and complexity as you go along to challenge or simplify conditions for any particular child.

FIG. 3.2. Still life you'll be using.

Level 1: The Teapot and the Vase (Levels 2 and 3 Also Start Here)

All levels will begin with the same instructions and draw the first two objects together. Levels 2 and 3, however, will need to plan from the beginning for all the other objects that will be included.

Warming Up

As usual, do your eye and body relaxations, review the elements of shape from your chart, and do some form of the warm-up exercises from Lesson 1.

Planning

Arrange Your Sample

Place the photocopy you made of the still life model (Fig. 3.4) and the simplified drawing of it (Fig. 3.5) in front of you at the drawing space.

LEVEL 1

Katie Lowry–age four

Whitney Gosden–age four

LEVEL 2

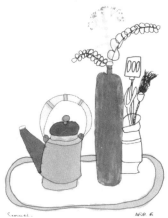

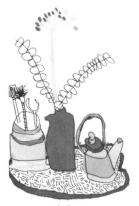

Samantha Naliboff–age six

Dick Lowry–age seven

LEVEL 3

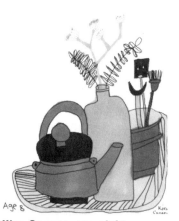

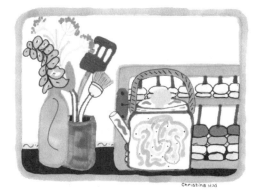

Christina Hild–age ten

FIG. 3.3. Two renditions of each starting level.

Kira Canepa–age eight

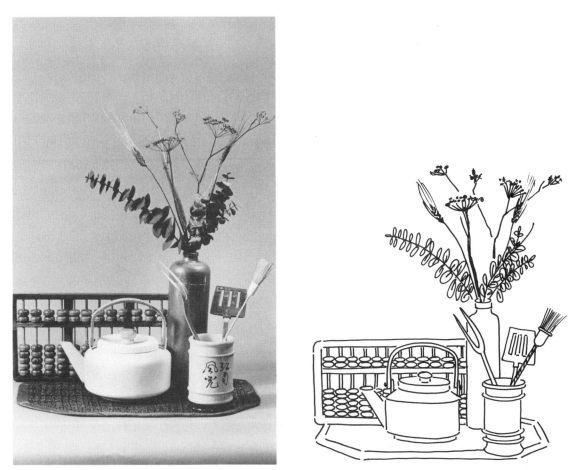

FIG. 3.4. Still life sample.

FIG. 3.5. Simplified drawing of still life.

Choose the Paper and Supplies

I recommend a paper at least 9″ × 12″ for Level 1, to allow for the grosser motor coordination and room for the tall flowers. For Levels 2 and 3 you can easily use sheets 12″ × 14″ or 11″ × 13″. If you don't have the larger paper, just do more eyeballing and keep the scale of things small. We will stick with the markers this time, but after you read about other media, you might want to come back and redo this lesson with pastels or pencil.

Imagine Your Main Subject in the Drawing

Since the central theme seems to revolve around the teapot, we will draw it first. Begin to project the image of it around on the blank paper; consider its location, and imagine how big you want it.

Imagine Your Whole Composition

For the sake of following the lesson, we all have to start with the teapot. So no matter what composition you plan, you will need to consider your teapot down front somewhere. This will make us consistent, since we all need to draw what is in front first. Start turning the paper itself from the tall direction to the sideways direction and imagine your composition both ways. The two examples drawn in Fig. 3.6 show how the composition can work either way, but notice how the height of the vase and flowers are altered. If you are doing the drawing at Level 1, play with different arrangements of the teapot and vase. If you are starting at Level 2, add the kitchen utensils to the planned composition, and if you are at Level 3, further add the abacus. All levels will add the mat last, in order for it to mold itself around all the drawn objects.

Make Preliminary Sketches of Your Ideas

Take a sheet of scratch paper and draw your freehand boxes to plan your composition in. Remember to use some tall and some sideways examples to play with. When you and the children have chosen your composition, you are ready to start.

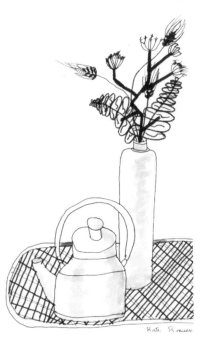

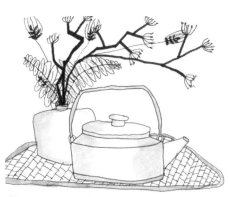

Kate Royer—age eight

Beginning

Since we have already determined the teapot to be the central theme and are choosing to put it in front, we will naturally start with it. Draw the general outline of all your objects by following the same steps as the instructions. Get all the objects into your composition and then go back and insert all the detail, decoration, texture, shading, and coloring in.

As in the previous lessons, the elements being discussed will be drawn in dotted lines and then converted into solid ones as we pass on to the next instruction.

THE TEAPOT

In deciding what part of the teapot to start with, we will follow the same process of considering what its central purpose is. Most basically, a teapot is a container that pours out its liquids. So the two most central points would be the hole in the pot and the hole in the spout. I've found it's far easier

FIG. 3.6. You can alter the sizes of things to create the composition you want.

to build off the hole in the pot than the one in the spout, so we will start there. But wait: This time the hole of the container is covered by a lid. So we'll start with the lid. And since the knob is the most central part of the lid, we will start our drawing with the knob.

1. *Begin with the knob in the lid.* Have the child show you where he intends to start his knob, in order to avoid premature starts. Check that the knob starts low enough on the page to allow room for a taller vase and long-stemmed flowers. Then check that the knob is high enough for the body of the pot not to go off the bottom of the page.

Draw an *elliptical (flattened) type circle* for the top of the knob. The size of your knob will completely determine the size of the teapot, so eyeball it well and keep it small. With four- and five-year-olds who have not quite controlled their small-motor coordination, you can take a piece of scratch paper and help them practice small circles first. Having started with a small knob, the rest will go fairly well. Then draw two *straight lines* to form the stem of the knob and a *curved line* across the bottom to define the edge.

2. *The lid.* Notice how the circle that forms the top rim of the lid goes behind the knob and is broken into a curved line. You can have a small child trace the swing of the curve with his finger in order to check out how big he plans to get. You need to keep projecting the image of the whole teapot on the paper, to avoid running off the bottom.

Draw a *curved line* from behind the knob, around the front, and back to the opposite side of the knob where you began. Then draw two *straight lines,* one on each tip of the ellipse, to make the sides of the teapot lid. To make the bottom edge of the lid, draw a *curved line* that follows the same curvature as the top edge above it.

3. *Body of the teapot.* Draw two *straight lines* slanting out and down from the bottom edge of the lid, in order to form the sides of the upper portion of the teapot. Then create the edge that runs around the front of the pot by drawing another *curved line* that follows the same curvature as the bottom of the lid above it. Draw two *straight lines* for the sides of the midsection of the pot, and then another *curved line* to create the edge around the bottom of it.

4. *The foot.* Draw two tiny *straight lines* to indicate the sides of the foot, and then come around the front with yet another *curved line* to form the bottom of the pot.

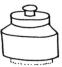

5. *The handle.* You can draw the handle in a simplified way for Level 1 and a more complex way for the higher levels. The instructions will be given for the simple version, but if you look at the photograph, you may decide to try a more complex construction of the brackets and handle attachments.

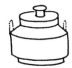

Simply make an upside-down *U-shaped curve* on either side of the upper portion of the body, to form the brackets that your handle will attach to. Next draw a *curved line* from the inside of one of the brackets over to the inside of the opposite bracket. Don't worry about making your handle have the same curvature as the model. Make your handle curve fit the size and style of your teapot. Then *double that curve* and close off the end with a tiny *straight line,* so that your handle will have the thickness it needs. Make the bolts that hold the handle onto the brackets by placing one *flattened dot* on either side of the bracket and handle where they join together.

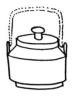

6. *The spout.* It is very common for young children to be displeased with the appearance of teapot spouts. I find the main reason has to do with them starting the spout on the side of the pot, doubling it, and then realizing it is too skinny and slants in the wrong direction. This problem is pretty well eliminated if you have the child start with the central idea of the spout and the hole, and then build back down to the pot.

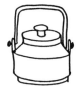

Place a small *squashed circle* somewhere across from the handle brackets on the side you want your spout to be. Notice where the top edge of the spout attaches to the side of the pot, and draw a *straight line* slanting over to it. Then notice where the bottom edge of the spout attaches to the side of the pot, and draw another *straight line* slanting down to it.

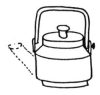

Save any shading, texturing, or adding of detail to the pot until after you have drawn the general structure of the rest of the objects. It's less frustrating this way, if you want to make any corrections.

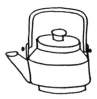

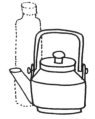

The Vase of Dried Flowers

Since the central function of the vase is to contain, we will start with the hole. Notice that the hole of the vase in the photograph is much higher than any of the examples in the student exhibition. This is definitely a case of all the artists taking the liberty to shorten it, in order to make the most of the paper and leave room for tall and beautiful flowers. If you intend to place the vase a bit behind the teapot, take your time drawing in the opening. You want to plan it so that at least some of one side of the vase shows from behind the teapot, or it can look quite cut off and stunted.

1. *Begin with the hole.* Have the child show you with her finger where she plans to start the opening of the vase. If you want an overlapping effect, place the vase hole above the teapot at any point that will allow the vase to fall partially behind it. If the child is a bit off, get her to eyeball again and move her finger herself. She needs to retrain her own eyes rather than become dependent on your finding the spot for her. Keep talking about and showing her the relationship of the different objects to each other, while she projects the images of the shapes on the blank paper. Draw a small *squashed circle* for the opening of the vase. Don't let it get too big, just big enough to allow several stems of flowers to fit down inside of it.

2. *The rim.* Draw two short *straight lines,* one on each tip of the ellipse, coming down for the sides of the rim. Come around the front of the vase with a *curved line* to form the bottom edge of the rim.

3. *The neck.* Draw two short *straight lines,* one on each side of the rim, coming down to form the neck of the vase.

4. *The body of the vase.* Use the principle of mirror imaging as you attempt to make the two sides of the vase the same; be alert and take it slow. Your vase is not going to be the exact same shape as the one in the photograph, so after you draw one side of your vase you don't need to refer back to the photograph. Look at the photo model to get the general shape, draw one side of your vase, and then study the shape of your own vase and duplicate that shape in reverse on the other side.

Draw one short *curved line* for the bulge at the top of the vase. Draw the side of the vase by using a *straight line* to come down to where you want the vase to end. If you are going to put the vase behind the teapot, it should end before the bottom level of the teapot. This will create the appearance of the vase being farther back in the picture than the teapot. Then use your mirror-image trick: Reverse a *curved line* on the other side for the bulge, and come down with a *straight line* to form the other side of the vase. If you are overlapping and run into something, jump over and keep going where appropriate. Then close off the bottom of the vase by using a *curved line.* If you have overlapped, part of the bottom of the vase may be hidden and your curve line may go directly up against the teapot.

5. *The anise plant.* Many small children begin their stems on the outer edge of the hole of a vase and need to be shown how to place stems all the way down into the hole. If the stem is light in color, the line depicting the opening of the hole will show through. This is a natural phenomenon in children's art and doesn't need any correction. As you both grow in sophistication, you will be able to plan as is necessary to avoid such lines.

The stem. Consider some possible options shown at the side of the page. You may want to draw the stems with a fine-tipped marker, as in examples a and b. You could draw with a color that is darker than you plan the color of the plant to be and then color it in with that lighter color later. Or you may want to draw them with a broad-tipped marker, as in example c, and let the bulges occur where the branches join. This effect is created by letting your hand hesitate momentarily at the joint of the branch and allowing the ink to blot a bit before continuing.

It is common for beginners and young children to forget to allow enough room for the blossoms at the top, so you might need a tiny *guideline dot* somewhere to indicate the height of the branch. Don't even attempt to make the same branch designs as the one in the examples. Make as many *straight, angled,* or *curved lines* as you need to form the type of branch that will fit your composition.

The blossoms. Again, look at the different options in the examples and decide which type of effect you want. Of

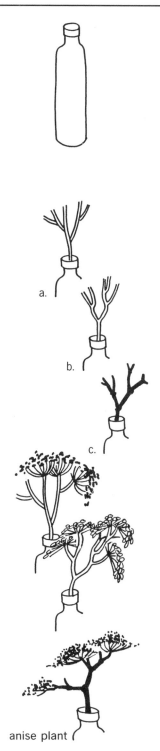

a.

b.

c.

anise plant

eucalyptus twigs

wheat stalks

course you are not limited to these choices and may think of other ways to use the markers.

Draw some combination of single or double *curved or straight lines* to form the little twigs that hold the seed pod endings that are left on the blossoms. Since these are dried anise plants, the petals have all fallen off. Then use any style of *dots or little circles* to form the seed pods on the tops of the plant.

6. *The eucalyptus twigs.* To add variety to your picture, you may want to start using colored fine-tipped markers to draw in the stems and leaves. It is not too early to think about what color they are going to be, so that you can use a marker that is complementary and darker. Draw as many as you want to work in your composition.

First form the number of stems you want by drawing thin single or double *curved lines.* You may have to start making them fit between the anise stems, so remember to jump over and keep going as you run into something. Consult the margin for three examples of ways to draw leaves, and then draw some of your own using those guidelines. Suit the complexity of the arrangement to your level. Notice that in all variations the leaves get smaller as they progress to the top of the stem.

7. *The wheat stalks.* Things may be getting fairly crowded at the vase opening by now, but you don't have to show each stem actually going into the hole. One wheat stalk by itself can look pretty lonely, so make several popping out from behind the other flowers. They have such skinny stems that it works out fine.

Draw thin *curved lines* for the stems, breaking them to allow for overlapping if necessary. On the end of each stem, draw a *pattern of dots* , then swing some *curved lines* out from the cluster.

Finishing Touches for Level 1

These instructions are for Level 1 only. Levels 2 and 3 may jump to Level 2, Adding the Kitchen Utensils, and continue adding objects to their drawings.

At this point you will not be drawing any more objects, so let's complete your composition. You can always take the liberty at the end of a project to add more. When you are

finished drawing all the objects in the still life, you will want
to ground the objects in some way, or they will look like they
are floating in air. Study Fig. 3.3 again, and notice the
different ways that placemats were incorporated for this
purpose. Draw in a mat, making the back-edge line jump
over the objects and show between them.

Finish the drawing by coloring and adding detail. Give
free reign to your color choices. After years of working with
people on color theories, I find they usually know best what
they want and are capable of working out beautiful ideas
that don't quite fit any of the theories. Refer back to the
drawing tips section to make use of ideas on flat, textured,
and shaded effects if you wish. It is highly recommended
that you do not try to color in the backgrounds of still life
with flat color. The marking pen doesn't seem to lend to
this, and you will usually end up with a streaky and distract-
ing result. Discourage a child from making a lot of zigzaggy
lines to cover up the blank paper in the background. Zigzag
lines, with white paper showing through, pull the eye right
to them and away from the subject at hand. The background
of white paper makes a lovely contrast to set off the articles
in the still life. When you later use other media, such as
watercolor or pastel, it will be possible to lay in a light
background color that won't be distracting.

After you complete this project, you can jump over to
the section Building Your Own Still Life and begin your
adventures together.

Level 2: Adding the Kitchen Utensils
(Level 3 Continue Here Also)

Refer back to your preliminary sketches and determine
where you are going to place the cup of kitchen utensils in
your drawing. You can alter your plans and make more
sketches if you wish. Level 3 needs to allow for the addition
of the abacus, along with any changes. Help children find
where they will want to add the object by talking about it
first, eyeballing the distances, and imagining how overlap-
pings will work out, depending on where they start.

The central function of the cup is to contain, so we'll
follow our formula and start with the hole. But this time
we'll draw the hole opening so that the line won't show
through the objects that go down into it. Level 2 and 3

children usually have no problem in grasping this idea. They will simply draw the front of the opening and put the back edge in after the utensils are in place. Since there is no way for me to tell how your cup of utensils may overlap with other objects, I will draw them standing alone and let you make any adjustments necessary to fit them into your composition.

Beginning

1. *Begin with the hole in the cup.* Consider some kind of overlapping this time. The drawing in the margin is an imaginary example. Get the child to show you where he intends to place things, and talk him through it. Be sure to project an imaginary image of the utensils onto the drawing, along with the cup, in order to allow enough room for them at the top.

Draw the front half of your oval circle, including the tips, by using a *curved line.* If your curve is interrupted by another object, jump over and continue on the other side. If it would be too long to continue on the other side, let the curve butt up against the object and stop.

2. *The rim.* Double the front edge of the opening of the cup by drawing another *curved line* all the way across the front.

3. *The body of the cup.* Notice that the body is a series of straight sections, which are spaced apart by rims made out of double curved lines. It is not important how many of these rims you put on your cup. Simply draw as many as you need to fit the size and placement of your particular cup.

Draw a *straight line* down each side of the cup to where you want your first rim. Then make a *curved line* across the front of the cup. When you double the rim by adding another *curved line,* let it bulge out each side a little to form the extended appearance. Repeat this same process for the number of sections you choose. Then make a final *curved line* to form the bottom of the cup.

4. *The foot.* Draw two *inward curved lines* to form the sides of the foot and another *curved line* to finish off the bottom of the cup. If you have placed the cup behind another object, then you want the cup to end above the

bottom of that object, in order for it to look as if it's farther back in your picture.

As you add utensils into your cup, you will notice that you and the children will all be confronted with different instances of overlapping. Due to the differences in placement and sizes of objects, some of you may already have flower, stems, or the handle of the pot to deal with as you sandwich in the utensils. In order to help you know that it will all work for you, I don't want to make the example in any one form. So with each instruction, I will change the arrangement of articles. This will give you many examples to observe and will help you develop solutions to the arrangements you and the children have arrived at.

5. *The fork.* You can place the fork in any part of the cup and at any angle that works for your arrangement of objects. If you are near the top of the paper, you may want to make a shorter handle to allow more room for the prongs of the fork. We will draw the handle first, so that it will fit into the cup properly, and then add the fork on the top.

Make a *guideline dot* where you want the prongs to begin. Draw a *straight line* from that point down to the front rim of the cup. Use another *straight line* to double the handle, but notice that it is narrower at the top than the bottom. Draw a *curved line* from the handle up to the point of the prong on each side of the fork. Then make a long *U-shaped curve* that starts at one point of the prong, dips down to the middle of the fork, and then rises to form the other pointed prong.

6. *The basting brush.* There are endless ways to draw the spiraling handle of the brush. Examples a, b, and c in the margin give you some ideas to play with. If things are getting crowded, don't hesitate to run the handle behind other objects.

Draw a *dotted straight line* this time to place the handle in the cup. The dotted line allows for individual interpretations of the spiral effect on top of it. Now double the handle with another *dotted straight line,* but keep it skinny, and add your way of creating the spiraling. Make a *U-shaped curve* to form the pocket for the brushes to fit into, and run a *straight line* across the top of it to make the edge. Make the edge double by two little *C curves* at the ends and another

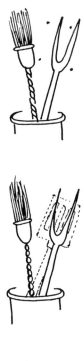

straight line across the top. Then draw a lot of *thin straight or curved lines* for the hairs of the brushes.

7. *The spatula.* Things are probably getting quite crowded by now, but challenge yourself to get everything in there. We will do the handle first again, in order to fit it into the cup properly. But before you draw the angle of the handle, it will help to project the image of the spatula turner into the overlapping problems. Then you can make a handle that will facilitate the direction of the turner. Have a child make a couple of guideline dots if she needs to.

Draw the little square on the end of the handle first with four *straight lines* converging at *angle corners.* Draw a *straight line* to form the bottom edge of the turner. Notice that the top edge is shorter, jump up to where you want it to be, and form it by drawing another *straight line.* Then make the sides of the turner by drawing two more *straight lines.* Make as many holes as you want in the turner with *long ovals or rectangles,* depending on what fits your style.

8. *Back edge of the hole in the cup.* Complete the oval circle shape of the hole by making *short straight or curved lines* between the utensils in the cup along the back edge.

Finishing Touches for Level 2

These instructions are for Level 2 only. Those who are at Level 3 may jump to Level 3, Adding the Abacus, and complete the drawing.

You will not be instructed to add any more objects to the drawing, but if you have something else you want to place in it yourself, take the liberty to do so now. If you feel real confident after this experience, you may be ready to go on to Level 3 and add the abacus.

After you have all the objects that you want in your still life, notice how they seem to kind of float on the paper in midair. In order to ground the objects and finish off the picture, we will add a mat for them to sit on. Go back to Fig. 3.3 and study all the different ways this can be accomplished. Use your imagination and draw in the outline of the mat you want. Don't worry if some of it runs off the paper; this can have a lovely look. Jump over all the objects as you draw the back edge of the mat, so that it shows between

them. Consider original ways to decorate the mat and finish off the edge of it.

As you color and shade your drawing, free yourself as much as possible regarding detail design. Encourage the children to try out ideas on their test paper, and really put thought into your choices. It is recommended that you leave the white paper as a background. Marker ink does not work well in still life backgrounds; it becomes streaky and can cause a distraction to the beauty of the overall drawing. Especially discourage the tendency to make zigzag lines to fill up spaces. These create a great distraction to the eyes.

When you have finished your project, jump over to the section Building Still Life Arrangements, and begin the process of setting up future drawings together.

Level 3: Adding the Abacus

The reason I chose the abacus for Level 3 is because this object requires a high degree of concentration and patience from the artist. In this way, children can learn to enjoy the time-consuming aspect of drawing fine detail, instead of feeling it is a drudgery. Drawing takes an appreciation for patience and discipline that most of our children lack. If they try to rush through drawing this object without that appreciation, it will show. Chances are their abacus will be quite crooked, the rows of beads will be jumbled, and it may have a nonfunctioning appearance. As children learn to meditate on the task and have patience and focus, parents tell me they transfer this attitude to other aspects of their lives. We can certainly all gain from this type of relaxed concentration in our busy and pressured lives.

Refer back to your preliminary sketches and decide where you want your abacus to fit in the drawing. If you have made changes during the drawing and want to alter your plan, take the time to make some more sketches before you decide. Think of the size and direction that will complement your drawing, and project the image of it into your composition.

This object has such a uniform design, there is no central point in its construction. Its outer edge is actually the characteristic that is most basic to its shape and how it will fit into your drawing, so we will start with forming its outer

edge. Most of you will have only a portion of it peeking out from behind, unless your arrangement is highly unusual. So you and the children might start by putting a guideline dot at each place one of the corners will show. Notice that the corners of the abacus are slightly rounded when you deal with joining them to the straight edges.

Beginning

1. *Begin with the outside edge.* Make very short *open curves* at each corner of the abacus that will be showing in the drawing. Draw *straight lines* from one corner to another, with breaks in them wherever something overlaps. If this entails a lot of objects and overlappings, eyeball the line as a whole first, then use your trick of "stop, jump over, and keep going."

2. *The frame.* You have drawn the outer edge of the frame. Now you need to draw the inside edge, the brackets, and the main bar across the middle. Notice that the bar that divides the two sections of beads is above the middle, and that there are two rows of beads on the top and five rows on the bottom. This is one of those lessons in which you can add a little history and explain to children what the abacus is and how the beads are used to calculate mathematics.

Place a *guideline dot* in each one of the corners again, on the inside edge of the rim. The corners of the inside rim are not rounded and you can use *straight lines* to join them together. Make the rim wide enough to allow for the bracket to fit in between the edges. Divide the space left inside the abacus with the mid bar of the frame, leaving more room in the bottom section than the top. Draw two *straight lines* across that create the same width as the outside rim of the frame. Study the shape of the bracket and add one to your drawing that will fit the size of your frame. It does not have to have the exact same design as the one in the example, but since its function is to hold the two pieces of frame together it needs to make a T shape over the spot where they join.

3. *The counting beads.* It is not necessary to make all 13 rows of beads, but in order to keep the character of the abacus it is important to make 5 beads in the bottom rows and 2 in the top. Since you don't want the sticks to show through the beads, we will draw the beads first.

Use *flattened circles* to draw in the beads, and then *double straight lines* to form the sticks that hold the beads.

It is not necessary to make every bead perfect, but you will have to concentrate more than usual just to get them similar. So if you see a child rapidly making circles to "get it over with," don't be surprised if he is unsatisfied with his results. Encourage your children to build the patience and attention span necessary for developing themselves as artists. As an added reward they will also be building the kind of concentration and patience necessary for achievement in other areas of their lives.

Finishing Touches for Level 3

After you have drawn in the general shape of all the objects, you will notice them floating around on the white paper as if they were in air. Placing a line across for a tabletop can be a bit simplistic, so let's make a fancy mat to contain and ground the objects. Refer back to the student exhibition in Fig. 3.3 and get some ideas from the different mats you see in the drawings. Then draw the outer edge of your mat into your composition, being sure to go between all your objects on the back edge. There's no problem if it runs off the paper at some point; this can actually cause an interesting effect.

Some real thought and planning should go into your color and finishing touches. Any drawing that takes a lot of energy and focus for its general outline needs an equal amount of consideration and development for the detail completion. If the child is tired, you might put the drawing up to finish another time.

When you are ready to continue, talk about ideas and use your scratch paper to develop beautiful color blendings. Consider uses of thick and thin line, shading, flat color, and texture. It is recommended that you do not try to color in your background. Going in between all the flowers and objects after the fact causes a rather blotchy and distracting look with the streakiness of markers. Other media, such as water color or pastels, are more appropriate. In general, white paper for a background is most effective, but you can also try light-colored papers for still life. Of course, discourage any zigzaggy lines to "fill up" leftover spaces. This causes a real visual distraction.

You have really learned all you need in this lesson to go on to creating still life arrangements for yourselves. Whenever you are ready, read the next section, and look forward to a truly limitless source of challenging projects.

Building Still Life Arrangements

With this lesson completed, you can now construct projects of your own. You will follow the same steps for them as you did in this lesson, so let the experience you had with it guide you in your choosing and arranging. For example, if a child had trouble overlapping more than one object in the lesson, then you know to stick with a couple of objects for awhile; or if a child had difficulty with the complexity of the teapot, then you know to pick some objects that are even simpler. Most important is to develop that attitude of it being part of the process to explore and learn together. The minute you set performance expectations and want to produce framable products, the fun can go out the window.

Open yourself to your whims and your fancies. Any inanimate object can be used. One of my greatest lessons was inspired by a six-year-old who wanted to draw the bottom of her shoe. Once we stopped laughing and listened, it turned out that the form of Miss Piggy was depicted in raised images on the sole of her tennis shoes. She took them off. Some students drew Miss Piggy, while others drew the tennis shoes themselves. After I witnessed the incredible results I listened more attentively to the children's suggestions. Consider everything in view as a possibility. A race car's exhaust pipe, cut up, mounted, and filled with dried flowers, became a wonderful subject, as Fig. 3.7 reveals. A Garuda statue from Bali, Fig. 3.8, presented an exciting challenge in detail and line.

As you choose and arrange objects for still life projects, keep in mind some general suggestions:

- Consider all objects as possibilities.

- Consider parts of any object as usable in some way, even if only a small section, an aspect of the design, or the particular color or texture of it.

- Imagine objects in combination with other objects, or abstracted in a design with each other.

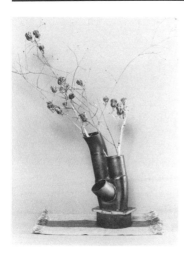

Devon Holiday–age nine

Christina Hild–age ten

FIG. 3.7. Consider everything as a possibility. A race car exhaust pipe filled with dried flowers becomes a beautiful subject.

Jenny Woods–age eight

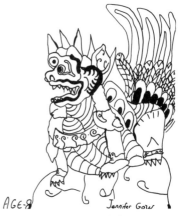

Jennifer Gow–age eight

FIG. 3.8. A Garuda statue from Bali becomes a challenge in exciting thick and thin line.

- Explore where you live, both indoors and out, and look at everything as a possibility for drawing.

- Collect the possibilities that interested you the most, whether you are sure they go together or not, and take them to your still life table. If you have trouble choosing, you can always save alternate choices for later projects.

- Play around with the arrangement. You may have to make a few exchanges in order to come up with a combination you like. Remember, you don't have to put them into your picture in any particular way, and you have the freedom to abstract, overlap, change, and add on as you go along.

- Choose at least two to start with. Or perhaps use one object, such as an animal statue or toy model, as a center of interest, and then make up an entire background scene from your imagination. You could try drawing a toy truck into a scene with farm animals and a barn, for instance, or into a construction site with office buildings in the background.

The student exhibit in Fig. 3.9 displays some typical still life arrangements. Here are some additional suggestions for traditional objects you can use:

- Teapots, canisters, and similar kitchen utensils.
- Bowls, cups, glasses, bottles, and jars.
- Plates, trays, or similar flat objects.
- Vases, flowers, and potted plants.
- Fruits, vegetables, and foodstuffs.
- Baskets, cornucopias, weavings, placemats.
- Candle holders, candles, knickknacks, and statues.
- Drapes, textured or patterned clothes, and scarves.

As less typical objects occur to you, remember to consider things that are important to the person who will be drawing the objects. The student exhibit in Fig. 3.10 offers

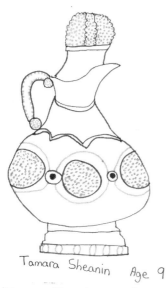

Tamara Sheanin

Age 9

Tamara Sheanin–age nine

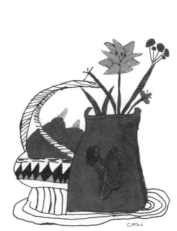

Carlos Zapata–age seven

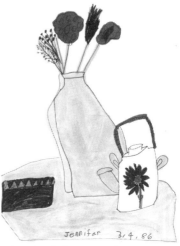

Jennifer 3.4.86

Jennifer Heim–age six

FIG. 3.9. Typical still life subjects.

Kareen Vilnai–age seven

Kristen Todd–age fourteen

Will Ortiz–adult

FIG. 3.10. Unusual still life subjects.

some unusual and individual subjects that encourage creative results. Here are some more:

- Sports equipment: a tennis shoe, roller skates, a hockey helmet and stick.

- Desk and school items: a clown-shaped lamp, a lunch box, cans of pencils, a typewriter, books.

- Toys: stuffed animals, dolls, dollhouse, trucks, statues of favorite characters, knickknacks.

- Personal items: a fish bowl and the package of fish food, a musical instrument and the sheet-music stand, a favorite modern statue in the living room.

Needless to say, any object, texture, mood, or shape can inspire a rewarding and successful drawing experience. The trick is to keep an open mind, teach yourself what you like, and enjoy exploring the process that each project leads you through. Remember, as an artist you might not like many of the finished products, but they all serve as growing experiences toward the ones that give you a rush of satisfaction and appreciation.

In this lesson you have learned to incorporate real objects into your drawing world. Now you have a formula for choosing projects from graphics and inanimate objects and rendering them into realistic drawings. You have learned how to use a drawing process that involves training your eyes to see the edges of everything and to duplicate their shapes on paper. You are now well on your way to handling any subject that you wish.

Many students come to me from drawing classes that have started with shading and that teach drawing objects by their volume. In other words, they are expected to capture the volume of the objects and the background by duplicating the subtle gradations of light patterns and shadings, without using any lines to denote the contour edges of the objects. These students tell me that they have found that the more the teacher asked them to "see" the shadings, and not represent shape by contour line, the more lost they felt. It has been my experience that once children or beginners are allowed to experience contour drawing first, they really

have no difficulty adding volume and shading to their repertoire later. If you take the approach that is offered in the next lesson, I expect you will follow suit.

You will learn the process I call volume drawing in the next lesson. Instead of defining objects by creating the contour edges, you will learn to see the difference between positive and negative space and block in contrasting areas of light and dark to define objects. Some very young children may need to wait a bit to take in this added dimension, but it all comes at the right time, and there is never any need to rush it. After some exposure to volume drawing and some practice with live subjects and landscape, you will have covered a full range of experiences and truly be able to tackle any combination of drawing styles.

Volume drawing can provide a different kind of expression. It is the road toward drawing with the subtleties of other media, such as watercolor and pastels, as well as the excitement of live models, such as people and animals. And if you are interested in oil painting, it is a good background for that transition as well. So I encourage you to approach the subject with an open mind and a lack of concern.

After your experiences with contour drawing, the transition to volume drawing should come easily. Follow the same advice and take pleasure in the process. I encourage you to eventually blend contour drawing and volume drawing into a synthesis and style of your own.

Volume Drawing

So far you've been doing contour drawing, which is looking at the edges of an object and creating lines on the paper to represent those edges. You were also indicating volume as you finished up your pictures with shading and texture. In this lesson you will draw by simply blocking in the volume, without forming an outline around the edge of the shape. Drawing the edges of things first gave you an understanding of shape that will help you in learning this new technique.

In volume drawing, the contrast between areas of light and dark or differences in texture form the edges of objects. This technique can have a more sophisticated look and lends itself to subtle gradations of shadings and a more realistic appearance to objects. For this reason, it is essential to use volume drawing principles in order to draw such things in the environment as landscapes, animals, and people. The student drawings in Fig. 4.1 demonstrate this technique applied to many different types of subjects—flowers, still life, landscapes, and people.

In this lesson we will study the characteristics of positive and negative space by drawing some tiger lilies. Since flowers do not present problems in perspective, things will be kept

simple. In the next lesson you will be able to use this technique with more complex subjects—life drawing, faces, and landscapes.

Beginners often lack confidence when it comes to this technique, so don't be surprised at a few groans and furrowed brows. We won't teach the lesson at different levels, so that everyone can start with the basic steps. Encourage a balance between relaxation and concentration with children, if they have difficulty. Some four- to six-year-olds may not be quite ready. Continue with contour drawing projects, and reintroduce the idea every two to three months until they find their way. There is no "right" age to be "ready," so there's no hurry.

To accomplish volume drawing, it becomes important to develop a visual awareness of positive and negative space. You have been dealing with these concepts spontaneously as you learned to eyeball how shapes related to each other on the page. Let's consider what the terms mean.

The Positive and the Negative of Space

The fact that the terms *positive space* and *negative space* don't represent the observer's experience seems to confuse people. Everyone can understand that the term *positive* relates to putting (positing) lines and shapes on the paper, but as soon as the word *space* is added, they falter: "How can a mark or shape on a paper be represented by the word *space,* when space is empty?"

The concept *negative space* seems to elude us even more. People resist being told to pay attention to the shape of *negative space,* when they believe that negative space represents *nothingness.* So without having to argue the age-old problem of nothingness versus somethingness, let's find a way to make them equal in consideration. All spaces are equally full when I think of them as containing different densities of matter. Some matter is dense enough to be seen with the human eye, and some so fine that it can't be seen. But just because we can't see what is there doesn't mean it is empty or should be disregarded. Scientists use their instruments to record some of the various types of matter to be found in so-called empty space. I will use the term *positive space* for space that is occupied with matter dense enough

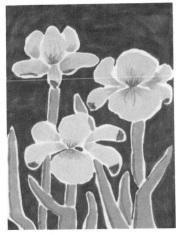

Scott Lessin–age nine

Ray Gottlieb–adult

Hazel Kight–age nine

Jennifer Knight–age four

Ashley Dearborn–age ten

Jeff Rennell–adult

FIG. 4.1. Student exhibition of volume drawing.

to be seen with the human eye, and I will use the term *negative space* for space that is occupied with matter so fine that it cannot be seen with the human eye. This may seem trivial and unrelated to the subject of drawing, but it isn't. The person who thinks of air as nothingness disregards its shape. You need to regard the shape of the spaces between objects in order to perceive the whole picture and draw the objects in proportion.

Treating positive and negative space as equal visual components is one of the keys to developing your ability to draw. By drawing the shapes of the spaces between objects (negative space), as well as the objects themselves (positive space), you become more accurate and can solve proportion and composition problems. We'll do some warm-ups that will train your eyes to observe the differences between negative and positive space.

Warming Up to Positive and Negative

The following exercises are designed to help you get used to seeing positive space and negative space as two equal aspects of the same field. Once you understand the process, you and the children can invent your own exercises to train your eyes.

1. Study the example in Fig. 4.2 and notice how it is the same design on both sides, with the black and white reversed in the two images. For the sake of these exercises, we will call the white portion of the design the negative space and the black portion of the design the positive space.

2. Use a black broad-tipped marker and your photocopies of the exercises shown in Figs. 4.3–4.6.

3. Take the first exercise, Fig. 4.3, and notice the shapes of the white negative space. In order to draw this negative space, take the black marker and copy the size and porportions of those white shapes into the empty box at the right. You will have duplicated the white negative spaces in black ink and created a reversed pattern like the one shown in the example.

FIG. 4.2. REVERSED IMAGES. Notice how the positive and negative space reverses in the two images. For the purpose of these exercises we will consider the white portion the positive space and the black portion the negative space.

FIG. 4.3. Positive and negative space exercise.

4. As you draw with the black marker you can make a general outline of the shape you are forming, but notice as you color in the shape it will not retain an outlined edge. In fact, you can make adjustments to the edges and change the shape once you start coloring it in. This is one of the advantages of volume drawing. It means that you have not boxed yourself in with an outline edge and can continue to shift the shape of things by altering the sizes. The severity of black and white doesn't lend itself to this as easily as the shadings of color that you will use in drawing projects. It is the training of the eye that is important, not a perfect likeness of the example. So if the first attempts are a bit off, just try again and don't suffer over it.

5. Follow the same process for the next two exercises, as shown in Figs. 4.4 and 4.5. You should end up with a reversed design image, the man with the hat being white with a black background, and a white tree with a black background.

Drawing negative space this way makes you aware of its presence and importance. You can make up this kind of exercise and use it like puzzle games with children in moments between drawing sessions. You can take three-dimensional objects, set them against a white background, and play the same game. The photograph of the bentwood chair and its negative-space drawing in Fig. 4.6 is an example of how this is done.

The simplicity of the black and white causes a condition in which it is easy to see the positive and negative. It helps the beginner to be visually aware, but it is too stark a result to be used in drawing itself. Life is never as simple as black and white. We need to expand our awareness, use gradations of shading, and develop a more realistic interpretation of what we want to draw. The next exercise will explore this by using gradations of gray between the black and white.

Warming Up to Shades of Gray

This time you will be copying the patterns in the shading exercise shown in Fig. 4.7 instead of reversing images.

FIG. 4.4. Ending up with a white figure.

FIG. 4.5. Ending up with a white tree.

1. Use a black and two shades of gray broad-tipped markers, along with your photocopy of the Fig. 4.7 exercise.

2. Study the exercise and notice how there are now four shades of light to dark instead of two. The white paper represents the negative space and the gray and black represent the positive spaces.

3. Use the blank square to copy the images of the sample. Start with the lightest gray and block in the shapes that you see. You may find that you draw the edges of the shape a bit with the marker as you block in the color, but you are not actually drawing an edge. As you shift the size and shape with the broad tip you will end up with flat areas of color with no outline edge. Notice how the shape you are drawing relates to the shapes of the white negative space, as well as the shapes of the dark gray and black positive space.

4. Now copy the shapes of the darker gray in the same manner, watching how the shapes you are blocking in relate to the white negative space and the light gray and black positive spaces. Notice that you can alter the edges of the light gray, if you want to, by overlaying the darker gray on top. You now can experience the advantage of volume drawing. If you start with the lightest color, you can continue to alter shapes as you overlay darker and darker colors on top of each other. This will be true in using

**FIG. 4.6. NEGATIVE SPACE DRAW-
ING OF A BENTWOOD CHAIR.** You
can place objects against a light
background and make studies of the
negative spaces.

FIG. 4.7. Shading exercise.

FIG. 4.8.

FIG. 4.9. Shading exercises.

watercolors, pastels, oil pastels, and eventually oil paint. With ink and watercolor you can never reverse the process and overlay light on top of dark, but with pastels and paint you have the added advantage of being able to overlay colors in either direction.

5. Lay in the shapes of the black, noticing that you can alter the shapes of the grays even further if you wish.

6. Follow the same process to complete the other two shading exercises, in Figs. 4.8 and 4.9.

As usual, don't fret if you end up with inexact replicas of the samples. It is the process of training your eyes that is important, not the finished product. Encourage children to be as accurate as possible without causing stress. When you use this technique in drawing it will not be important to accomplish exact duplication. You will need only to accomplish similar structure of shape and gradations of shading to make a recognizable drawing of an object. This will allow the freedom for individual interpretation of feeling and style.

You might want to refer to other drawing books for ideas on how to shade and create volume in your drawings. Since most of them do a good job of covering the basics, I felt it was not important to repeat the information in the same format. Nonetheless, I do want to share a few tricks I use to help young children begin to feel comfortable with the complexities of shading. What is important is that you begin to see these gradations of shading in color as they appear in the real world. The shadings follow consistent patterns that come from the source of electric lights or the sun. If you don't follow these natural patterns, your drawing can look "off." If you simplify things and control the light source for the beginner, it can speed up the process of learning.

Warming Up to the Light and Dark

The eventual goal is to be able to look at a scene in the environment and duplicate the gradations of light and dark shadings that you see into your drawing. It is usually too big a leap to expect beginners to deal immediately with the complexities of shadings in their environment. Since multiple light-sources can cause conflicting shading patterns, the

problems can become overwhelming to a beginner. One way to break in slowly is to control your light sources. Here are some suggestions for drawing from the environment, from two-dimensional graphics, or from your imagination. First we will deal with the three-dimensional world of our environment.

OUTDOORS

The natural light source of the sun is your ideal condition. When you are outdoors you will notice that everything facing the sun is in the lightest shades, everything inside of holes or away from the sun is in the darkest shades, and all the areas in between are gradations from the lightest near the sun to the darkest away from the sun. The main way you can control conditions outdoors is to pick a view that makes the most of the light. Best is to sit in a position with the sun over the back of either shoulder; the objects in the scene will have a consistent pattern of all being light on the same side and dark on the other, as in Fig. 4.10. Sitting with the sun directly behind you, as in Fig. 4.11, can cause more problems for the beginner, since the middle of an object will be light, and variations of shading will appear on either side of the same object. If you sit facing the sun, as in Fig. 4.12, you will cause a strain on your eyes and have to deal with silhouette patterns.

INDOOR LIGHT AT NIGHT

Since the sun is down and no natural light is inside, you will be dealing with electric light. If you shine one bright light onto your subject you can create the same conditions as the one light source that comes from the sun. Any other lights in the room that are close enough to throw shadows need to be turned off. Place the main light to the side of the subject in order to create the half light-side and half dark-side view. Avoid shining the light directly at or directly behind the subject.

INDOOR LIGHT IN THE DAYTIME

This condition is the most difficult to simplify. Natural light comes in unnatural patterns through windows and bounces off mirrors, while electric lights confuse the issue even more. It actually helps to diffuse the natural light by

FIG. 4.10. For the best view of shading outdoors, sit in a position with the light source over one shoulder, providing objects with consistent patterns of light on one side and dark on the other.

FIG. 4.11. The light directly behind can cause confusing light patterns, with variations of shading appearing on both sides of the object.

FIG. 4.12. Facing the light source can cause eye strain and eliminate a view of shading due to silhouettes.

closing curtains, turning off all conflicting electric lights, and shining one single electric light onto the subject. Place the light in the same manner as above.

When you are drawing from graphics or your imagination, you need to create an imaginary light source. Here is a little trick that even children as young as four can grasp:

1. Place your drawing on top of scratch paper that is larger than your drawing paper.

2. Decide which side of the objects in the drawing you want to be the "light sides."

3. Draw a sun on the scratch paper in a location that will cast the rays of light onto that side of the drawing, as in Fig. 4.13. Use your imaginary sun as a guide. It will remind the child that the surfaces of objects facing the sun will be the light sides, and the surfaces at the other side of the objects will be the dark sides. The child will quickly understand to gradate the colors in between from light to dark. This is the procedure we will use for our tiger lily project.

Levels 1, 2, and 3: Tiger Lilies

In the drawing of the tiger lilies in Fig. 4.14, the negative space (or the background) is a plain light color, while the positive spaces (or the flowers) are portrayed in many shadings of gradated color. You will be using several shades of colors to draw the flowers, while you observe the negative shapes of the background to help you form the correct proportions. You will draw the flowers first, leaving the background white, and then fill in the background.

In the prior projects, it was not important to draw objects in any particular size, combination, or placement. This time, in order to learn how to duplicate gradations of shading and pay attention to the sizes of positive and negative spaces, we are going to copy the photograph of the tiger lilies as accurately as possible. Expecting exact perfection is not necessary; just get as close as you can.

We will do the tiger lily project in the colored markers. Since you will not be drawing outlined edges, you will use

the broad-tipped markers and complete the coloring of objects as you draw them. You are faced with the added challenge of having to translate from the black-and-white photograph into color. But this will actually encourage children to use original color schemes, instead of being tempted to copy one from the book. As you try to duplicate the shadings of color in your world, it is very valuable to be able to translate in this manner back to the black and white. Imagining what you see in shades of gray simplifies the complex world of color. This will be explained more fully in the project, as you are told to compare the lightest gray in the picture with the lightest color you will be using.

Warming Up

With volume drawing, you need deep concentration, so your predrawing preparations are essential. Do your body and eye relaxations and some type of warm-up exercise from Lesson 1.

Planning

ARRANGE YOUR SAMPLE

Place the photocopy you made of the tiger lilies in Fig. 4.14 in front of you at the drawing table.

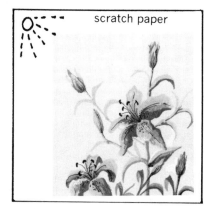

CHOOSE THE PAPER AND THE SUPPLIES

Since you are going to try and make a duplicate of the positive and negative spaces, it is recommended that you use the same size paper as your photocopy of the tiger lilies. If you want a larger rendition, you could have the photocopy enlarged. Place your drawing paper on a larger piece of scratch paper and draw in your imaginary sun to guide you regarding your light source.

FIG. 4.13. Draw an imaginary light source on a piece of scratch paper, to remind the young child which side will be light and which will be dark.

This time you are going to choose the color scheme before you begin the drawing. You will be using the broad-tipped markers only, except for the few fine-line details on the stamen and dots of the flowers. First, decide on the color you want the tiger lilies to be. Tiger lilies are white, red, yellow, or orange, but you can choose other colors if you want. I have seen some beautiful renderings in shades of violet, blue, and even brown or gray. Now look at the black-and-white version of the sample and notice that there are

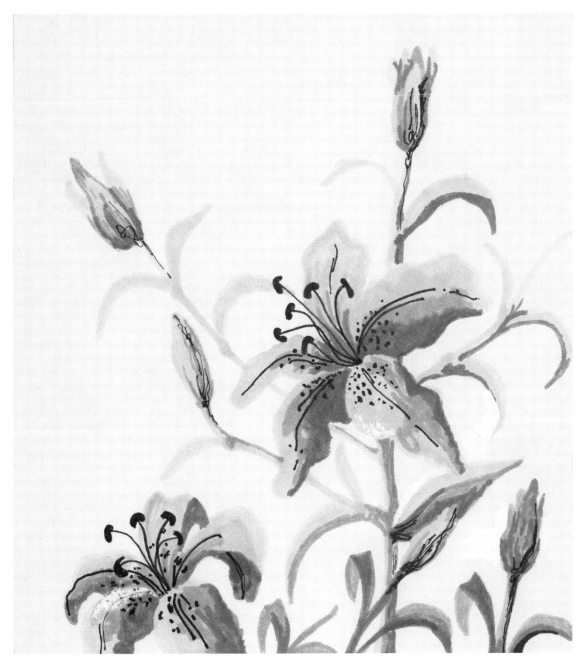

FIG. 4.14. Tiger lilies.

about three shades of gray in the petals of the flowers. Pick a light, medium, and dark shade of the color you chose for your flower to represent those three shades of gray. Pick several shades of green for your stems and leaves and the color (or shades of colors) that you want for your background. Then pick a dark-colored fine-tipped marker for the stamen and detail lines and dots of your flowers. Test the colors that you pick for blending and compatibility on a swatch of the same paper. You can change as you go along, but this will orient you enough to get you started.

Imagine Your Subject and the Composition

Since you will duplicate the same composition, notice the placement, size, and arrangement of all the flowers, buds, leaves, and stems. Project the image of that composition onto your blank drawing paper. We will follow the "where to start" formula and begin with the center of the main flower in the drawing.

Beginning

Start with the center of the large open flower that takes prominence. It will not be necessary to give step-by-step visual instructions this time, since you already know how to copy shapes. If you follow the verbal instructions and take time to concentrate on the relationships of the positive shapes to the negative spaces, you should be able to duplicate the shadings in the drawing.

1. Have the child point to where he plans to start the center of the large flower. Take the dark-colored fine-tipped marker that he chose for the stamens and have him place a dot in that place.

2. Draw the stamens coming out of the central dot, then form the kidney-shaped dots on the ends of them.

3. Take the lightest broad-tipped marker that you intend to use for the petals, and block in the entire shape of the whole flower. Once you have the whole shape of the flower in the lightest color, you can go back and overlay the darker shadings on top of it.

4. Take the darkest marker; noticing the darkest shade of gray in the photograph, duplicate those dark areas on your petals. Notice how they fall in the undersides of petals or the surfaces that are away from the rays of your sun source.

5. Use the medium shade of your petal color to block in the shapes of the shading between the dark and the light sides.

6. Take your dark-colored fine-tipped pen and draw in the detail of the central lines of the petals and the dots. It isn't necessary to duplicate the same pattern and numbers of dots.

Finishing Touches

As you follow the steps to completion, notice that you continue to block in an object with the lightest color, establish the darkest areas, and then complete the shadings in between.

1. Follow the same process as above for the other flowers in the drawing.

2. Take the lightest flower color and block in the general shape of the buds. Overlay the darkest shade and the medium shade in between.

3. Take the lightest color you intend to use on your stems, and block in the entire shape of all the stems.

4. Shade the dark side of the stems with a darker green. Continue to notice how the dark side is away from your sun source.

5. The leaves on any one plant are never all the same color, so use as much variety as you can. Block in the whole shape of the leaves, with the lightest greens you intend to use.

6. Shade the dark sides of the leaves with the darkest greens, and fill in between the light and dark side with medium shades. The black-and-white photograph does not allow for a differentiation

between shades of green, so this is where your judgment comes in to create a variety of leaves. As long as you make the side toward your sun source the light side and gradate the shadings toward the dark side, you will maintain the proper pattern.

7. Now you can lay in the background. Choose any color, and use either one flat shade or else several different shades. First, go around all the edges of the flowers and the edges of the paper; then fill in the negative spaces between them.

That's it. You have added one of the most valuable abilities to your artistic repertoire. This new technique will open multiple doors, beyond which lie endless projects to explore. Let's put some thought into how you might choose them.

Choosing Other Projects

You can render any drawing with this technique, but some projects lend themselves to it more than others. Begin by reconsidering the subjects that you think may be too difficult to draw. In most cases you will discover it is because of the lack of contour lines around the edges. Now that you understand volume drawing, you can handle it more easily than you thought. Photographs or paintings are well suited for inspiration. Of course, your own three-dimensional environment does not have outlines around the edges of things and will endlessly provide you with subjects.

With your new ability to use shading and produce volume in your drawings, a much wider range of possibilities is open to you. You can choose to render a drawing with either contour lines or volume shading, or a combination of the two. After the next lesson, you will have the added potential of using these styles with many more subjects and a variety of media.

Keep exposing your child to projects that lend themselves to this technique. Encourage her to be patient and to be willing to experiment. Volume drawing is a road that leads to painting, so once you feel comfortable with it you will be ready to tackle a canvas.

Widening Your Horizons

Now you are ready for some drawing projects that are considered more advanced. This lesson will offer tips on other media, concepts on design principles, and some guidance in figure drawing, portraiture, and landscape. The lesson is meant to give you some general principles to follow, rather than specific step-by-step drawing instruction. You will follow the same warm-up, planning, observation of elements, rendering styles, correction techniques, and finishing touches that you have used in all the preceding lessons.

As you explore the drawing of designs, people, environments, and nature, what you've learned about one area can be applied to the others. Go through this lesson doing one project for each subject, then go back and alternate between them. Be brave and try it all. On those of my class days when there is free choice of media or project, the 10-year-olds who have been around for five or six years have started opting for challenges instead of the things they know they can be successful at. Last week, a student announced with no hesitation that she didn't like the way she drew faces, went and got a mirror, suffered through 30 minutes, didn't give up, and then slowly began to smile as she said she really liked

what she was doing. The secret is to drop that silent critic and get involved in the learning.

If you combine the contour line and volume drawing styles from Lessons 1 through 4, continue to use the markers. But if you are feeling confident about your drawing ability, you may want to begin experiencing other media. While felt-tip markers are perfect for young children and beginners, they can be limiting when you want to portray the subtleties of life drawing and landscapes. This lesson's first section offers ideas for using different kinds of media. If your child is not quite confident yet, he can use the markers for a little while longer. But go ahead and try the new materials yourself, and he will learn along with you.

Media Tips

We do not propose here to give you complete information about the basic composition, nature, and uses of other media. This subject is quite extensive and is covered in a thorough and similar manner in many good drawing books. It will help if you expose yourself to some of these books before trying out your new materials. *Drawing and Sketching,* by Stan Smith, and *Drawing For Fun,* by Alfred Daniels, are a couple of good sources.

Nonetheless, some additional information on introducing these new drawing materials to beginners may be helpful, along with some tips on purchasing them with a minimal investment. Following are some of the exciting new media you might consider. They are listed from the simple to the more complex. Introducing them to young children in the order they appear here will enable them to integrate the experiences.

Conté Crayon

This refined type of compressed chalk comes from France and is available in wooden drawing pencils and little square sticks, as Fig. 5.1 shows. I prefer it to charcoal, since it doesn't smear as much and comes in a wider range of colors—black and white and several brownish earth tones. I recommend the sticks over the pencils because they are softer and easier to blend. The sticks come in three different softnesses, and it is best to get the softest you can. An entire

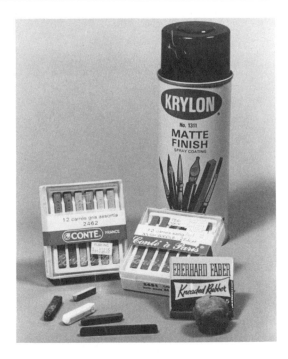

FIG. 5.1. Conté crayon and kneaded eraser.

box is quite expensive, but most stores allow you to buy them by the stick. Two sticks of each color are plenty for both of you to get started with. You will also want to buy a pad of variegated shades of charcoal paper, a pad of inexpensive newsprint paper, and some spray fixitive, which will keep the finished drawing from further smearing and give it a protective coating. As you begin using these new media, you will find most helpful the appropriate types of erasers that accompany them. The loose and flexible drawing with the soft Conté calls for adjustments and control of smearing with an eraser. No other eraser works as well with Conté as the Eberhard Faber kneaded rubber eraser. Get a couple of the large-sized ones.

Conté is an excellent material with which to introduce beginners to the more sophisticated drawing techniques. The still life in Fig. 5.2 and the life drawing in Fig. 5.3 attest to the beautiful effects that can be achieved. Even with its smearing problems and difficulty in erasing, it is the easiest of all the materials to capture the subtleties of life drawing, still life, and portraits. Following are some tips on how to use this material with the young artist.

Loreal Chan–age eight

FIG. 5.2. Conté still life.

Alice Fine–adult

FIG. 5.3. Conté life drawing.

- Take the kneaded eraser and stretch it out, wad it up, and stretch it out again. This takes advantage of its self-cleaning feature. Shape it into different kinds of points to discover how you can best erase marks.

- Play with the Conté on the newsprint paper and explore how it works. Learn to draw with your hand raised off the paper, to lessen the smearing problems. Use the corner, the flat end, and the side under various amounts of pressure to explore the range of shading possibilities. Notice how difficult it is to erase the darker marks, and take that as a warning to draw lightly in the beginning stages of your drawings.

- As smearing begins, here is one of the most valuable tips I can share: Take the kneaded eraser and *erase the Conté off your hand.* Then erase the smearing on the paper as you go along. It makes things worse to wash your hands, because any wetness fixes the smearing to the paper permanently. Also, get used to turning the drawing so that your hand is not on top of the drawn portions. You can also lay a piece of scratch paper on the drawing under your hand, to protect the completed sections until you are done.

- As you experiment with shading, don't hesitate to use your finger and your eraser in any manner that creates a desired effect. Use the eraser to form a lighter highlight in the shading. Or make a thick swatch of Conté on a separate paper to dip your finger into and use for shading. Don't worry if the sticks break; that's part of the process. Learn how to make the most of the little pieces.

- When finished, spray the entire paper with fixitive. You won't be able to erase anymore, but it will still be possible to add something, if you want. Then spray it again.

Try this medium with the contour line and the volume drawing techniques that you learned in Lessons 3 and 4 as well as the projects in this lesson.

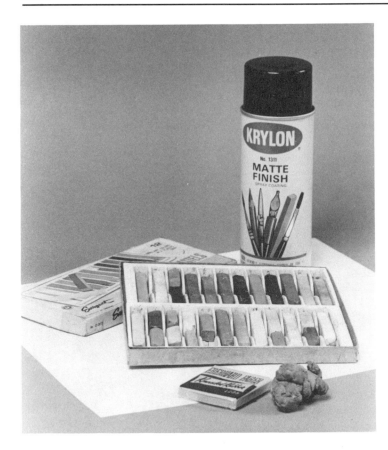

FIG. 5.4. Pastels, kneaded eraser, fixitive.

CHALK PASTELS

Pastels are used in the same manner as the Conté crayon, but they come in a full range of colors. The type that you can buy in separate sticks is usually more expensive than the sets you buy in boxes, so compare the two. You will use the same techniques with charcoal paper or newsprint, kneaded erasers, and fixitive with this as you did with the Conté crayon.

The still life pastel in Fig. 5.5 lost something in the translation to its black-and-white reproduction—mainly, its vibrant colors. Children love pastels and can experience the beginnings of blending colors the way they will in painting. You can overlay colors and blend them more efficiently than you can with the marking pens, so challenge yourself and experiment a lot.

Aaron Tell–age eight

FIG. 5.5. Pastel still life.

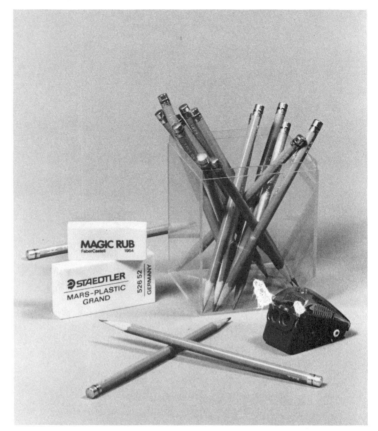

FIG. 5.6. Drawing pencil and Mars eraser.

Francine Taran–age seven

FIG. 5.7. Pencil still life.

Drawing Pencil

Carbon pencils give you all the variety of line and shading that you could possibly achieve in the subtleties of drawing. Now that you feel more confident about your drawing, you can deal with the potential dependence on the eraser. But if you get to where you erase as much as you draw, your eyes are getting sloppy and you need to draw with ink for a while again.

Pencils are graded by H for hardness and B for softness. A hard pencil creates lighter lines and shading than the deeper blacks of the softer leads. The price of a pencil directly relates to its quality, so it may be worth buying the better brands. Get drawing pencils that don't have an eraser on the end and the white or clear type of stick erasers, such as the Mars brand shown in Fig. 5.6. I recommend a basic set of one #H, one #2B, and one #5B or #6B Berol

drawing pencils for each artist in your group. Test your pencils on different kinds of drawing papers, and notice the different results.

The still life pencil drawing in Fig. 5.7 shows the lovely quality you can enjoy with pencil. The secret is to draw very lightly with the #H, slowly add some shading and detail with the #2, and then put in the final darkest shadings with the #5B or #6B. This is one of the most convenient and versatile media you can use. Get into the habit of carrying a sketch pad and a set of pencils with you so you can enter the world of drawing in your spare and relaxed moments.

COLORED PENCIL

Colored pencils are used in the same basic way as drawing pencils. Try them out in the store for softness before you buy. Some of the cheaper and harder leads result in a dulled color range and a limited ability to blend the colors. They should be soft enough to be erasable and to allow for lighter shades to be overlayed on top of darker ones. It saves money if you buy a basic set and then supplement with a few additions of your favorite colors.

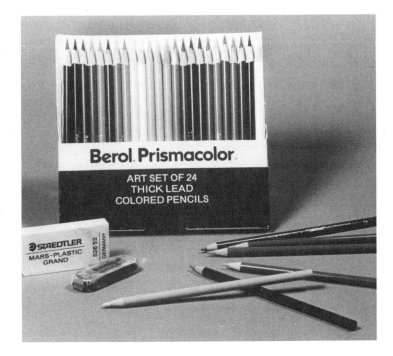

FIG. 5.8. Colored pencil and Mars eraser.

Jennifer Levine–age ten

FIG. 5.9. Colored pencil.

The colored-pencil drawing of the roses in Fig. 5.9 shows how children can make the most of this medium. The challenge is patience. It takes three to four times as long to render the same composition in colored pencil as it does in marker. But the experience is well worth it. The secret is to use smaller paper and to make the layers very thick. If you lightly fill in areas and don't get rid of the white paper showing through, the result looks something like crayons and is not worth the effort.

OIL PASTELS

Oil pastel sticks look something like crayons but have an entirely different quality. When used thickly, they can build up like oil paint and produce a stunning result. I recommend both the Mars and kneaded erasers to deal with corrections and special effects, and different-colored charcoal papers to complement your composition. You can overlay light shades on top of dark ones, so blending and shading potential is at its best. Explore the possibilities on test paper before start-

FIG. 5.10. Oil pastels and eraser.

ing to draw. Oil pastels will break like the Conté and the chalk pastels, but you can take advantage of the sharp edge of the broken pieces by using them to make thinner lines.

The wonderful oil pastel of the model in Fig. 5.11 shows how this medium can be developed. The challenge is patience, since this process can be even more time-consuming than that of colored pencil. The secret is to do a little at a time and to be willing to wait for the more-than-satisfying results in the end. Form the undersketch with a very light color and then build on top of it. Use the tips of your fingers to blend the shadings. If you want to change an area, you can erase it all the way down to the paper and start layering all over again. Teachers report that the focus that is necessary for this type of work shows up in a student's ability to concentrate and have patience in other subjects.

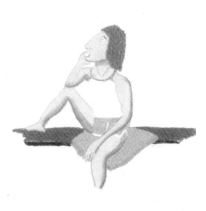

Lilia Fulton–age eleven

FIG. 5.11. Oil pastel of model.

WATERCOLOR

A watercolor painting is just as much a drawing as it is a painting. If you look at unfinished watercolors, you will usually see some form of a light pencil underdrawing as the

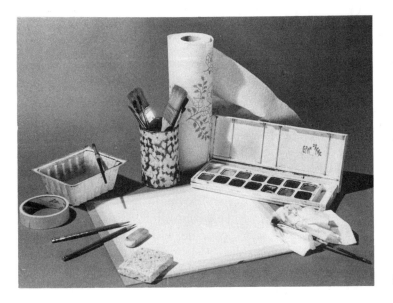

FIG. 5.12. Watercolor setup.

Alexis Armour–age nine

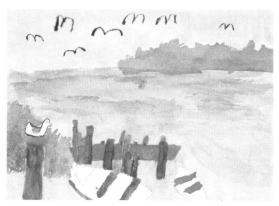

Alexandra Salkeld–age eight

FIG. 5.13. Watercolor.

artist's guide. You'll need a piece of watercolor paper taped to a board, a #H drawing pencil, a kneaded eraser, a tray of watercolors, three sizes of brushes, a container for water, and some paper towels. (Fig. 5.12) Children's favorite medium seems to be watercolor, so it's worth the extra planning it takes to prepare and clean up. Having your supplies organized and working properly is important to the success you can expect.

The inexpensive type of watercolor paper that comes in a pad is fine to start with. Tape it onto a piece of cardboard with masking tape, so that it won't curl when it gets wet. If you put the masking tape around the edge in a straight line, it will create a lovely white border around your painting when you remove it. Have the watercolors as close to the child's painting hand as possible, with several loose sheets of paper towel handy. Have the brushes in the type of container that does not tip over easily, and change the water periodically to keep it fresh.

Pick your subject and draw in the general shapes of your composition with the #H drawing pencil, keeping it as light as you possibly can. The watercolors of the boats and the lighthouse in Fig. 5.13 were inspired by other graphics. The

children who did them can attest to the usefulness of the following steps in controlling the wetness and keeping paintings fresh.

- First, do any large backgrounds—sky, water, or grassy areas. Mix the color for that area in a very watery form. Mix it in the lid of the paint pan, making more than you think you might need. If you have to stop in the middle to mix more paint, it can start streaking and drying up on you. Take the largest brush and simply paint the entire area with *plain water*, first, going around the edges of the area, and around any large objects. Then fill the already wet area with the premixed paint and it will stop spreading at the edge of the dry areas of paper. This keeps the main objects in the composition free from paint and ready for fresh use later. Have children paint in one direction only, and keep the tip of the brush wet and pointed. The biggest challenge for children is to stop scrubbing the paper with the brush, keeping the bristles in one smooth direction, and painting with a pointed tip. Continue laying in your premixed color on already wet area. If you want to shade with other tones, lay those in right away before the background dries.

- Paint all the large areas on the composition in this same manner, and then put the painting aside for several hours. Check that it is completely dry before you start again.

- Once all is dry, paint in the detail of the object in the painting with a thicker mixture of paint. Use your lightest colors first, and then slowly build up to the darker shades.

- After the painting dries again, you may want to go in and add a few more touches of detail. If very young children don't have the fine-motor coordination it takes to handle a tiny brush, they can use fine-tipped markers for these finishing touches.

- After the painting is thoroughly dry and the paper has returned to its flattened condition, tear off the

tape and remove it from the board. Warning! Tear the tape away from the painting, or you may end up ripping it.

This method should bring you and the children a high degree of success. But don't stop there. This is only one way to approach watercolor. Study other watercolors and try to imagine how the artist achieved different results. Get books from the library and read about the ways artists think about and use watercolor techniques. One of my watercolor teachers actually put salt on his painting. It made lovely white areas when it dried and caked off. He also taught us how to use laundry bleach to lift paint off sections of the white paper, which provides a great solution to making clouds in blue skies. Again, you are encouraged to explore and experiment. Use other media in conjunction with watercolor and see what new techniques you can create for yourself.

As you proceed with this lesson, enjoy and try different combinations of media with the children.

Design

Design is actually a component of every piece of artwork, no matter what the subject or the medium. In this lesson we will refer to the type of designs that use abstract shapes or abstracted objects to create the composition. Here are some general suggestions on how to develop this type of design work. As you read the five pointers, study how they are reflected in the two student examples in Fig. 5.14.

Relating to the World of Design

1. *The five elements as your repertoire.* The average person, when asked to fill a space with design, will most likely make a combination of nothing more than X's or V shapes. Seldom are there patterns of interweaving curves, circles integrated with angles, or groups of dots used in the composition. With five known elements as a guide, you have a repertoire to play with and greater potential for creativity.

2. *Using the whole space.* Plan as you would for any other drawing. Consider the whole paper as the area of your composition and integrate your ideas until they make the best use of the entire space. The only thing that keeps some doodles from being framable abstract designs is that they end up on an edge of some inappropriate piece of paper.

Ellen Rennell–adult

Suzy Prudden–adult

FIG. 5.14. Abstract designs.

Hazel Kight–age eight

Brent Iloulian–age five

FIG. 5.15. Free-flow design organized around the five elements of shape.

3. *Repetition of ideas.* Repetition is one of the main keys to an integrated design. Most beginners insist on using too many shapes and colors, with chaotic and disappointing results. You can't miss if you stay simple, repeating similar colors in different shades or repeating the same shapes in different sizes and patterns.

4. *Balancing the composition.* As you develop a design, keep an eye on balance of size, color, and shape. For example, notice if your shapes represent a variety of small to large sizes, with the emphasis on one or the other. If your design is mostly cool blues and greens, add a few hot reds or yellows somewhere for variety. If most of your shapes are angular, add a few curves or place a dot in a significant space. Unless you are trying to achieve a psychaedelic effect, avoid using every color in the spectrum. Choose a simple color theme, with repetition of the same color in many shadings and a little of another complementary color.

5. *Creating a center of interest.* Most beginners end up feeling that their first attempts are boring and can't figure out why. It's usually the lack of a center of interest that is the culprit. One of the best ways to create a center of interest is to alter one particular area of the drawing so that it features shapes and textures opposite to those used in the rest of the design. As a rule it is more aesthetically pleasing if your center of interest is not directly in the middle of the paper. And if it is too near the edge, it can lead your eye right off the paper, never to return.

Developing Design Projects

Here are some suggestions on ways to construct exciting design projects. Try to think of more on your own.

FREE-FLOW DESIGNS

The spontaneous and lovely designs in Fig. 5.15 show how sophisticated design can become when it is organized around the balance of the five elements. These children were aware of using the elements and talked about them as the design unfolded. Markers are well suited to this process, but tempera and watercolors can be used for a freer feel.

Template Designs

Templates, found in the drafting section of art stores, are plastic forms that you can use the holes or edges of to guide you in drawing shapes. The designs that grow from templates can have an extraordinary quality. I was actually inspired to use templates in a drawing class in which the teacher challenged me to draw the live model in a way I had never imagined. Since I was a realist, I did a flip to the other extreme and agonized over abstraction, using textures and templates to deal with negative spaces and interacting shapes. The results were designs that seemed to have no relationship to a model. I was now experiencing the world of abstract design for the first time.

Templates can be difficult to work with for children under eight, since they may need a little assistance in holding the form still. Help them hold it, lightly, and then ease up more and more until they can do it on their own.

FIG. 5.16. Templates can be used to develop sophisticated abstract design.

Template designs with shapes floating around randomly on the paper tend to be disorganized and unattractive and are unsatisfying to the artist. Notice how the successful template design in Fig. 5.17 has shapes touching each other and making repetitive and symmetrical patterns. Children under 12 seem to need constant reminding to plan the design. I think the fun of using the templates makes children lose their concentration so that they begin drawing shapes all over the paper without much thought. Teenagers love this project. They have the motor dexterity to control the templates at a very professional level and can experience tremendous success. Template projects are a sure way to bring a reluctant teenager into the world of drawing.

GRIDS

Working with reversed and repetitive patterns on grid paper, as shown in Fig. 5.18, can be challenging and stimulating. Teachers report that children who have difficulty concentrating can sharpen their general learning skills by working on these patterned grids. Ready-made graph papers are available at most art stores, or you can make your own larger versions with rulers. You can facilitate the young child's understanding of how to plan the repetitions by having them place guideline dots to highlight the pattern of boxes that you want to work on.

OBJECTS

If you've been collecting unusual objects, as I recommended in the section Building Still Life Arrangements, now is your chance to draw them. The design in Fig. 5.19 from kitchen utensils shows how uniquely these can be used. It helps to forget the name or purpose of an object and pay more attention to its shape and energy while you are planning the composition.

Placing objects into an abstract line composition, as in Fig. 5.20, is one of those surefire projects everybody can get involved in. First make lines all over the paper, and then use a few objects to place in the spaces that are created. Don't overdo the number of lines, or your spaces will be too small to work with. If your child is too young to hold the ruler by herself, let her decide the placement and help her hold it. Then help her less and less until she can hold it alone.

Rebecca Robbins–age ten

FIG. 5.17. Template design.

Carrie Norred–age eleven

FIG. 5.18. Working with reversed and repetitive patterns on grid paper can be challenging and stimulating.

Kristen Todd–age thirteen

FIG. 5.19. This design from a group of kitchen utensils shows how you can use seldom-drawn objects in a unique way.

Karen Stewart–age eleven

FIG. 5.20. Placing objects into an abstract line composition is a project all ages enjoy.

Notice how the object is only partially drawn, abstracted, or repeated in different ways. Study how the objects are drawn up against the edges of the spaces. The design can lose its organization if you float objects or shapes in the middle of spaces and don't integrate them to the edge of the space. You can use templates to make aesthetically perfect circles and lines, or you may prefer drawing freehand for a looser composition.

FABRICS AND TEXTURES

Fabrics and wallpapers are one of the best sources for inspiration, but train your eye to look everywhere for textures and designs. Even the plank in the ceiling offers potential design ideas from the textures in the wood. You can add lovely texture to a drawing by using strips of decorative preglued paper for a border. This usually works best if you do not surround the entire drawing, but choose the sides or top and bottom only. You can incorporate the same color scheme or types of textures into the design for the beauty of repetition and balance. The student's design in Fig. 5.21 was inspired by a piece of fabric.

Gina Hirsch–age nine

FIG. 5.21. This drawing was inspired from the fabric on a student's jacket.

People

People are not harder to draw, they just seem that way because something is blocking you from dealing with the subject. It may be due to any or all of the factors that follow.

Discomfort with a Live Model

Whenever I speak to a group, I ask them to call out things in their environment that represent the five elements of shape. It is rare for anyone in the audience to look at other human beings and call out a shape on them, whether it be a body part, clothing, or accessories. When I point this out after the exercise, the room usually fills with embarrassed laughter. Needless to say, if you aren't comfortable looking at a subject, that subject will be difficult to draw.

Confront any problems you or the children might have with staring at and being watched by people. Children under six have little difficulty with this. Children from 6 to 12 become more and more self-conscious, and by the time they are teenagers it is almost impossible. Practice sessions of staring at each other help everyone get the giggles out and become more comfortable.

Michelle Green–age eight

Darren Kawaoka–age six

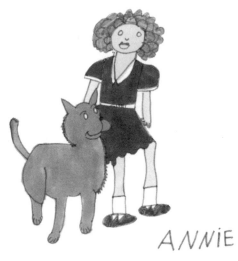

Charlene Percy–age five

Tenley Naliboff–age eight

FIG. 5.22. Student exhibition of people, inspired by illustrations.

Lack of Concentration and Focus

The body is a complex instrument, and its parts have a structured set of relationships. It is more important to accurately represent the shape of an arm than it is the limb of a tree or the petal of a flower, which have more variation and flexibility. Therefore it takes more concentration and more time to draw the human figure than it does to draw most other subjects.

Be willing to spend this extra time and effort, and train yourself on the relationship of parts to the whole. For example, when the arm seems awkwardly drawn, check out things like how far the elbow is from the waist, where the wrist is in relationship to the torso, or how far the shoulder is from the chin. With a realistic set of expectations and a change in attitude you can draw people just as easily as you can anything else.

Using Other Illustrations

You will use the same step-by-step process for drawing people from illustrations as you did in Lesson 2, "Drawing from Graphics." The only difference is that you will pay more attention to proportion and those relationships of the parts of the body to the whole. The student exhibition of people in Fig. 5.22, which was inspired by illustrations, shows you how charming the effects can be. In general, start with the features of the face; then finish the head and torso and add the limbs.

As your child learns to draw full-bodied people during drawing sessions, she may continue to draw stick-figure people at other times. There is no need to stop or judge this activity as regression. The two styles of drawing need not be compared and are engaged in for different reasons. Nonetheless, it is good to have the child notice the differences and be aware of the options. If you don't keep the child active in both experiences, she will revert to the limitations of stick-figure drawing only.

Using Live Models

Now that you are ready to study drawing a live person, you and your child can draw each other. Make the pose simple at first by avoiding twisting torsos, complex overlap-

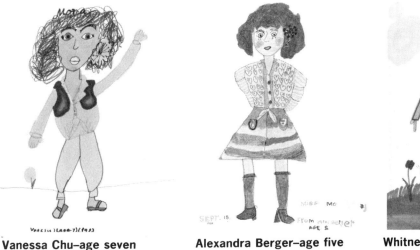

Vanessa Chu–age seven **Alexandra Berger–age five** **Whitney Minson–age six**

pings of limbs, and limbs sticking straight toward the artist's view. The student exhibition in Fig. 5.23 offers some examples of simple poses to use. Here are some techniques to help you orient yourselves to drawing from live models.

FIG. 5.23. Drawing from a live model, using simple poses at first.

DRAW WITHOUT LOOKING AT THE PAPER

One of the best ways to get over the fear of drawing people is to draw without looking at the paper. It removes the artist from the responsibility of result, and allows him to study the subject more closely.

The regular-tipped black Flair is recommended for this type of drawing, since it flows the easiest on the paper. You can use large sizes of inexpensive newsprint or butcher paper, at least 10" × 13", to encourage freedom of movement. Start with the model's eyes. Force yourself to stare at the model and study each and every line, letting your hand duplicate those lines on the paper without looking at it. Give yourself two or three peeks to place your pen in a new starting place if you feel totally lost, but don't let it move until you look away from the paper and back at the model again.

The amount of resistance you feel is equal to the amount of worry you need to get rid of. The exercise is more about learning to see and feel the model than having a likable drawing. You are trying to accomplish letting go of

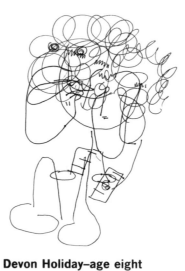

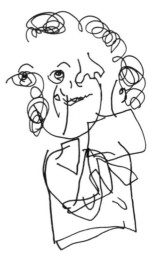

FIG. 5.24. Drawing without looking at the paper can help loosen you up and train your eyes to see.

Devon Holiday–age eight

Sabrina Bassett–age eight

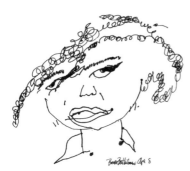

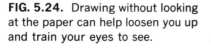

Brooke Bartholemew–age eight

FIG. 5.25. Drawings that result from not looking at the paper can turn out to be wonderfully expressive pieces. This process encourages movement and feeling in your work.

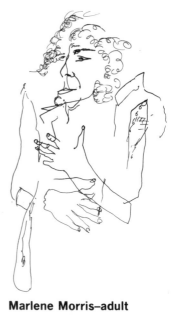

Whitney Minson–age seven

Marlene Morris–adult

caring about the results. This is one of the major ways to practice getting feeling and aliveness into your life drawings. Most of the results will be a mass of scribbles, as Fig. 5.24 shows, while others turn out to be wonderfully expressive pieces, as with Fig. 5.25. Notice the movement and aliveness of the characters portrayed.

Use the Circle-and-Tube Formula

Seeing the whole body as a group of circles and tubes, as in Fig. 5.26, is very helpful in drawing humans and some animals. Whenever you tackle a different pose, it allows you to quickly get the proportions accurate and make a general sketch of the model's position. The sketches look like mannequins and are very stiff, but this is only an undersketch that you establish as a guideline, and it can disappear in the final drawing. If you build in the proper tilting and directions of the energy flow of the body, a sensitive and feeling drawing will grow out of such an undersketch.

As you explore drawing people, try different media possibilities. You can use Conté crayon on large newsprint paper in the undersketch and through a shaded and finished drawing. You can use light pencil on drawing paper and finish up in shaded tones of pencil. Or you can use a light pencil for the undersketch, go over the final sketch in ink, erase the pencil lines, and finish up in ink.

Do the following exercise on scratch paper with a fine-tipped marker. First, you be the model and then switch with the child. You will learn from both experiences. This is for practice, so don't take time to erase. If you get stuck, just go on and start a new sketch. Stand where the child can see your whole body, and put the Fig. 5.26 diagram within view. Stand in a simple, straight posture, with one arm hanging at your side and the other bent with your hand on your hip.

As you go through the exercise, talk the child through each step and make a demonstration drawing along with him. As you demonstrate feeling your body parts, have the child get up and feel the corresponding part in his own body. Notice the sequence that you draw the body parts in. If you learn to follow this sequence, you can develop the ability to confidently sketch the general shape of a person, whether moving or still.

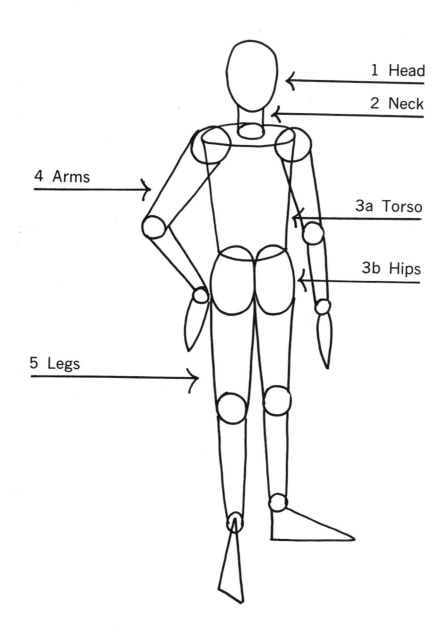

1 Head

2 Neck

4 Arms

3a Torso

3b Hips

5 Legs

FIG. 5.26. The body seen as a series of circles and tubes can allow you to get the proportions quickly in an undersketch. Then you can develop a sensitive and feeling drawing as an overlay.

1. *The head.* Look at *the head as an oval circle,* the shape of an egg with the chin being the tip. Feel your head and notice how much volume is in the skull and behind the hairline. Most beginners have a tendency to make the top of the egg too small and create a flat head, with the eyes way up in the forehead area. Practice drawing egg-shaped ovals until you can make them with ease.

2. *The neck.* Both you and the child feel your own *neck as a tube* and notice where it enters the side of the egg shape of your head. Rotate your head around on its tube and feel the relationships change as you bend your neck from one direction to another. Look at the examples of the different directions of heads and notice how the egg extends itself out in the side view. Make several sketches of the different directions in which you can turn your neck and head, using just the egg and the tube.

3. *The torso and hips.* Think of the entire *torso as one big tube.* Feel how far the shoulder edges extend beyond the size of the head and form its length to the waist with about two more head sizes. Now feel the full-volumed *circles of your hips,* pretending they are two large, flattened balls that meet in the center of your body, from the waistline down to the crotch. Make some more sketches of torsos and hips as they relate to the head and neck.

4. *The arms and hands.* Feel the three *circular joints* of your shoulders, elbows, and wrists. Dig your fingers down into the joint and feel the full volume of them, noticing that the elbow is about half as big as the shoulder, and the wrist is about half as big as the elbow. Many beginners make the shoulders too big, because they don't notice that the shoulder circles are inserted into the top of the torso tube. Draw the circles for the shoulders. Notice where your elbows are in relation to your waist, and draw them, half as big as the shoulders. Notice where your wrists are in relationship to your hips and draw them, half as big as the elbows.

Always draw the circular joints of the limbs first, and the tubes will automatically taper properly as they go from the larger joints down to the smaller ones. Now join the joints together with the *tapering tubes* of the upper and lower sections of the arms. You can use a simple *leaf shape to indicate the hands* for these study sketches. Put your hand

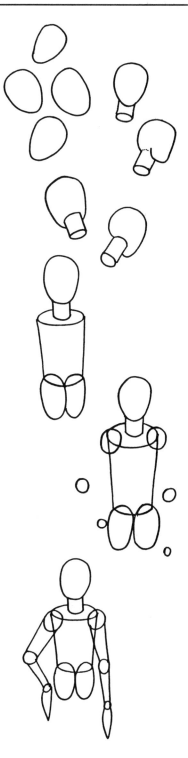

on your face, with the tip of your middle finger at the hairline of your forehead, and notice how long the length of your whole hand is compared to the length of your face. Make your leaf-shaped hand as long as the face in your drawing. Most beginners make hands too small, due to their fear of drawing them.

5. *The legs and feet.* The *circular joints* of the hips, knees, and ankles follow the same pattern as the joints of the arms. They get progressively smaller as they go down the leg. Feel their relative sizes on your body, and then draw them into your sketches. Next join them together with the *tapering tubes* of the upper and lower sections of the legs. You can make a general *triangle shape for the feet,* but compare them with the size of your hands and face. Beginners also tend to make tiny little feet out of fear of drawing them wrong.

Make lots of sketches of each other, from the front, side, and back. The only time you need to change the sequence is when the legs need to be drawn before the arms. This happens when a more complex pose has the legs falling in front of the arms in some way. When you are drawing a side view notice that you have to overlap the hip circles on top of each other and adjust the shoulder circles to the degree the body is turned (see Fig. 5.27).

USE ARROWS TO CAPTURE BODY DIRECTION AND ENERGY FLOW

Study more complex poses, as in Fig. 5.28, and notice how the neck can be tilted in one direction while the torso can be bent in two different directions or twisted at the waist. Capturing this kind of body flow is what gives your people their feeling and aliveness. The circle-tube formula will work for every pose there is if you add this additional factor. Notice how the arrows designate the energy flow and movement of the model. When a person is not standing straight and still, you need to watch which way the different sections of the body tilt. Of course with people, more than other subjects, you want to capture that feeling. The process of focusing on the movement of a subject is essential when trying to capture a quick position of a person who may move or leave the area. It allows you to get sketches of people that you can finish later at home and a freedom from the pressures about proportion.

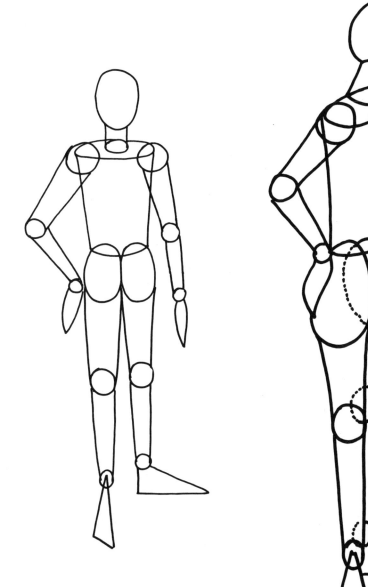
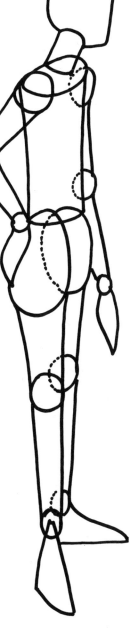

FIG. 5.27. Side view. Notice how hips overlap.

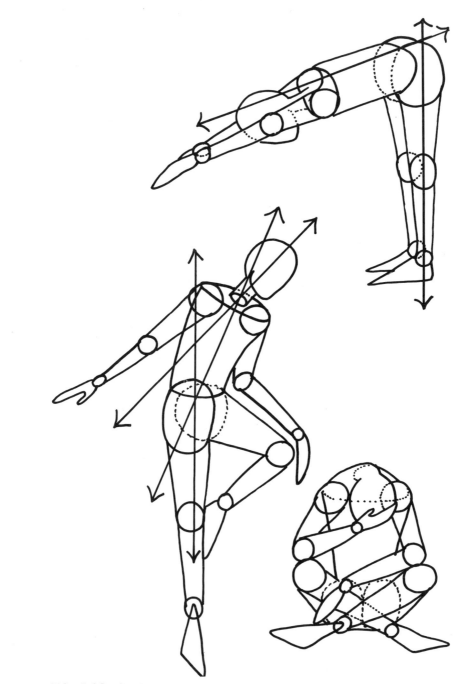

FIG. 5.28. Study complex poses and notice direction and energy flow.

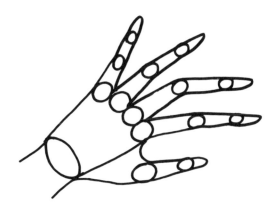
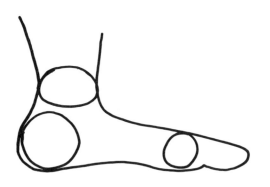

FIG. 5.29. Hands and feet.

FIG. 5.30. Hands and feet. (Simplified version for younger children.)

CONCENTRATE SPECIFICALLY ON HANDS AND FEET

Study the examples in Fig. 5.29 of hands and feet, and get the basic shapes that are involved. You can draw your own hand in many positions with the circle-tube process. But feel the joints and notice how they really inset into the base of the hand. Remember to do all the circles first for the fingers, so the proper tapering will occur. When you draw a side foot, notice how it is built from the circles of the ankle, the heel, and the ball. When you draw the foot from the front, you will be working off an angle that is longer on the side of the big toe.

It is a bit much for children under eight to draw hands and feet with this much detail, and I use the simplified versions in Fig. 5.30 when teaching them. It is just a matter of making long U-shaped curves for fingers, instead of all the joints, and U-shaped curves for the whole foot, instead of the heel, arch, and ball segments. Drawing feet with young children is really more about drawing shoes; this saves the anatomical understanding for when they are ready.

Using Yourself as a Model

Drawing themselves gives children a new appreciation of who they are and what they look like. It can be done by using the mirror or by the imagination. Teachers say that even the most withdrawn child tends to reach out socially after this experience. When people draw themselves into an environment, they tell me they feel like they have been there or that it is something they imagine will happen to them. The student exhibition of self-portraits in Fig. 5.31 shows the foreseen joining of a baseball team, a walk in nature, and a t'ai chi instructor's image of his dancing spirit.

Using Your Imagination

If you don't have any understanding of how the body is constructed or the capacity to see a model in your inner vision, you will feel blocked from drawing people from your imagination. But once you have used the circle-tube method, drawn from models and illustrations, and practiced the general proportions of people, you will begin to see them in your imagination. Children who are not so hard on themselves about proportion can enjoy this to its fullest. They will

a. Jeffrey Nason–age six

b. Windsor Lai–age four

FIG. 5.31. The self as a model
a. Joining a baseball team
b. A magical walk
c. T'ai chi instructor's dancing spirit.

c. Will Ortiz–adult

Alexandra Berger–age five

FIG. 5.32. A drawing of herself from her imagination, ice skating on a pond.

work people all through their drawings and create an enormous amount of movement, story telling, and emotional content. They need only a few reminders about the general shapes of the body and limbs. The five-year-old's imaginative drawing of herself ice skating in Fig. 5.32 came after a brief demonstration of how the body parts fit together.

Faces

The issue I feel needs attention when drawing someone's face is the question of *likeness.* I can find nothing in the dictionary that says a portrait has to be an exact likeness of the model, let alone a recognizable one. However, I find this to be the main reason people give as to why they can't draw the face of a model. When I tell them that art students use the model only to create from and are not that concerned about likeness, they are amazed. For the purpose of learning to draw faces, I see no reason to be concerned with specific likeness. We want to capture only the general type of person we are drawing. The change in attitude about how much likeness is really necessary can increase your ability to draw faces before you ever begin.

Media to Use

If you and your child are ready to draw more realistic faces, you are confident enough about your drawing ability to begin using *pencil, Conté crayon, or pastels.* Even if your child isn't quite ready to use pencil in other subjects, let her do so with portraits. The harshness of the ink is a bit much to control with the subtleties of the face, unless you are really good with volume-type shaded drawing. So use the light #H pencil we discussed in the Media Tips section of this lesson. If you can't come by a #H, use a regular #2 or #2B and don't press too hard. Try to use a special clear or white drawing eraser if you can, rather than the pencil-end eraser, which sometimes leaves a pinkish tinge.

Picking Your Subject

The Japanese lady and exotic man in Fig. 5.33 were inspired by a photo and an illustration. "Sean," the six-year-old artist's relative (Fig. 5.34) was done from life, and the self-portrait in Fig. 5.35 was achieved after learning the procedure that follows.

Amir Marcus–age eleven

Mark Hall–adult

FIG. 5.33. A Japanese lady, inspired from a magazine photo, and an exotic man, inspired from an illustration and the artist's incense burner.

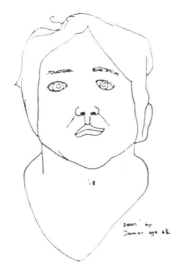

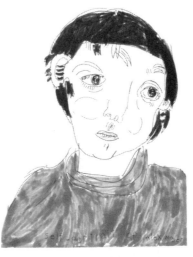

Damian Akavi–age six

Alex Moyer–age eight

FIG. 5.34. A contour line drawing of his uncle.

FIG. 5.35. A self-portrait, after one lesson in the sequence of drawing faces.

Decide what you are going to use for a model. If you are using an illustration or a photograph, put it in good light close to your paper and follow the shading patterns that you observe. If you are using a live model, have him near you and in the kind of light we discussed about shading in Lesson 4, where the light is to one side and makes one side of the face darker than the other. If you are going to draw yourself, get a mirror placed where it is comfortable to sit still and just glance up and down at yourself. Put a light on your face that creates the half-light, half-dark pattern.

A Sequence to Use in Drawing Faces

All you need for exploring on your own is some general information on the structure of the head and face. The illustrations of head and facial structure in Fig. 5.36 show the basic shape of the head on the neck, the positioning of the features on the face, and some studies of isolated features. Since you may be drawing from an illustration, a model, or your own face, I can't draw along with you this time. But follow the sequence of suggestions and you should be pleasantly surprised at the results.

1. *Basic shape of the head on the neck.* Even though there are enormous differences in people's head structures and individual features, the basic shape of an egg sitting on its small end is enough to get started with.

- First, draw the oval-shaped head, noticing any tilt, with the tip resting in the chin position.

- Place the tube of the neck into the head, at the angle it is tilting.

- If from the front view the head is *tipped backward,* the chin line will reverse and cause an upward curve, as in the example.

- Add any *side view of the skull* to come around to the side or back of the neck, and *adjust the shape* of the egg to conform more to the individual head type you are using as the model.

- Add the beginning indications of which slant the *shoulders* will take.

1. BASIC SHAPE OF THE HEAD ON THE NECK

The oval and the neck tube.

A head tipped back.

Adjust the egg to conform to a side view.

Add the beginning indications of the shoulder slant.

2. POSITIONING THE FEATURES ON THE FACE

Front View Th ·quarter View Side View

FIG. 5.36. Head and facial structure.

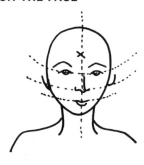
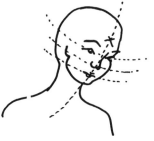

FIG. 5.37. Individual features.

2. *Positioning the features on the face.* Notice the dotted lines on the drawings of the three heads in Fig. 5.36, as well as their direction and tilt. If you make a light pencil line of dots as guidelines for the features to fit into, you will seldom have problems with proportion and placement.

- Place a *midline* right down the center of the face, noticing how it curves with the volume of an egg shape. Put an X about where the hairline starts. Most beginners place the hairline too high and cause a blunted head, with eyes that are up on the forehead.

- Eyeball the spaces between the eyes, nose, and mouth and form a light dotted line for the *eye line.*

- Form a light dotted line for the *nose line.*

- Form a light dotted line for the *mouth line.*

- Recheck everything before you commit yourself to putting features into the drawing. It helps to stand the paper up somewhere or hold it out to see at a straight angle.

3. *Inserting individual features.* Studying how to draw features from books will give you a better understanding of their general shapes. The isolated features shown in Fig. 5.37 give you some examples. But you are going to have to look straight at your particular model to get the feeling and mood of that kind of person. Here is where you need more concentration than you have used in the previous lessons. Checking out the distances between the separate parts and determining how they relate to the edges of the jawline— or temple line or cheekbone—is important. If you want to capture likeness, simply pay extraordinary attention to these details, since an infinitesimal shift in a line is what allows likeness to happen. The biggest secret in either case is to *draw lightly!* Some hints on sequence follow.

- Make the marks very light until all is in place.

- Establish the basic placement of the eyeballs.

- Make the curvatures of the eyelids and folds around the eyes, noticing how they cut off the top and bottom of the eyeball circle and eliminate buggy eyes. Study the model closely.

- Add the beginnings of the shading for the eyelashes and eyebrows and bridge of the nose.

- Make a little curve to establish the end of the nose, but don't draw any further in case of changes.

- Make the midline of the mouth, noticing your model's length, in relation to the eyes above.

- Lightly sketch in the upper and lower lip-line.

- Double-check that the eyes and mouth are in the right place on the face before going further.

- Put in the nose, avoiding dark nostril holes that tend to create a piglike effect.

- If the ear shows, just put in the tips of the lobes, unless you have a full side-view. Drawing the whole ear tends to create an elephantlike effect. Take your finger and run it across from the midline of the mouth to the bottom of your ear; it should be straight across. This is true of almost all people, no matter how different we all look. Don't worry about all the detail. Take it slowly, and simply draw what you see.

- Darken up a few of the places that you are satisfied with, making further adjustments with the other parts of the drawing.

- Begin to experiment with a few lines to indicate the hair. Make your drawing lines follow the direction the hair grows in, picking the main folds to emphasize.

- Drawing faces is a process of making continual adjustments until you are satisfied. Begin to look at the light and dark areas and shade them in the same way you did with volume drawing.

Be willing to challenge yourself, relax, and draw lots of faces. Carrying a sketch pad really comes in handy. You will learn there are lots of occasions when you are waiting in areas with people and can practice on them. If you let people know you are just practicing and would like to sketch them, they usually relax along with you and don't mind.

Environment

The entire world is now open for your drawing ideas. You can look at any object, break it into its components of shape, change it any way you want, decide on your own composition and style, and make a statement. You can begin to consider every scene in your environment as suitable for a drawing project, especially since you know how to isolate pieces of objects and scenes and integrate them into your various drawings.

This section offers suggestions on how to deal with indoor environments and outdoor scenes. You can incorporate ideas from paintings, illustrations, photographs, or from the location itself; the basic formulas to constructing a landscape or environment are about the same. Study the environmental scenes in Fig. 5.38, and notice the different elements and media. If you use a system like the one that follows, you should have no trouble.

Preparing for the Environment and Media

How you plan to draw environments is crucial to a successful experience. Preparing to work from paintings or illustrations requires considerations totally different from those of a field trip. Take time to think through the various kinds of experiences you want to have and what you will need in order to create them.

If you choose to draw in an indoor environment, there are many places to go to that will provide you with people who will stay fairly still for long periods. But it is very important also to consider the working conditions. Imagine the different supply needs and environmental problems you'd face in the following situations: pencil sketches of people in a restaurant while you eat a leisurely lunch; pastel drawings of animal statues in a museum; or watercolor drawings of the customers in a bank. Even if the site is in your own living room, you have to consider the same issues. This checklist could save you complications.

- Does the location offer things you really want to draw?

- How can you transport the supplies?

- Where will you sit and arrange the supplies for use?

Rennie Nelson–age nine

Janet Eto–adult

Al Sutton–adult

Daniel Marc–age eight

FIG. 5.38. Student exhibition of environments.

Main Street, Santa Monica, California

Whitney Rugg—age six

FIG. 5.39. Field trips can be wonderful adventures if planned well. The basic drawing can be started at the site and finished in the studio from sketches and photographs.

- Do you need to plan who, what, when, and where with any managers or owners of a site?

- Did you make the whole agenda clear to the children?

If you choose to draw in an outdoor environment, much more planning is necessary. The corner street-scene in Fig. 5.39 was drawn on a field trip with several six-year-olds, and it went well because of prior planning and attention to potential needs and problems. We had to deal with traffic dangers, hunger and bathroom needs, a child who suddenly wasn't feeling well, and the adjustment to passersby who naturally wanted to watch but distracted the drawers. With this in mind, add to the above checklist some of the following questions:

- Did you plan the hours at a good time for light?

- Are you prepared for any possible changes in the weather?

- Will bathroom or eating facilities be needed?

- Could any other events in the area cause conflicts?

Making the Drawing Work

Once you settle on the particular method you will follow to draw a scene, the procedure you use to compose the drawing is the same. You want to create a drawing that has some statement of movement, interest, or feeling. Here are some of the things I find myself helping students consider while they are planning their scene:

PRELIMINARY SKETCHES

Never stop planning drawings if you want to achieve results that you like. Be sure you have supplies to do some rough sketches of composition ideas, so that you can try out several arrangements. You can make a sketch of one thing and then move to another area and add other ideas. You can also make further sketches to help you remember things and finish at home. Of course you can go on a site for the purpose of sketching or taking photographs only, with the intent to draw from them later.

CENTER OF INTEREST

Going to the beach may be a good idea, but if you end up on a long, empty sand dune with waves and water, you may be in trouble. Instead, pick a spot where there is a building, a tree, a boat, a person with a big umbrella, or an old log with a bird on it. If you are having trouble finding your ideal scene, you can put in a center of interest from one site and combine it with ideas from another site. You can get your central ideas into the drawing with light pencil line. Remember to draw what is in front first, and follow your "stop, jump over, and continue" procedure for the overlapping that results.

CREATING DISTANCE AND PROPORTION

Most drawing books adequately explain technical methods for creating the illusion of perspective. I find that most beginners and children do quite well from just attuning their eye to the changes they see and creating a natural kind of observed perspective. The play yard scene in Fig. 5.40 is a perfect example of this process. The child worked out in preliminary sketches the composition and how to make the buildings look like they were receding. Then he was able to follow his plan on the main drawing. Since he was only five years old and tired easily, he actually worked on the drawing three different times for about half an hour each time. The preliminary sketches of the distance and proportions and the freedom to work on it gradually was what made this complex drawing possible for such a young child. Along with any technical information you study on perspective, I recommend that you begin to do the following:

- Use your observation and duplicate what you see in terms of things diminishing in size as they get farther away. Notice the direction the edges of buildings or roads slant as they recede and become smaller.

- Study how things in the distance become duller in color and less defined.

- Notice how large areas are never really one solid color. The sky may be gradations of very light

Ben Pfister–age five

FIG. 5.40. TOCALOMA PLAY YARD.
This five-year-old student captured
the memory of his nursery school.
Since he was so young it required
three different drawing sessions of
about 20 minutes each to complete.
He did preliminary sketches with the
guidance of the instructor and
planned his composition first.

blue-gray near the horizon, all the way to a bright blue as your eyes move above it. A field of grass may be yellowy green near where you are sitting and slowly turn to streaks of bluish green in the distance.

- Use darker shades inside holes and recesses and lighter shades on surfaces of things turned toward the light source.

- Notice how a scene is a series of layers (sometimes referred to as foreground, midground, and background). Draw the objects in the foreground first, and then lay in each receding layer behind it.

- Place the main objects in the drawing first and then fill in the detail of the spaces between them. You can take liberties with how much of the detail you want to portray.

Point these things out to your children, and they will begin to make drawings that have depth and perspective. They will no longer be limited to a blue stripe across the top of the paper for a sky, or a tree with all the leaves the same color.

Filling in the Spaces between the Objects

I find that there is a tendency for beginners to kind of scribble in some random color between things in their pictures. This appears to come from lack of experience rather than aesthetic choice. So use your imagination and look at lots of artwork to observe ways you can create texture and shading to indicate grassy areas, bushes, cloudy skies, or large areas of water. It helps to use at least two or three shades of a color for a particular area. A green hill rendered with short strokes of five different green colors imparts a totally different feeling than does a hill with one green color zig-zagged back and forth across the space. Try to color in any white paper showing through, since this condition tends to create too much contrast and interest in background areas. If you've drawn a lovely sailboat in the water, you don't want your viewer's eye to gravitate faster to the annoying spots of white paper showing through the ocean than to the center of interest.

How you create the foliage patterns, hills, water, sky, and other background and foreground areas in the drawing is entirely up to you, so explore all possibilities to see what you like. Study other drawings and paintings to develop ideas. You might plan some trips to the museum to observe how the masters solved these problems.

Infinite Possibilities

Some of my students have been with me since I started with this process six years ago. This has forced me to come up with a new project every week for six consecutive years. With all its inconveniences, I am eternally grateful for having had such a challenge. It has made me see the potential for beauty or excitement in nearly everything my eyes fall upon. I could go have my car repaired and find myself imagining how the spare parts could be used in a still life, or how the oil on the floor could create design patterns.

You have been exposed to a tremendous amount of material in these lessons, and it wouldn't be unusual if you were feeling a little unsure of it all. My desire has been to give you enough experience to be aware of your options and to know how you can be successful. How far you want to take that now is up to you.

You needn't say "I can't draw" anymore. Rather, it has now become a matter of your deciding how *much* you want to draw and what kinds of drawing you want to do. You can now refer back to your experiences and build off them, skipping around the book and reinspiring yourself regarding different types of projects. Alternate the kinds of drawing and types of media that are suggested. I guarantee you, you will never run out of exciting new ideas.

As you become more and more confident with your drawing, you might use your new attitude to consider exploring your other untapped and hidden talents. One adult student, a musician, told me that learning to use his inner vision in these new ways inspired him to improvise on musical instruments with fuller understanding. A handicapped teenage boy, who refrained from talking, began to risk saying the "wrong word" with the same ease as making the "wrong line" in drawing. Another student, a slow learner who avoided math, considered trying it and was successful after

he surprised us all with gorgeous drawings. After a few successes in communicating through drawing, a three-year-old girl who didn't speak English and hid in her locker most of the day began to come out and participate in the alphabet and number games with her classmates at school. Of course, the most personal experience I have had with this phenomenon is my own. Long after it was supposed to be too late to teach my stiff body to dance, I took my own advice and decided to try. Five years later, way beyond the age it's supposed to be possible to perform for the first time, it happened. It's not a coincidence that it happened the same year I wrote a book, which was the last thing I thought I could ever do. I was inspired by the people who came to me who were sure they couldn't draw. As I watched them begin to draw with confidence I felt I could do the same in dance, writing, music, or any other subject I chose.

Once you see the drawing possibilities in your world, there are endless experiences to explore. You can eliminate unnecessary concern over the finished product and feel free to develop your own form of expression. As you let go of old role models, you can enjoy learning along with your children and take advantage of the potential for self-teaching. Drop your fear of judgments and know that there is no "wrong way." Then open your eyes and heart to the countless ways the universe has always provided for us to be creative.

A Note to Teachers

If you are going to draw with children in a classroom, there are a few extra words I'd like to share with you. You don't have to wait until you are completely comfortable with your drawing in order to begin. Setting up a climate in which you acknowledge your discomfort and state you will be learning together can bring you the pleasant surprise of cooperation and success. Students can be very supportive to the teacher and each other when they are aware that you are all equal and learning together. How well you draw isn't the point anyway. You are only providing the general structure that is needed to get everyone involved and give them permission to make their own interpretations. You can be comfortable with your students and experience the process of discovery together.

You don't have to wait for a determined "art time" to draw. Start noticing how you can weave drawing through everything you are teaching. You can draw most of the things you are studying in science lessons together, gain insight and knowledge about other cultures by drawing things related to those other environments, learn math concepts by drawing abstract designs of digits and elements, and grow in writing skills by illustrating and writing in journals.

One of the best ways to help this happen is to have your equipment organized and easily available.

Let children know that drawing is about learning to see and that the work you do with vision is as important as the drawing time. When there are only a few minutes until recess or when children are waiting impatiently in a line, take those moments to play the visual perception and inner vision games that you learned in Lesson 1, "Learning the Basics."

Along with establishing drawing in your regular curriculum, try to have at least one hour a week for a planned drawing project. If your school's budget cannot accommodate the cost of markers, you might suggest a fully equipped drawing cart that can be shared by all the teachers in the school. Another solution is to reconsider your supply needs for such items as crayons, tempera paint, and construction paper and possibly make some trade-offs. When you demonstrate in front of a large class, use big butcher paper and a broad-tipped black marker so that everyone can see easily.

As you draw along with a group, you do not have to wait for everyone to finish before going on to the next instruction. There is no need to rush the slower drawers. Wait until nearly all of the group is ready to go to the next instruction. Then ask everyone to put the pens down for a moment. Explain the next part, and remind those not finished that they will catch up. It's rare that they don't. If for any reason you need to stop the whole class before finishing a lesson, just collect the projects and put them in a box for unfinished work. Establishing an unfinished-drawing box takes the pressure off the slower drawers. They can also put a drawing up to finish later. It conveniently turns out that the slower drawers are often the same students who become restless with nothing to do at other times of the day. You can set up a drawing desk, equipped with supplies, for children to go to when they have finished their other lessons.

When you have a one-hour project, try to keep your instruction portion to no more than 20 minutes. Once you get used to the flow, you'll find it's best to take about 5 minutes for the relaxation exercises and eye warm-ups you learned in Lesson 1, "Learning the Basics," and about 15 minutes for your guided instruction of the project. This

instruction will address the planning of the composition and the demonstration of how the general shapes of the main objects are constructed. During this portion of the lesson, if you don't make them understand the importance of silent concentration, you will find the instructions dragging on endlessly as the students get more and more distracted and confused. After your preliminary 20 minutes, let them take a stretch break, with some opportunity to make noise. Then settle down into a freer atmosphere that allows for quiet talking and controlled interchanges as they put in their detail and finishing touches. This is where it's important for you to start circulating and helping them develop their individual ideas. Keep watching for hands that stop drawing when talking goes too far. You may have to move certain talker teams away from each other. Remind them that it's for the sake of everyone's drawing ability, not just the same old disciplinary conventions. When someone becomes dissatisfied with her drawing and begins making a ruckus about it, you can usually make a quiet point of the fact that it's no coincidence it happened to the same person you've had to remind time and again about talking too much.

While you circulate to help the finishing up process, look for those signs we talked about in the Troubleshooting section of *Preliminaries.* Keep track of frustrations and pay some attention before they build too much. When someone is stuck, give as many verbal suggestions as possible; then take a piece of scratch paper and offer a few solutions related to the already expressed ideas. I make it a rule not to spend more than three or four minutes doing this before moving on. It's best to leave someone alone to think again after a few suggestions, or you begin to go beyond the drawing lesson and into attention neediness. Don't forget the quiet students who are having no problems; they need a little acknowledgment or they may begin having problems too.

Support the success of the whole class and try not to single out any student's work that you may personally prefer. If you exhibit artwork, collect one handsome piece from each child and show them all. You may have trouble doing that if you try to get them from one particular project, but that wouldn't be too interesting anyway. Maintain a folder for each child's finished artwork from which you can draw

for your student showings. Learn how to appreciate the differences in individual tastes and styles, and you will be able to have exhibits for which every child has a different and exciting piece. The students love it when teachers include their drawings in the exhibit. When many teachers and students at the same school begin to adorn the walls with this type of artwork, something very noticeable starts happening. The teachers and students begin to communicate better with each other as they learn a subject together. Once or twice a year, after art displays are taken down and you send home the folders, I guarantee you the drawings receive a different kind of respect than the half-finished compositions that once came home folded up in a lunch box or jacket pocket.

Try to remember that what is considered "good" may merely be a function of personal preference. Challenge yourself to find the beauty in each child's form and style of expression. Watch the progress each child experiences with himself, instead of comparing him with others. If you use a grading system, consider what is really being determined. You might consider a pass/fail system in the arts, based solely on participation, if your school district is in agreement. Your aim is to help the children appreciate and learn from each other. Let them look at each other's work for ideas. Have a discussion about the subject of copying. They easily understand that it is not acceptable to copy answers from each other when being tested on academic subjects, so they find it hard to believe that it is acceptable to copy in drawing. Once you give them permission, they soon learn from experience that it's almost impossible to copy something the same while drawing; a design will invariably change in some way. Children need to feel free to use an idea from wherever they see it and feel complimented when their idea inspires someone else.

Bibliography

ALLEN, JANET. *Drawing.* New York: Van Nostrand Reinhold, 1980.

BAILEY, ALICE A. *Education in the New Age.* New York: Lucis Publishing, 1954.

BATES, WILLIAM. *Better Eyesight without Glasses.* New York: Holt, 1940.

BIRREN, FABER. *Color Perception in Art.* New York: Van Nostrand Reinhold, 1976.

BIRREN, FABER. *Creative Color.* New York: Van Nostrand Reinhold, 1961.

BLOOMER, CAROLYN. *Principles of Visual Perception.* New York: Van Nostrand Reinhold, 1976.

BORGMAN, HARRY. *The Pen & Pencil Technique Book.* New York: Watson-Guptill, 1984.

CARNEY, KAY. "Tao of Acting." *Contact Quarterly* (Northampton, MA) 10 (Fall 1985).

DANIELS, ALFRED. *Drawing for Fun.* Garden City, NY: Doubleday, 1975.

EDWARDS, BETTY. *Drawing on the Right Side of the Brain.* Los Angeles: J.P. Tarcher, 1979.

ERNST, BRUNO. *The Magic Mirror of M.C. Escher.* Toronto: Random House, 1976.

FIELD, JOANNA. *On Not Being Able to Paint.* Los Angeles: J. P. Tarcher, 1957.

GILL, ROBERT W. *Manual of Rendering with Pen & Ink.* Rev. and enl. ed. New York: Van Nostrand Reinhold, 1984.

GOLDSTEIN, NATHAN. *The Art of Responsive Drawings.* Edglewood Cliffs, NJ: Prentice-Hall, 1984.

GUPTILL, ARTHUR L. *Freehand Drawing Self-Taught.* New York: Harper & Brothers, 1933.

HATCHER, CHARLES. *What Shape Is It?* New York: Duell, Sloan and Pearce, 1963.

HILL, EDWARD. *The Language of Drawing.* Englewood Cliffs, NJ: Prentice-Hall, 1966.

HOFFMANN, ARMIN. *Graphic Design Manual.* New York: Van Nostrand Reinhold, 1965.

KLEMIN, DIANA. *The Art of Art for Children's Books.* Greenwich, CT: Murton Press, 1966.

MEGLIN, NICK. *On-the-Spot Drawing.* New York: Watson-Guptill, 1969.

MENDELOWITZ, DANIEL. *Mendelowitz's Guide to Drawing.* 1967. Revised edition edited by Duane Wakeham. New York: CBS College Publications, 1982.

MEYER, URSULA. *Conceptual Art.* New York: E. P. Dutton, 1972.

MUGNAINI, J., and Lovoos, J. *Drawing: A Search for Form.* New York: Reinhold, 1965.

NICOLAIDES, KIMON. *The Natural Way to Draw.* Boston: Houghton Mifflin, 1941.

RICO, GABRIELE. *Writing the Natural Way.* Los Angeles: J. P. Tarcher, 1983.

SIMON, HOWARD. *Techniques of Drawing.* New York: Dover Publications, 1972.

SMITH, STAN. *Drawing and Sketching.* Secaucus, NJ: Chartwell Books, 1982.

TEISSIG, KAREL. *Drawing Techniques.* London: Octopus Books, 1982.

WATSON, E., and WATSON, A. *The Watson Drawing Book.* New York: Van Nostrand Reinhold, 1962.

WATSON, ERNEST. *The Art of Pencil Drawing.* New York: Watson-Guptill, 1968.

Index